Animal Artisans

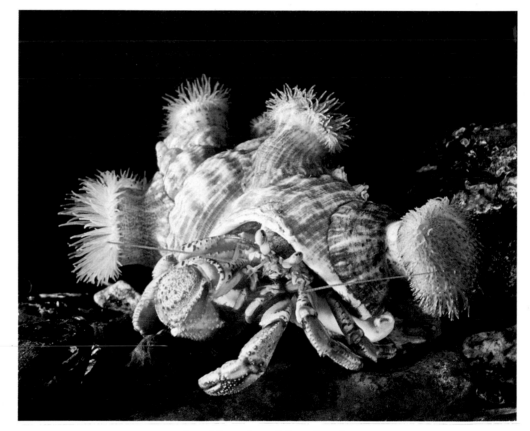

above A hermit crab has placed
stinging anemones on its shell to
ward off aggressors.

overleaf A young harvest mouse
in its nest.

endpapers Common wasps make
their paper nests from chewed
wood pulp.

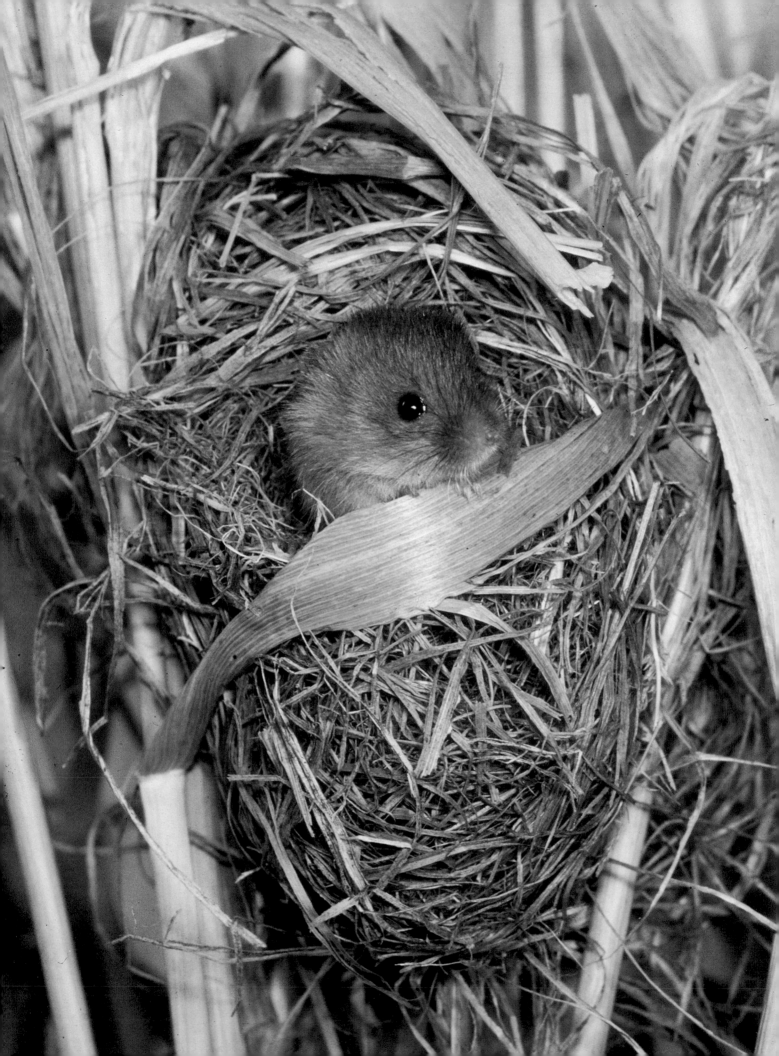

Animal Artisans

Michael Allaby

1982
Alfred A. Knopf
New York

THIS IS A BORZOI BOOK
PUBLISHED BY ALFRED A. KNOPF, INC.

Copyright © 1982 by Michael Allaby

Published in the United States by
Alfred A. Knopf, Inc., New York.
Distributed by Random House, Inc., New York.
Originally published in Great Britain by
George Weidenfeld and Nicolson Limited.

Library of Congress Cataloging in Publication Data
Allaby, Michael.
Animal artisans.
Bibliography: p.
1. Animal intelligence. 2. Tool use in animals.
3. Animals, Habits and behavior of.
I. Title
QL785.A58 1982 591.5 82-47962
ISBN 0-394-52451-9 AACR2

Manufactured in Great Britain

First American Edition

Contents

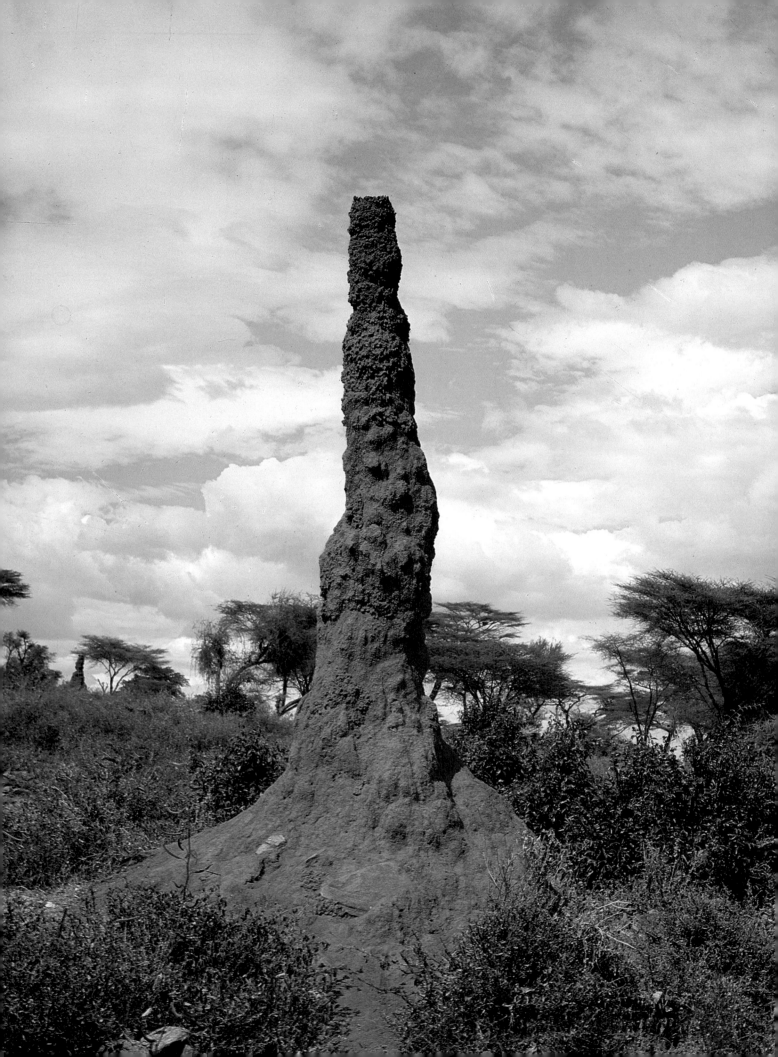

Introduction

LOOK around you and you will see only the things made or arranged by humans. If you are indoors, this is hardly surprising, but if you go outside you will find a world no less arranged by humans for their own convenience. In the city you will see buildings, streets and vehicles. Trees may have been planted, and parks and open spaces landscaped, to create effects or provide amenities humans find pleasing. If you go into the countryside you will find that much of it – in Europe almost all of it – has been altered by generations of human farmers so that it bears little resemblance to the landscape into which men and women first ventured.

Today we are changing the face of the earth on a scale that is unprecedented, and because our success as a species makes such heavy demands on other species it is easy to assume that it is only humans who modify the world around them – that we are unique. This is quite wrong. Long before our ancestors began to tame animals and till the soil other species had created surroundings that suited them, by taking what was there and changing or rearranging it. The entire surface of our planet, from the bed of the oceans to the top of the atmosphere, has been made by living things. Because we are skilful at performing tasks we flatter ourselves that we are fundamentally different from all other animals in this respect.

In this book an attempt is made to set straight the record, in an entertaining and also informative way. It examines a range of activities that many of us consider peculiarly human and shows examples of them taken from the world of other animals. We will find not only that many of the things we do and make are also done and made by other species, but that in some cases they are done better. We will see non-humans that build, that grow food crops, that produce exotic interior decoration for the structures they have made, that collaborate in ways more sophisticated than anything of which we are capable, that weave fibres and sew.

Each chapter of the book deals with a particular activity, but these activities group themselves naturally into sections, so that one leads easily into the next. If we begin with the provision of food, we can continue by examining the use of tools, which leads in turn to building. Building is an activity associated – among humans as well as among other species – with the raising of young, and we can examine interior decor, used by some animals as an aid to courtship. Other buildings, and their equivalents, are more permanent, and we look at them. The construction of nests requires some modification of the immediate surroundings, but some animals go much further and produce major changes in the local landscape. We consider ways in which animals travel without making use of the legs, wings or fins with which nature equipped them. The collaboration which often enables a colony to travel invites us to look at other forms of mutual cooperation, and from what we see of the behaviour of animals, we may learn something about our own.

A termite nest, the most spectacular of all animal buildings. Air conditioned and with its internal temperature controlled, it houses and sustains a complex society, sometimes with millions of individual members.

Pastoralists and Farmers

IN the course of our rather short history, we humans have obtained our food in several ways. Our ancestors did their best to steal game from larger, better armed predators, allowing the real predator to make the kill and then driving it away from its meal. It is easier to do that than you might think, at least with some predators. People ate carrion when the predators were likely to raise serious objections to being robbed, making do with what was left of the carcase after the carnivore had eaten its fill. They did a certain amount of killing on their own behalf, making a great song and dance of it, and for the rest – which in fact amounted to the bulk of their diet – they gathered fruits, nuts, roots and berries, and they grubbed around for insects.

Then they invented agriculture and pastoralism, both at about the same time, varying from about eight to about twelve thousand years ago in different places. Instead of hunting animals they confined, managed and, in time, domesticated them. Instead of gathering plant foods they sowed seeds and reaped the harvest.

In many places farming began with the clearing of land, which was needed to provide grazing for the herds and flocks, and also for cropping. To clear the land, much of which was forested, people developed quite effective techniques. Using stone axes they would fell trees chosen so that in falling they would bring down more trees. If timber was needed, this was the time to take it. The wood, and more especially the leaves and small twigs, were allowed to dry, and then a fire was started. This burned off the undergrowth, with all the small shrubs and saplings; and as the ground cooled again, grass began to grow. This itself was merely an adaptation of the way fire had been used for many thousands of years, for the distant ancestors of these people used to light forest fires in order to drive out the game animals on which they fed. The use of fire, and the domestication and cultivation of animals of other species and of plants, is uniquely human behaviour, we believe. Or is it?

The black kite (*Milvus migrans*) is confined mainly to Africa, Asia as far south as Australia, and continental Europe, although occasional individuals do stray over southern England. In India it is one of the most common of birds, and because of its omnivorous feeding habits it is known popularly as the 'pariah' kite. It has another common name, however – the 'fire hawk'. It is often to be seen at the leading edge of grass and brush fires, picking off the animals as they run for safety: in this it is behaving much like prehistoric humans.

It is but a small step from such profiteering to a little fire-raising; humans have done it, and so have the kites. The birds do not make fire for themselves, of course, any more than the first humans did. They merely take advantage of naturally occurring fire, spreading it to their preferred site by picking up smouldering sticks and dropping them on to dry grass.

The black kite, or 'fire hawk', may actually start fires in order to drive from cover the small animals on which it feeds.

This is not farming, but it is worth mentioning in order to refute the common belief that it is only we who have mastered the use of fire: we are not alone in taking that first step, which in our case led to farming.

Of animals that farm in the true sense there are many. Consider first the delightful pikas, also known as mouse hares or calling hares. These are small animal, no more than 20 cm (8 in) long, related to the rabbits, cotton-tails and hares, but without their floppy ears and long, powerful hind legs. There are fourteen species to be found in the mountains of North America, Asia and eastern Europe, all belonging to a single genus, *Ochotona*.

Some live in colonies in burrows, others live alone above ground, finding shelter in crevices among the rocks; but either way they space themselves out so that each is some distance from its neighbours, but within hailing distance. It is their habit of shouting to one another that gave rise to the name 'calling' hares. The calls may be concerned with the defence of feeding ranges, or they may be warnings.

The secret of their success lies in their ability to survive in climates that would defeat most small animals. They are to be found in Kamchatka, in the far east of the USSR, and *O. wollastoni*, the Mount Everest pika, lives at altitudes of more than 5,000 m (above 16,000 ft), which makes it the world's highest resident mammal. They live in high, dry deserts, above treelines, and what is more, they thrive. They have thick fur, which helps, even on the soles of their feet, which are very good at

The attractive pika, or 'mouse hare' is a close relative of the rabbits and hares. It collects plant material to make hay, on which it feeds during the harsh winter.

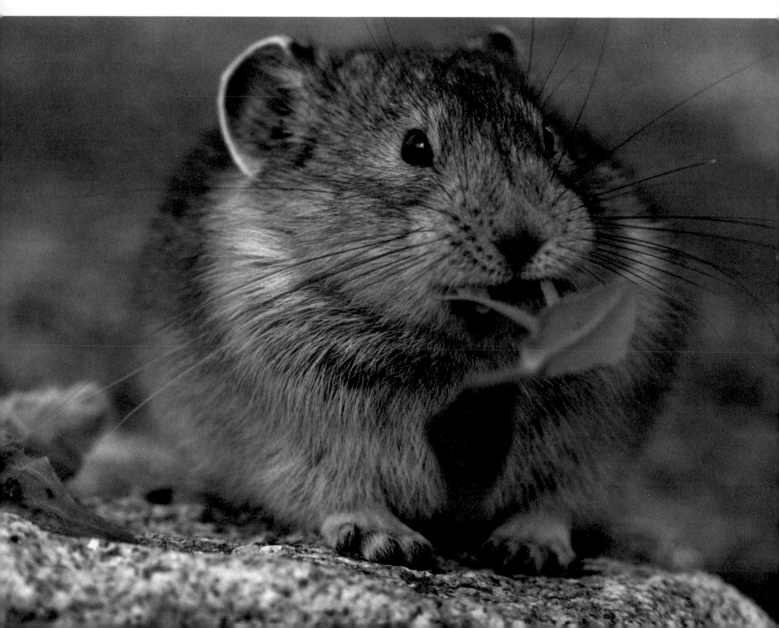

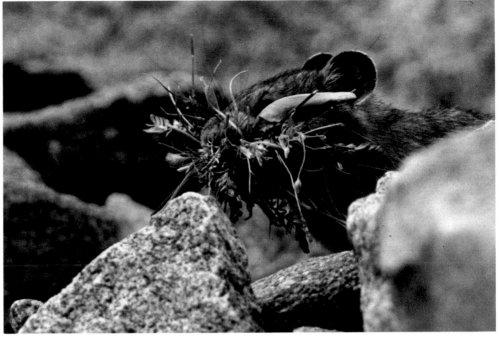

above The food store of a pika: plant material dried carefully to make hay.

above right In the mountains it inhabits there are few seeds or nuts to feed the non-hibernating pika through the winter. All kinds of plant material must be stored.

gripping icy or wet rocks; and they can close their nostrils to keep out the cold air. However, they do not hibernate, and so if they are to survive the winter they must store food, like many animals. Unlike most food hoarders they must have a really efficient system because their very lives depend upon it.

They feed on grasses, sedges, herbs and other low-growing plants, and during the growing season they feed almost constantly. In their habitat there are no nuts and few seeds large enough to be worth storing, and so they have no choice but to lay in winter supplies of green material. They start to do this as autumn begins, collecting leaves and laying them out in the sun to dry. From time to time they turn their heaps to make sure everything dries evenly, and when they are satisfied with them they carry the material to rocky shelves protected by overhanging ledges, and there they build haystacks. In fact they have made hay in just the way any human farmer would, and good hay it is. Their haystacks do not smoulder through being too damp, nor do they rot nastily into a black, slimy, smelly mess. In some places the local shepherds know about the pika haystacks and are not above stealing them when food for their flocks is short.

The pikas are not the only animals to make hay, although they are the only non-human mammals to do so. At least one species of termite, *Hodotermes mossambicus*, also prepares and stores food in this way. These insects have large, flat chambers, up to 1 m (3 ft) in diameter, situated close to the ground surface; in these plant material (mainly grass) is placed to dry. As it dries it emits gases, especially carbon dioxide, which must not be permitted to enter the nest itself. As soon as the hay is made and no more gases issue from it the workers carry it closer to the centre of the nest and stack it in storage chambers.

The pastoralists of the animal world are to be found among the ants, which commonly domesticate aphids. Aphids, or 'plant lice', form large colonies and so are prime candidates for herding. They feed on plant sap obtained by piercing leaves. Under certain conditions the sap is quite rich in sugars, but much less rich in the minerals that the aphids need. To obtain these the aphids must consume large amounts of sap; this provides them with surpluses of sugar, which they excrete as 'honeydew'. The honeydew, then, is the crop, and it is the aphids which provide it.

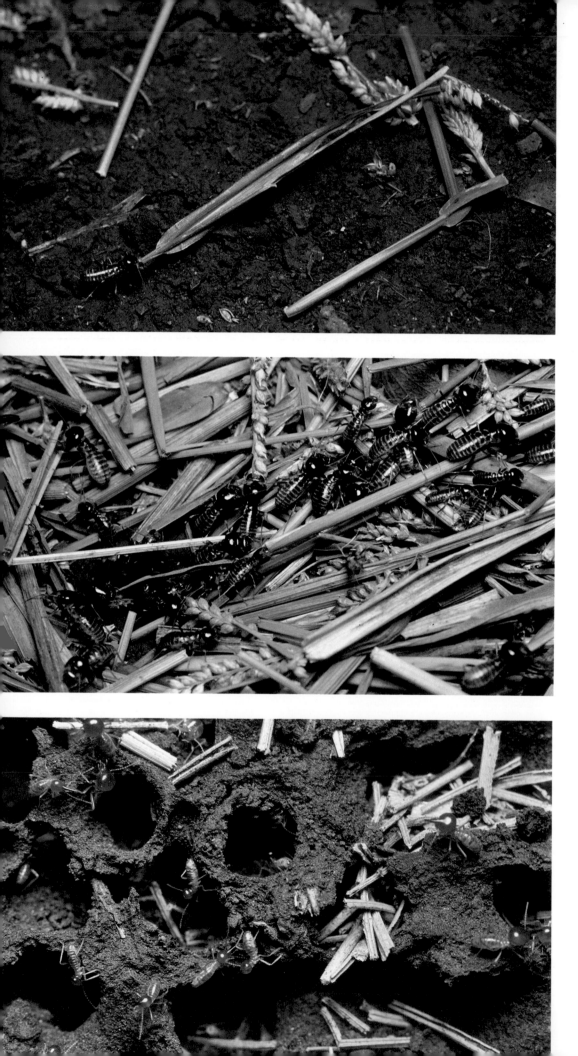

Harvester termites also make hay, transporting pieces of grass much larger than themselves for the purpose (*top*). Outside the nest entrance the grass is cut into small pieces to be taken inside (*centre*). When the nest is broken open (*bottom*), the termites can be seen arranging the stored grass. As it dries it gives off carbon dioxide, so the store is isolated from the rest of the termitary to prevent the gas from contaminating the air. The final store, from which no gas is emitted, is close to the centre of the termitary.

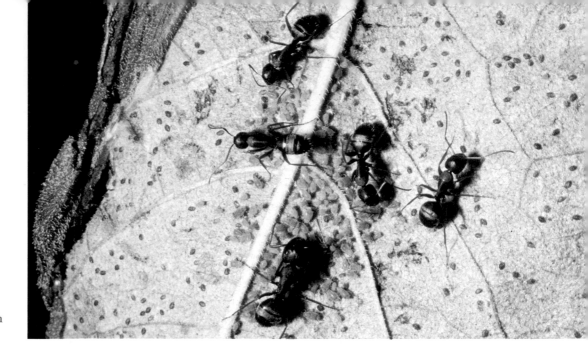

These ants, in Utah, are tending aphids. The aphids feed on the leaf, which supplies them with more sugar than their bodies need. The surplus is excreted as 'honeydew' which is eaten by the ants.

It is only when plants are manufacturing sugars in large amounts that aphids produce honeydew, and only under these circumstances are ants attracted to them. At the simplest level, herding ants will merely surround the aphids and feed on the honeydew, driving away predators. Aphids that show a tendency to wander will be brought back by the ants, who will sometimes bite off the wings of their flock to prevent any attempt at mass migration, much as humans clip the wings of their own domesticated aviators. This could be unfortunate for the aphids, because they rely on mass migration to carry them from food plants that are starting to wilt probably because of their activity – to new, healthy ones. The ants are prepared for this, however, and when the need to move arises they carry the aphids, one by one, to a new plant they have chosen. *Paracletus* is one genus of aphids that has become so dependent on the care lavished by ants that it cannot complete its life cycle without them.

When the ants move their aphids they do not take them to just any plant. They know which plants will give the largest honeydew yield and give them protection as well as the aphids. Where honeydew collects on leaves it is liable to block stomata, so inhibiting the growth of the plant and in extreme cases causing it serious injury. The ants make sure that honeydew does not collect in this way. Left to themselves, this is a service the aphids perform automatically, if not very efficiently, by kicking away each drop of honeydew as they excrete it. When ants are present the kicking stops.

The ants further stimulate honeydew production by stroking the aphids with their antennae; it has been estimated that in this way a large aphid, given a nutritious diet, can be induced to produce almost 2 cu mm ($\frac{1}{100}$ cu in) of honeydew an hour.

Protection of their flocks involves some ants in considerable work. There are species that use leaves to construct roofs over the flock to keep off the rain as well as airborne predators. Others use soil to make a roofed enclosure, and some even leave their own nests to live with their flocks, building a complete structure, a kind of pavilion, in which both groups of insects live together.

In autumn, farmers in many parts of the world bring their herds and flocks down from the high summer pastures and house them under cover for the winter. There are ants which do something very similar. In autumn the cornfield ant (*Lasius americanus*) collects eggs of the corn-root aphid (*Anuraphia maidi-radicis*) and takes them to the ant nest. There the eggs are stored carefully through the winter, until in spring they hatch. Aphids do not develop through a larval stage, and so they do not

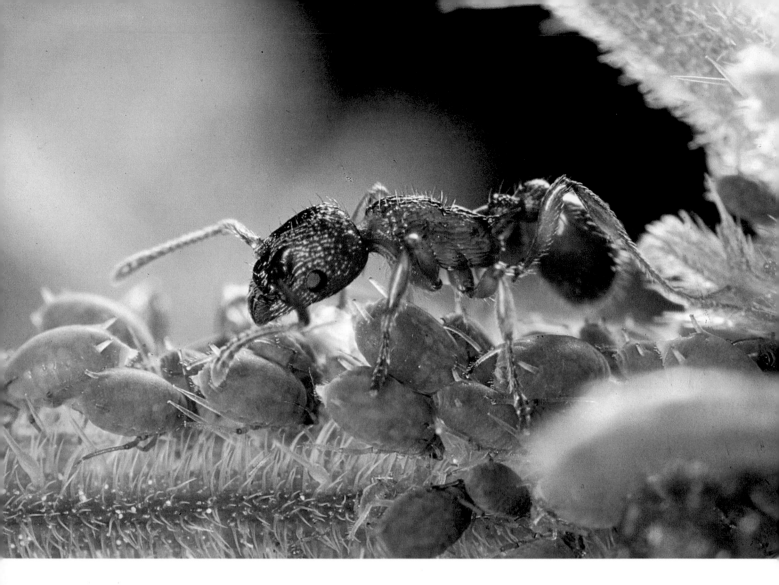

metamorphose: the nymphs are like smaller versions of the adults, and grow by moulting. This first generation of the year is especially valuable to the ants, for it consists only of 'stem-mothers'. The ants carry the nymphs to the roots of the wild plants on which the young aphids feed. When they mature into stem-mothers, in a matter of days, they begin to reproduce asexually. All of them are female, as are all their offspring, who begin to reproduce in the same way, so that a small number of eggs tended through the winter can lead very quickly to a large flock of aphids. As soon as obliging human farmers have sown their corn and it has begun to grow, the ants move their flocks to the corn plants, which produce better honeydew yields. The aphids themselves continue to multiply: although the life expectancy of an individual aphid is no more than two or three weeks, during that time a stem-mother may produce several young a day, ready to feed at once.

Later in the year the flock produces males and females. These mate and the females lay the fertilized eggs which will survive the winter only with the ants' care. By collecting and tending the eggs the ants ensure that the aphid population is maintained at a high level: without their intervention the eggs would be laid on the roots of plants that die as soon as the corn crop has been harvested. In this case the new stem-mothers must begin their lives by searching for plants on which to feed. Most will fail, and there will be a delay before the population recovers. During this time isolated stem-mothers will produce colonies of females, some of which will manage to migrate to new food sources.

Where the aphid species that is favoured by a particular ant feeds on a perennial plant, the problem of stock management is much simpler. The ants take the aphids

The ant stimulates the aphid to release honeydew by stroking it. Like human stock farmers, some ants carry their aphids to food plants they know will produce high honeydew yields, protect members of their flocks from predators and prevent them from straying.

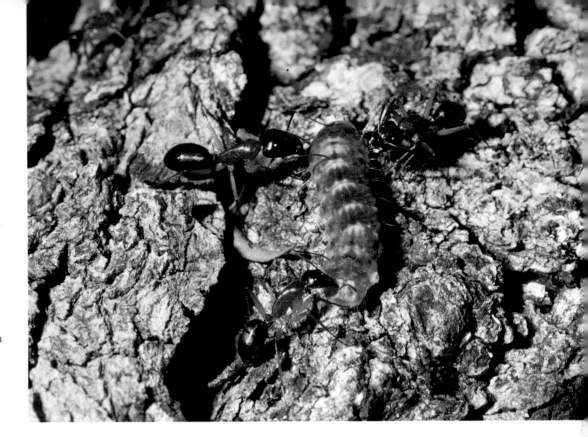

Not only aphids feed ants and are tended by them: some caterpillars are treated in much the same way, the caterpillar benefiting from the protection of the ants. This caterpillar is being taken by night to feed on mistletoe.

This American honey ant has expanded its crop to store food which it regurgitates for other members of the colony. In this way the ants can store liquid food, using their own bodies as storage vessels.

to the roots, place them in position, and build their own nests around the exposed plants. It is a little like the old crofting practice of housing overwintering stock and the crofter's family at either end of the same building.

In dry climates it might be a good idea to find a way of storing liquids, and three genera of ants, *Myrmecocystus, Leptomyrmex* and *Campanotus* have done just that. Ants' tools are specialized versions of themselves, and here it is the worker ants themselves – called 'repletes' – that comprise the stores. Like all ants, bees and wasps, they possess a crop, a stomach which serves only to store food that can be regurgitated. It is by means of the crop, or 'honey stomach', that ants feed their larvae and one another. Among these food storers, certain selected workers are fed truly colossal amounts of honeydew. This enters their crops, which begin to swell, continuing until they are the size of large peas. An ant in this swollen state moves only with the greatest difficulty, and so the repletes retire to chambers within the nest set aside for the purpose, where they attach themselves to the roof. They hang there for as long as may be necessary. Hungry ants visit them and by stroking compel them to regurgitate food.

Ants like sweet foods, but it is no more than their fancy, and if aphids are not available there are many other foods to sustain them. The great majority of ants are vegetarians, and among them are some that have gone much further in the direction of agriculture than the pastoralist aphid-herders. They actually grow their own food, under rigidly controlled conditions. Moreover the food itself consists of species of fungus that have entered into the spirit of the thing, and cannot survive without the ministrations of the ants.

The ants in question live in tropical America, belong to the genus *Atta*, and are known as 'leaf-cutter' or 'parasol' ants. They are regarded as pests by human farmers because they require leaves for their work, and prefer the leaves of citrus trees. Like all ants they work as highly coordinated teams and do not waste their time, so they are inclined to descend upon an orchard and strip every leaf from every tree.

The columns of workers advance under the protection of soldiers, which are much bigger than the ordinary workers, some of which are very small indeed.

The leaf-cutter ants of tropical America cut in an arc by anchoring themselves by a back leg to the edge of the leaf, biting from one side to the other as far as they can reach (*top*). Carrying their pieces of leaf above their heads to the nest (*centre and bottom*), they earn their other name of 'parasol' ants.

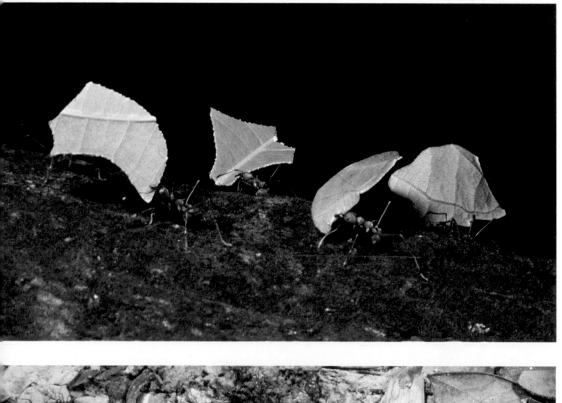

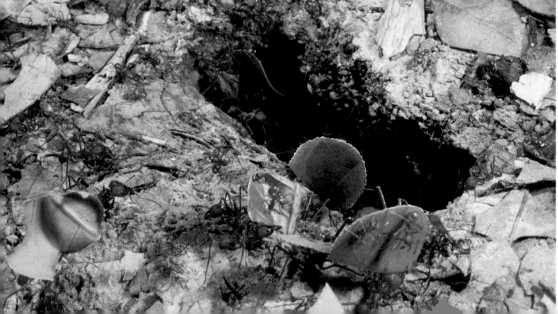

Arriving at the chosen tree they climb along every branch and twig, and once in position the medium-sized workers begin to make cuts into the leaves. If the tree is in flower, so much the better: they take the flowers. The cuts themselves are curved, because each ant stands in one place and bites from as far as it can reach on one side to as far as it can reach on the other. As soon as a piece of leaf is detached the ant hoists it high above its head and makes off with it back to the nest. Before long the tree bears columns of ants carrying what look very like parasols, and this accounts for their common name.

On top of each piece of leaf there sits one of the very small ants. Their role puzzled scientists for years, for it would be uncharacteristic of ants to go along just for the ride. At last the mystery was solved. The *Atta* ants are especially vulnerable to an insect predator, even smaller than themselves, which lays its eggs on their necks. When they hatch, the parasitic larvae eat forward into the head of the ant and devour the contents. The tiny passengers, riding atop the pieces of leaves, are in fact soldiers. They are small because it is much more convenient. Because gravity is a force of little consequence among such tiny animals there is little doubt that each worker ant could carry its slice of vegetation as well as another ant its own size, but a small passenger is easier to manoeuvre than a large one. At all events, the guard sits on the 'parasol' with its mouth wide open, and so protects both itself and its client from the attentions of such appalling parasites.

Once back in the nest, the small worker has other chores to occupy it. It is the gardener of the colony. The leaves are not eaten by the ants; instead they are chewed into small fragments, mixed with saliva and ant droppings, and so formed into spongy lumps of compost. These are placed in gardens made in underground chambers that may be as much as 1 m (3 ft) long and 30 cm (1 ft) wide and high. When the compost bed is prepared the ants seed it with bits of mycelium taken from fungus growing in an exhausted bed.

Different ants use different species of fungus. Some use *Leucocoprinum gongylophora*, some *Tyridomyces formicarum*, others various species of *Lepiota* or *Auricularia*. Each grows only in the nests of the ants that cultivate it.

Once in the nest the leaves are chewed into fragments, mixed with saliva and excrement, and used as a compost in which fungus is grown (*right*). When the compost is 'spent' the ants remove it (*above*).

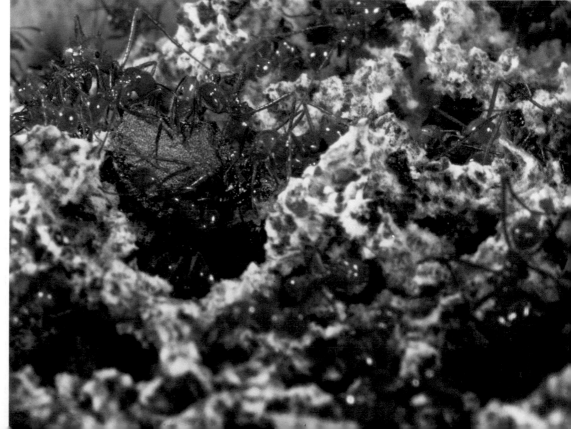

As the fungi grow, the ants inject the compost with a bodily secretion that kills bacteria and unwanted fungi. They destroy 'weed' fungi that grow in spite of their fungicides, and as their own fungus grows they bite off the ends of its hyphae. This produces club-shaped heads, which the ants eat. It is their only food. An *Atta* nest may extend 5 m (16 ft) below ground level and accommodate a million or more individuals, all of them fed by the fungus gardens, and the fungus is also used to strengthen walls within the nest.

When the time comes for the colony to divide and for new queens to depart and establish new nests, each female takes with her a small piece of mycelium. It is her most treasured possession, for her reproductive success depends upon it absolutely. She has a small recess inside her mouth in which she carries the fungus. When her larvae mature into adult workers, and begin the serious business of building the new nest and tending the millions of eggs she will lay during the remainder of her life, she passes the fungus on to them. They know what to do with it.

Why do the ants go to all this trouble instead of eating the leaves themselves? The answer is that the great majority of plant cells are somewhat indigestible, and most animals can derive very little from them. Among the mammals there are some, like the horse, that compensate for this by eating vast quantities of food and passing it through their guts as quickly as they can, extracting as much as possible from it. Others, the ruminants, have very complex digestive systems in which bacteria are employed to break down the cellulose cell walls in which plant nutrients are sealed. By themselves, ants could not digest cellulose, and so they could not subsist on a diet of leaves. Fungi, however, can break down cellulose, and they themselves contain little of it and are therefore easily digested. Thus the ants eat their leaves at second hand, allowing the fungi to do their work.

Termites, on the other hand, have bacterial populations in their guts which do break down cellulose; this enables them to devour wood, for which many of them have a special liking. Nevertheless, there are some termites that grow fungi in gardens, and they do so in much the same way as do the *Atta* ants.

A termitary is a complex structure which in some cases houses more than one species of termite. Among the *Macrotermes*, for example, it is possible to find termite mounds that are dark at the top and pale below. Termites use their own faeces as a building material: the colour difference arises because the mound is occupied by two related species, one dark in colour and producing dark faeces, the other pale and producing pale faeces. Both termites cultivate fungus. Indeed, their lives are

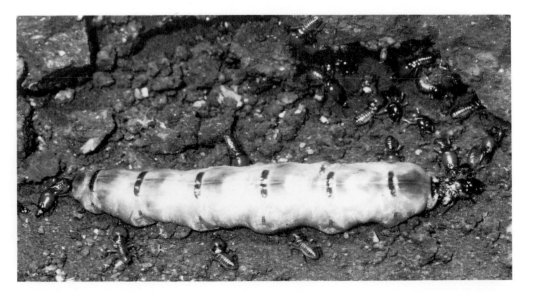

Unlike a bee or ant queen, the termite queen is extremely large and quite helpless, depending utterly on her attendants.

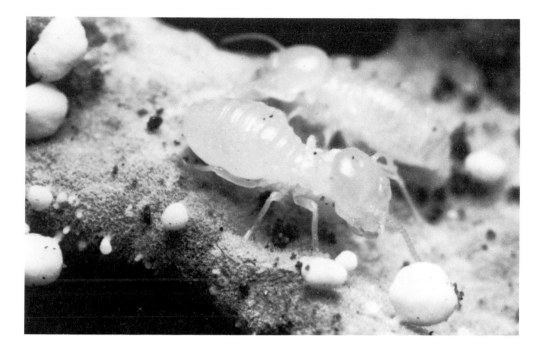

Termites, too, grow fungi. This nymph is tending the fungus garden.

very similar, but they are different species and although they occupy the same complex they have little to do with one another.

At the centre of these particular termitaries, although not at the centre of all, is the royal chamber, occupied by the king and queen. The queen is immensely large, often 10 cm (4 in) or so in length, and quite incapable of looking after herself. The king is very small; his only task is to copulate and her only task is to lay eggs. Since this is all the couple do it is rather misleading to think of them as rulers whose decisions affect the lives of their subjects. True, their worker subjects tend them ceaselessly, but within a termitary power resides nowhere at all: the governing institution consists in the members of the community as a whole.

The workers of the royal chamber are smaller than other workers, and the entrance to the chamber permits no larger termite to pass. As the queen lays eggs, these workers carry them to nearby nursery chambers, where they are cared for until they hatch, and as larvae afterwards.

Not far from the nursery chambers are storage chambers containing finely chewed bits of leaves or, in some termite species, wood. Material is taken from here to make the beds in which the termites grow fungi of the genus *Termitomyces*. The beds consist of leaf or wood particles mixed with termite faeces, and the termites feed upon the fungi. Even the larvae visit the fungus beds when they are hungry, for the termitary maintains a cafeteria that is open twenty-four hours a day, every day, to provide food for all citizens.

Thus far the technique is very similar to that used by the *Atta* ants, but termites suffer one disadvantage. They are soft-bodied and very vulnerable to predators, and most of all to the many carnivorous ants. For this reason they are most reluctant to sally forth in the open, and spend their entire lives inside the protection of the substantial walls of their mounds. They collect the raw materials for their fungus beds by tunnelling into the ground up to 4 m (13 ft) away from the nest. Moving very close to the surface of the ground, they gather their material and chew it into fragments for transport back to the stores.

If there is an activity that is uniquely human, it is not agriculture.

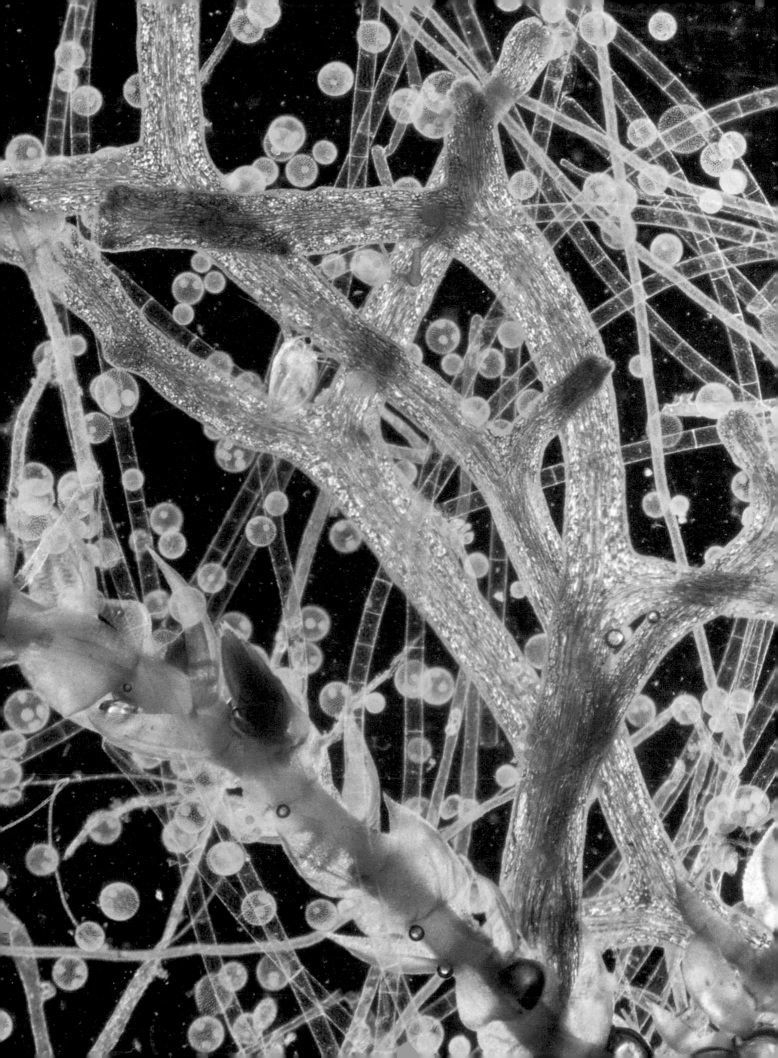

The Natural Fertilizer Factory

WHEN farmers sow seed they supply the earth with fertilizer as nutrient for the growing crop. Although it had been observed that the addition of manure led to heavier crop yields, it was not until about a century ago that scientists discovered why this should be so. Baron Justus von Liebig claimed the credit for the discovery, but in fact there were many workers studying the subject, which clearly was fascinating. No matter who was responsible it was this discovery that led to the creation of the fertilizer industry and that produced the style of farming we know today.

British farmers now use well over two million tonnes of fertilizer each year, supplying the three nutrient elements nitrogen, phosphorus and potassium, and about two-thirds of the total amount consists of nitrogen. Plants need nitrogen in particular if they are to grow healthily.

Our atmosphere is about four-fifths pure nitrogen gas, so there is no possibility of a shortage, but there is a problem. Nitrogen cannot be absorbed by plants in its gaseous form. It must be made into compounds, by combining it with hydrogen to make ammonia (NH_3) or ammonium (NH_4) or amino (NH_2) compounds, or with oxygen to make nitrite (NO_2) or nitrate (NO_3).

In order to make such compounds, the ordinary nitrogen molecule, consisting of two atoms of nitrogen, must be split to supply single atoms. This is difficult because

opposite Fresh water may support a wide variety of plants and animals. Here we see a liverwort, water moss, *Volvox* and *Spirogyra*, magnified many times.

right A cyanobacterial colony, or blue-green alga, one of the most ancient of all associations of cells.

Living organisms have adapted to life under extraordinary and apparently hostile conditions. This green alga is growing in thermal water at Waimareh Thermal Valley, New Zealand.

the atoms in nitrogen molecules are strongly bonded together. They can be split only by expending a large amount of energy. When nitrogen combines with hydrogen to make ammonia, energy is released, but nevertheless the process of making ammonia from nitrogen gas is extremely energy-intensive. In the fertilizer factory it is carried out at temperatures of 300 to 400° C and at pressures of 400 to 1,000 atmospheres. Something like half of all the energy used in modern farming goes into the making of nitrogen fertilizer.

Before nitrogen factories were built, however, plants obtained some of their nitrogen with the help of lightning, which injects appropriate amounts of energy into the atmosphere, splitting nitrogen molecules as it does so. This causes the separate atoms to combine with oxygen to form oxides that dissolve in rainwater and so are washed to the ground. We may imagine that thunderstorms with lightning are fairly uncommon events, and in any one place so they are. In the world as a whole, however, they occur constantly, and there are thousands of lightning flashes every day. The world's chemical industry uses some 44 million tonnes of nitrogen a year to make nitrogen compounds. Lightning 'fixes' about 45 million tonnes of nitrogen a year, making as much fertilizer as our factories. Unfortunately, this is nowhere near enough to account for the growth of plants before the fertilizer industry set up in business. In fact, we know by how much it falls short. There are a further 175 million tonnes of nitrogen in plants, animals and the soil, for which we have not accounted. We must look for a natural fertilizer factory.

The search takes us to some of the simplest, most primitive organisms on the face of the earth, to certain blue-green algae and to simple bacteria. The blue-green algae are plants, of course, not animals, but they never live alone. They consist of long chains of cells forming filaments which tangle and lie across one another so that the community of plants develops into a mat. Inside the mat there are bacteria and other organisms, so that a blue-green algal mat is a little world of its own. You can see them sometimes in shallow pools where the water moves slowly, covering rocks and often beaded with bright bubbles of gas. The bubbles contain oxygen, not nitrogen, for the algae engage in photosynthesis, releasing oxygen as a by-product, and they also contain carbon dioxide as a by-product of their respiration. It was these mats that first began to release oxygen into the atmosphere on a large scale and so to convert the primitive atmosphere of the planet into the oxygen-rich

The upper layers of water support a large and diverse population of very small plants and animals, known collectively as plankton. This freshwater plankton includes protists, rotifers, algae, *Bursaris*, *Volvox*, *Stentor*, *Vorticella* and *Chonchilus*.

atmosphere we have today. In some places the mats form over many years to thicknesses of several feet, and fossils of such mats are among the oldest of all fossils. The blue-green algae have thrived on earth since soon after the first appearance of life. It is not only in the provision of oxygen and nitrogen that they are involved. They also concentrate minerals, and so may qualify as microscopic 'miners' similar to those we will meet again in 'Microscopic Metallurgists'.

How do single cells manage to invest the large amount of energy that is needed to obtain the nitrogen which they require? Their secret lies in their small size and large number. The energy needed to split a single nitrogen molecule is not great. It becomes great only when countless zillions of molecules must be split all at the same time. Each cell invests a small amount of energy, obtained chemically, and originally from sunlight, to fix a small amount of nitrogen which is perfectly adequate for its needs. The process is significant because each of the countless cells is engaged in it. Working together they demonstrate most convincingly that there are more ways to obtain energy than by the burning of coal or oil.

Root nodules on the roots of a broad bean plant. Each nodule contains a culture of bacteria which has infected the root. It takes carbohydrate from the root but releases nitrogen, an essential plant nutrient.

The bacteria which fix nitrogen are of two kinds and they are to be found in almost every soil, and certainly in any soil that a plant would regard as a promising one in which to grow. Some of the bacteria are free-living, others fix nitrogen only while they are living inside the roots of plants. The free-living ones, such as *Clostridium pasterianum* and *Klebsiella pneumoniae* and those of the genus *Azotobacter*, fix nitrogen constantly, and once this is completed there are other bacteria, such as those of the genus *Nitrosomonas*, which derive all the energy they need from converting the ammonia produced by the nitrogen fixers into nitrite. Yet more, of the genus *Nitrobacter*, convert nitrite (NO_2) to nitrate (NO_3) and obtain their energy in that way, both groups basing their lives on the fact that some chemical reactions release energy while others absorb it.

The Rhizobia, members of the genus *Rhizobium*, are bacteria which live and reproduce freely in the soil, but obtain their nitrogen from ammonia produced by other bacteria. It is only when ammonia becomes scarce that they change their way of life. They move towards the roots of plants, usually the plants we call legumes, and enter through the root hairs. Once inside they begin to multiply, and this leads the plant to grow nodules, white 'blobs' on its roots about the size of match-heads. Inside their nodules the bacteria lose their ability to reproduce, but they do fix nitrogen, which passes through the root system directly into the plant. In return the plant supplies them with carbohydrates which sustain them.

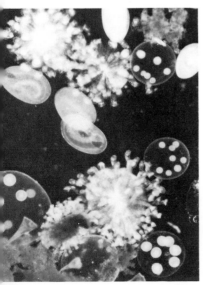

The story does not end there. If it did the chemistry of our planet would be very different, for atmospheric nitrogen would be scavenged from the air but would move subsequently through the environment by routes about which we can only speculate. In fact the nitrogen that is fixed by micro-organisms is returned to the atmosphere, also by micro-organisms but of a different group, the denitrifying bacteria. These are bacteria which can obtain energy from the breaking down of nitrogen compounds that they find in the wastes left by plants and animals.

Bacteria are neither plants nor animals. They belong in a kingdom of their own, and in the view of many modern biologists they should be placed in two kingdoms, Protista and Monera. The protists are the larger-celled organisms, the protozoans such as amoebae, and those whose colonies we shall meet again in 'Teamsters'. The monerans are the 'microbes', the smallest of all single-celled organisms, and the first forms of life that appeared on the planet. It is they that move many elements through the environment and it is they whose activities supply most of the nitrogen used by plants and, through the plants, by animals. They are the workers in the natural fertilizer factory who have been working diligently for some three and a half billion years.

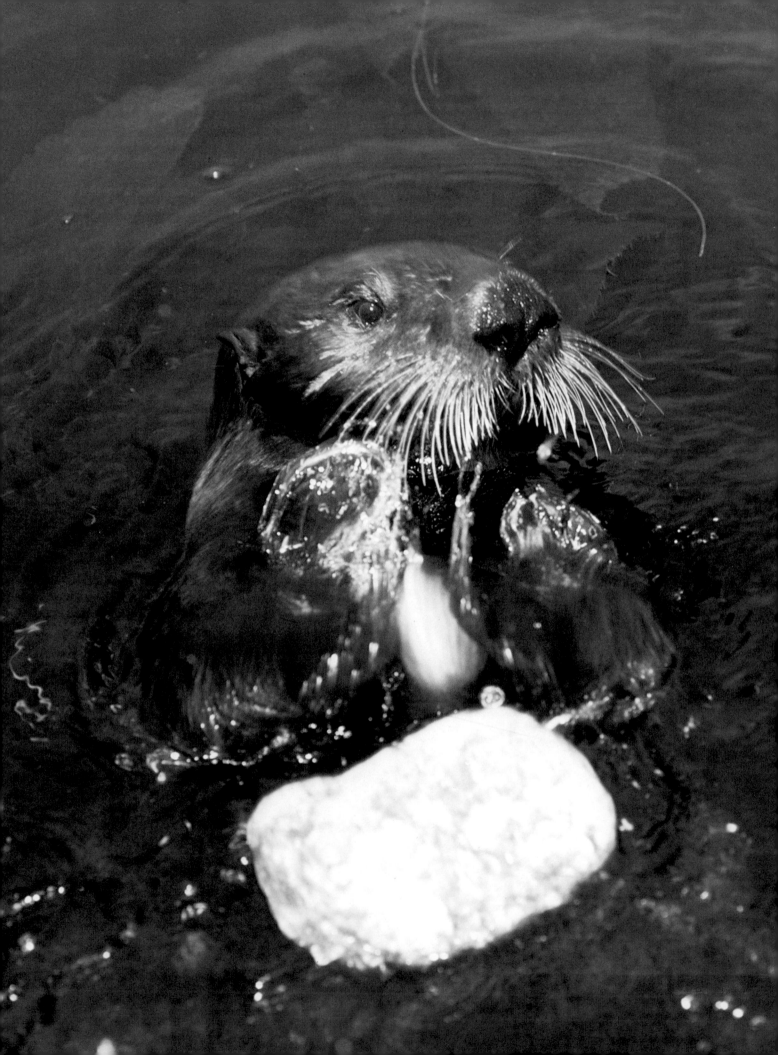

Users and Makers of Tools

opposite Sea otters usc stones as tools with which they break open shells that are too hard for them to crack with their teeth.

below The decorator crab (this one is in the Red Sea) covers itself with bits and pieces of materials it finds on the sea bed, so providing itself with a very effective camouflage.

THE hermit crab, whom we shall meet again in 'Teamsters', lives in a shell vacated by the owner who built – or rather grew – it. Once installed in its acquired shell, which it will have chosen with some care and discrimination, the crab carries it about until the time comes to move to a new shell. The shell is a tool, an article carried by the crab and used for shelter, but not manufactured by its own body chemistry. Some hermit crabs do more than simply occupy vacant shells. Those of the genera *Dromia* and *Stenorhynchus*, the 'decorator' crabs, collect shells, sponges, anemones and other animals that spend their lives in one spot; these they place on their new shells, presumably to serve as camouflage.

If at the simplest level a tool is any article used by an animal which is not part of itself, then the shell which grows from the body of, say, an edible crab is not a tool, but the shell found and used by a hermit crab is. If we imagine that the use of tools is a peculiarly human activity we delude ourselves. Among animals as a whole it is not uncommon and, as the hermit crab demonstrates, it is not even confined to the vertebrates, far less to the mammals.

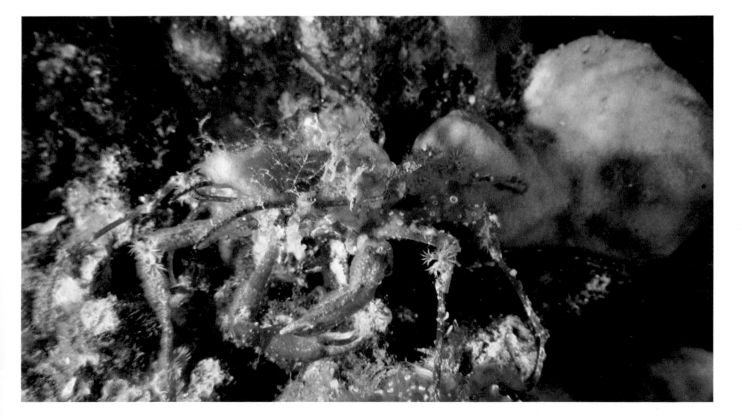

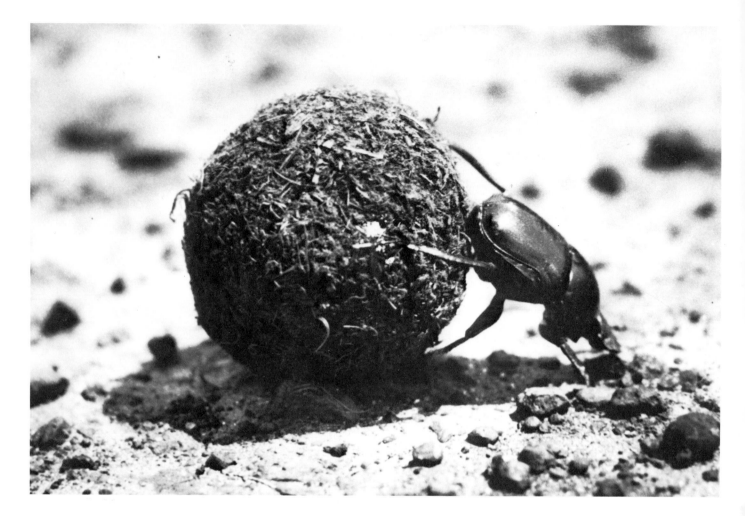

Humans are not the only animals, either, to obtain food in one place and carry it to another to eat it. For many animals it would be highly dangerous not to carry food to some secure location; for while it concentrates on eating, with its head down, an animal is bound to be less observant of its surroundings than at other times. In a world inhabited by predators, mealtimes for prey are likely to be mealtimes for hunters as well.

Animals have various ways of transporting food, of course. Some of the cats carry or drag food to the core area of their ranges. Hamsters and pocket gophers have cheek pouches in which to carry seeds. Dung beetles roll their meal into a ball and push it before them. Animals that prefer liquid foods must find their own methods.

Many ants like honey, fruit juices and similar sweet foods, and when they eat other insects they do so by extracting the body fluids from inside the hard exoskeleton. Preferring liquids, the ants have three choices. They can eat their food wherever they happen to find it; they can swallow as much of it as they can, return to the nest, and regurgitate the food; or they can devise some means of transport. Since ants are social insects and most of them make permanent nests, the first solution is unlikely to appeal to them: they enjoy eating at home. The second has possibilities, but an ant is a small animal and it can carry only a small quantity of food in its crop if it is to remain mobile.

Some ants have opted for the third choice; what is more, they assist one another in the task. There are at least four ants of the genus *Aphaenogaster* and one of the genus *Pogonomyrmex* – the harvester ants of the Mediterranean region – that use improvised 'plates' and 'sponges'.

The Egyptian scarab beetle (*Scarabeus sacer*). It collects dung which it rolls to its burrow to provide food for several days.

The problem facing them is rather different from the problem a human would face. At the small scale of the ant world, liquids behave quite differently. Surface tension becomes a force stronger than gravity; so in their dealings with material objects generally surface adhesion is far more powerful than gravity. A fly can walk up a wall because little assistance is needed to provide it with sufficient adhesion to overcome the very weak gravitational force acting on it. At this scale, things will cling strongly to one another and items small enough for an insect to move will weigh very little. An ant can carry something much larger than itself without difficulty and without needing a strong set of muscles: the limit is imposed by the size and manageability of the object, not by its weight.

The foraging ants locate the food, and then collect material from nearby to use as a tool. It may be a bit of leaf, or stick, or some mud or sand, and it is poked into the food, laid over it, or mixed with it, as appropriate. Some of the liquid will adhere to or be absorbed by the 'plate' or 'sponge'. This takes a little while, and rather than hang about waiting the ant often goes in search of more food, returning later to pick up its tool and food together. If it is bent on returning to the nest it will take with it any food-bearing tool it finds, whether its own or not, so ensuring that the team of foragers takes home all the food that has been found. Once back in the nest all the ants feed by sucking up the delectable liquor. The method may sound slightly messy, but it is very efficient. Scientists have calculated that an ant with a 'plate' or 'sponge' can carry ten times more food than if it were to swallow the food and regurgitate it later.

If there are ants that use plates, there are wasps that use hammers. Some wasps are social, but most are solitary and parasitic. They operate in different ways, but often the female wasp finds or makes a burrow into which she places insect larvae she has paralysed with her sting. She then lays one or more fertilized eggs in the burrow and seals the occupants in their hole. The larvae that hatch from her eggs

The harvester ant (*Messor barbarus*) feeds on plant seeds, which it takes back to the nest.

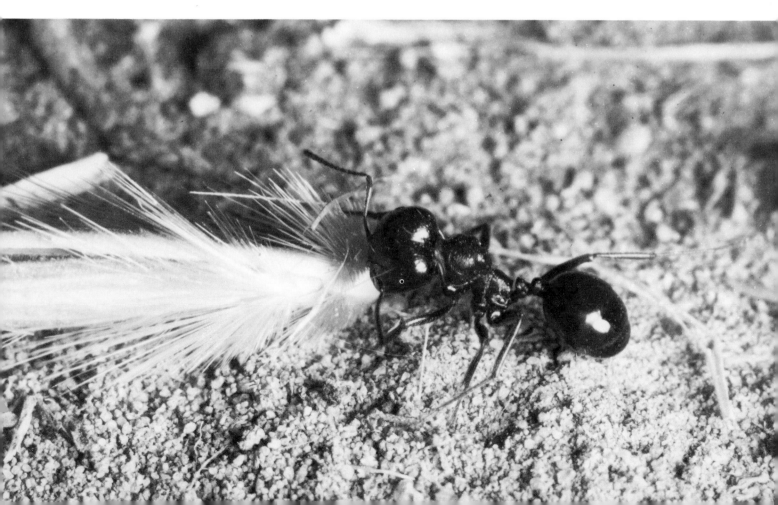

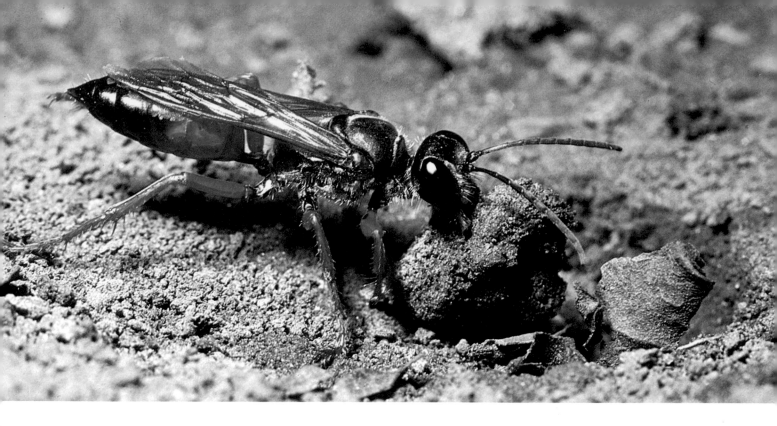

are thus provided with food enough – sedated so it can neither run away nor bite back – to last them until they mature.

Ammophila and *Sphex* wasps seal their burrows with pebbles or bits of soil. At first these are temporary, because each burrow must be stocked with a number of paralysed insects which must be brought one at a time. While she is searching for more grubs the wasp covers the entrance to the burrow to prevent her collection from being raided. At last the store is full, the eggs are laid, and the burrow is sealed for the last time.

If the small stones and soil particles with which she has made her 'door' are tools, selected and moved quite deliberately into position, then at the final sealing more tools are used. Probably to pack the seal tightly and to make it more difficult to find, the wasp pounds the mouth of the burrow with whatever is at hand. They have been seen to use pebbles, bits of stick, hard seeds, and even parts of insects' skeletons. In each case the tool is held in the mandibles, and the pounding is deliberate and variable from one individual to another. Wasps have even been seen to use sticks to prod the burrow entrance, packing soil down into it.

Probably the use of tools for pounding is no more than an extension of the head-pounding with which closely related wasps seal their burrows. Nevertheless, the step from the use of the head to the use of a tool held in the 'jaws' is a move to true tool use.

There are even snails that use tools. If a snail is rolled so that it lies with its shell beneath it, it is clearly in a fix. Such an occurrence is rare for land snails, but among aquatic snails it can happen fairly easily. To right itself the snail reaches out with its foot, finds a solid surface it can grip, and pulls itself back into the proper position. Naturally this is impossible for the unfortunate snail which finds itself on a surface of sand or gravel, where no solid surface exists, and among snails placed in this predicament by scientists the response is subtle. The snail picks up whatever material it can reach and collects it on its foot, adding more and more until it becomes top (or, more correctly, bottom) heavy and the force of gravity rolls it back on to its foot.

It is among the vertebrates that tool use reaches its highest levels of sophistication, however. There are birds which drop bombs, for example, and

The thread-waisted wasp (*Ammophila*) lays its egg in a burrow which it has stocked with food, then seals the burrow with soil.

there are others which hurl missiles from their bills with a flick of the head. The reason is entirely practical. The bombers feed on the eggs of other birds, and often choose as victims species whose eggs are too tough to be broken easily and quickly. The theft must be completed quickly if it is to go undetected, and the thief is to escape unscathed.

Egyptian vultures (*Neophron percnopterus*) are bombers. These are the birds that wheel high in the sky above weary film actors expiring from heat and thirst beneath the pitiless Hollywood sun, and when actors are in short supply they make do with ostrich eggs. They break the eggs by dropping stones on to them; it is simple. Sometimes an impatient vulture – or one with a faulty aim perhaps – will vary the pattern a little by standing over its chosen egg and battering it until it breaks with a stone held in its bill.

Birds will hurl missiles either to obtain food or to protect their own nests and young. The common raven has been known to do this: approach a raven nest too closely, and if there are any stones available you may be pelted with them. A raven can throw a stone the size of a golf ball, and while it will never win any prizes for its marksmanship it does sometimes score hits. It will not throw just one stone, after all, but as many as are necessary to make you leave, or as many as it can find, whichever number is the smaller. Egyptian vultures, too, have been seen to throw

The Egyptian vulture steals eggs from other birds. This vulture is breaking an egg by hurling a stone at it.

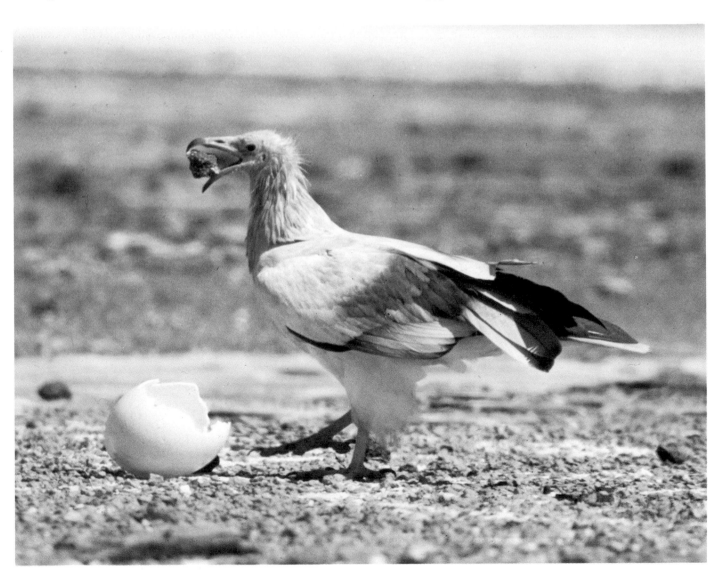

stones in their egg-smashing operations, and on average they can score a hit with one stone in two.

The American national bird is also a stone thrower, though its effective range is limited to about 60 cm (2 ft). *Haliaetus leucocephalus*, the bald eagle, uses stones to knock down and batter the small animals on which it feeds. Its diet includes turtles and these, like ostrich eggs, must be smashed open before eating. A bald eagle has also been known to throw things at humans.

There are many birds that use sticks to probe for insects. Indeed, this behaviour is so widespread as to be barely worthy of comment, for several groups of species make use of it. The technique varies a little from species to species, but generally it consists in inserting a suitable stick into a hole and either spearing insects with it or allowing them to walk on to the stick. The stick is withdrawn with its charge of insects and held with the foot while the bird picks off its prey. Sometimes it is used to lever fragments of bark from the trunk of a tree to reveal the insects that cower beneath. It is possible that on some occasions the sticks become weapons. In a colony of captive woodpecker finches (*Cactospiza pallida*) one bird was seen to stab aggressively at another with a stick.

Obviously, not just any stick is suitable; the stick probers choose their tools with care, and in some species at least they will break off protruding bits that would make it difficult to insert them into a hole. Some birds will shorten a stick to the length they find most convenient.

Even more remarkable is the behaviour of some members of the crow family, which appears to be a deliberate response to a situation created for the birds by humans.

In his *Animal Tool Behavior*, a scholarly study of such phenomena, Dr Benjamin B. Beck of the University of Chicago reports the case of some captive blue jays (*Cyonocitta cristata*) which used small bits of paper or grass to reach food outside their cage. One of the jays acquired the habit of dipping a piece of paper into its water bowl and using the wet paper to wipe around its food dish so that the last few crumbs of dry food stuck to the paper. In this way the bird could eat the last of its

The thrush uses a flat stone as an anvil on which it smashes the shells of snails, always returning with its prey to the same stone.

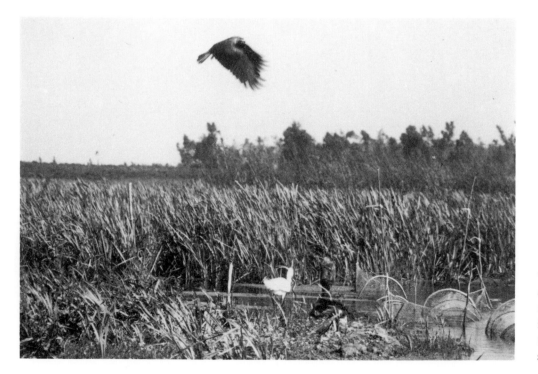

The black kite is a robber: the egret on the ground has caught an eel, and the kite is bombing it with stones to make it release the prey, which it will then steal.

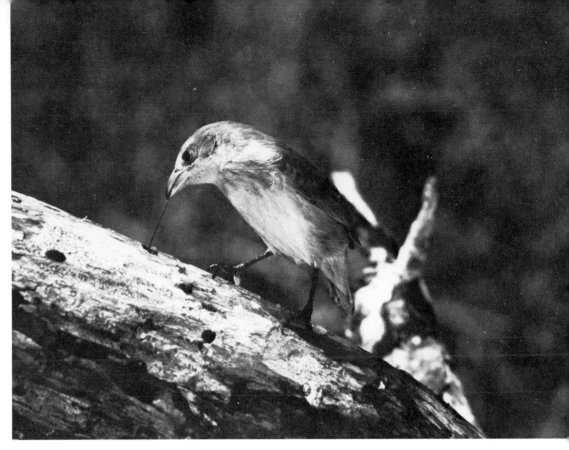

The Galápagos woodpecker finch (*Camarhynchus pallidus*) uses a cactus spine to probe for insect larvae in the bark of a tree.

food, which it would not have been able to pick up with its beak had the crumbs remained in the food dish.

The really extraordinary story, however, concerns a crow (*Corvus brachyrhynchos*) which lived at the University of Chicago and which Dr Beck observed personally. It was employed as a research subject, but seems also to have been something of a pet. The bird's cage contained various trinkets which were changed from time to time, and it was fed a diet that included a dry mash. The mash was moistened with water to make it more palatable, but sometimes the assistants who fed the crow forgot to do this. On these occasions the bird was seen to pick up a plastic cup, which was one of its trinkets, take it to the water bowl, fill it, and then carry it some five metres (16 ft) across the cage before pouring the water on to the mash. It repeated this operation until the mash was moistened to its liking. If it spilled the water it would return and refill the cup rather than continue with it empty. Dr Beck assures his readers that this behaviour appeared quite spontaneously: the bird was not trained to do it in any way at all. Other birds have been known to carry water in nutshells and similar containers, and to drink from them, but the crow is by far the most ingenious and inventive.

Another example of tool use involving water comes from the herons. The species concerned are the American green heron (*Butorides virescens*) and the squacco heron (*Ardeola ralloides*) of the Mediterranean region, which use bait to help with their fishing. (It might be worth watching the northern European grey heron, *Ardea cinerea*, to see whether this familiar bird on occasion behaves in the same ingenious way.)

The green heron collected pieces of bread that were floating in the water, driving away any other bird which tried to eat the bread. It carried the bread to a place where it had seen a fish or where it supposed a fish might be lurking, floated the bread above the chosen point, and waited, retrieving and replacing the bait whenever it began to drift. As soon as a fish approached the surface to take the bait, the heron stabbed. The squacco heron worked in much the same way, but it used insects as bait.

The archer fish can shoot down prey by firing a jet of water with great accuracy.

Perhaps we should not be surprised to learn that an animal related to ourselves as closely as the chimpanzee also uses bait, sometimes mischievously, and sometimes to obtain food. Its target is usually a duck or a chicken, and bread is often a convenient bait. Guenon and capuchin monkeys have also been known to lure poultry in this way.

Normally water cannot be considered a tool, but the jet of water from a water cannon, used to disperse rioters, is a weapon, and therefore a tool. Similarly, a missile thrown by an animal in order to achieve some desired objective is also a tool; and, more particularly, the archer fish of Asia shoot water into the air in order to bring down food into the water and so within their reach. There is not much that a fish can use to shoot down prey apart from water. It is a kind of angling in reverse, and it is difficult, because light is refracted as it enters water, so that a target's position may appear distorted. The archer fish allow for this, possibly by angling their own bodies to minimize optical distortion as they take aim. Whatever the method, at a range of one metre (3 ft) an archer fish can hit its target almost every time, and with less accuracy it has a full range of about three metres (9 ft). Its achievement is remarkable when you consider that the fish itself is only a few centimetres long.

There are six or seven species of archer fish. They will shoot at an insect hovering just above the surface of the water, or at any attractive looking object, perched on a leaf or other overhanging support, that will fall into the water if it can be dislodged. As well as being accurate, the fish are also subtle. If a jet of water hits a small object

The harvest mouse climbs straw to reach the seeds at the top. At least one harvest mouse has been known to carry a straw into position, lean it against a support, and so use it as a human might use a ladder.

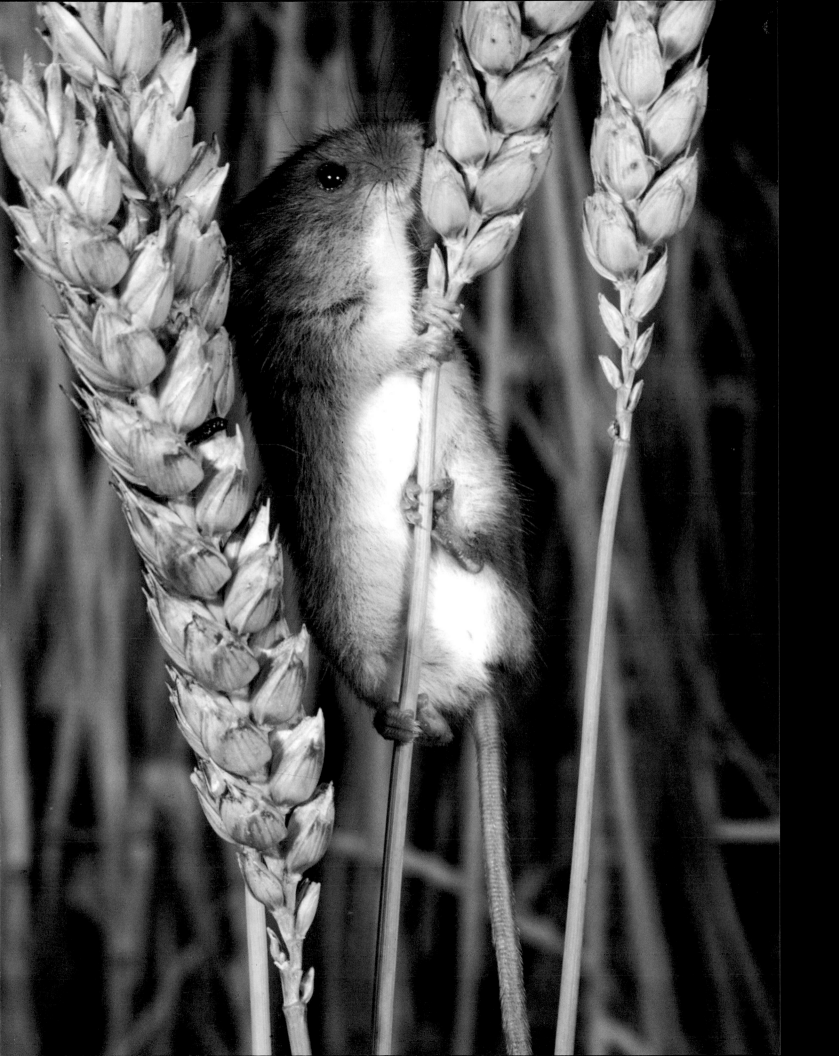

directly it may knock it away and out of reach, so defeating the object of the exercise. This fish usually hits its prey not with the jet, but with the drops formed as the jet breaks, and if the target is perched it may aim not at the target itself but at its perch, so that it loses its grip and falls into the water.

The archer fish achieve their expertise in spitting by drawing water through their gills under pressure, and then forcing it out through a tube made by curling their tongues against the roofs of their mouths. It is not their only means of obtaining food, of course. Like any other fish they will rummage around in the water, and they will also leap if that seems the best strategy. Spitting is reserved for items that can be obtained in no other way.

Elephants, too, are accomplished users of tools, and they also throw missiles, though apparently only at humans. There are many reports of African and Asian elephants scratching themselves with sticks held in their trunks, and there is at least one story of an African elephant using a stick to reach towards food it could not obtain with its trunk.

Similar stories tell of elephants using small branches as switches to drive away tormenting insects: one nineteenth-century account, by S. Peal in an early issue of *Nature* (1879), is especially convincing. Its author was riding an elephant which seemed to be suffering acutely from swarms of insects out of reach of its trunk. The man gave the animal free rein, and it crossed to the side of the track, pulled a branch from a tree, and began to beat at the insects until it was free of them. Another ingenious elephant was seen to pick a bunch of grass and to use it to wipe a wound clean.

As every child knows, most small rodents will climb ladders as to the manner born; and there is at least one small rodent which was not supplied with a ladder and made one for itself.

It was a harvest mouse (*Micromys minutus*), and it had set its heart on reaching the sheet of wire mesh that covered the top of its cage. The task proved impossible until it discovered it could climb up a piece of straw to the mesh, where it performed its gymnastics. Then came the interesting point when the mouse found it could lean its straw against the side of the cage, where it was stable, like a ladder. After that it used its ladder regularly. Although it lived in a cage this mouse had never been trained in the use of ladders: it worked it all out for itself.

Surprisingly, since their forepaws seem poorly constructed for the manipulation of objects, bears are only slightly less adept than elephants at using tools. Their strength allows them to use tools that we would consider heavy, and they frequently throw things. Sometimes they do this at one another, playfully (though the missile may be the size of a beer barrel) and sometimes they aim at other objects or animals. The Eskimos (who continue to insist that a stalking polar bear will push along a lump of ice to camouflage its black nose despite the fact that this attractive tale has never been confirmed by any non-Eskimo observer) claim that polar bears will throw ice and rocks at seals. Since they most certainly do throw large objects, this may well be true. The effect, say the Eskimos, is either to kill the seal or to injure it sufficiently to prevent its escape before the bear can reach it. This behaviour is recorded in some Eskimo ivory carvings.

Polar bears use rocks to break the ice beneath which seals may be swimming, and they also have one much less pleasant hunting technique. Coming across an unguarded seal pup, left behind after the adult seals in a rookery have been scared into the water, a bear may maim the pup and return it to the water. Its struggles and bleeding will bring its mother hurrying to its aid, whereupon the bear will kill her. Since the pup is used as bait, and since we allowed that the use of morsels of bread or insects by birds and primates in order to lure prey was a

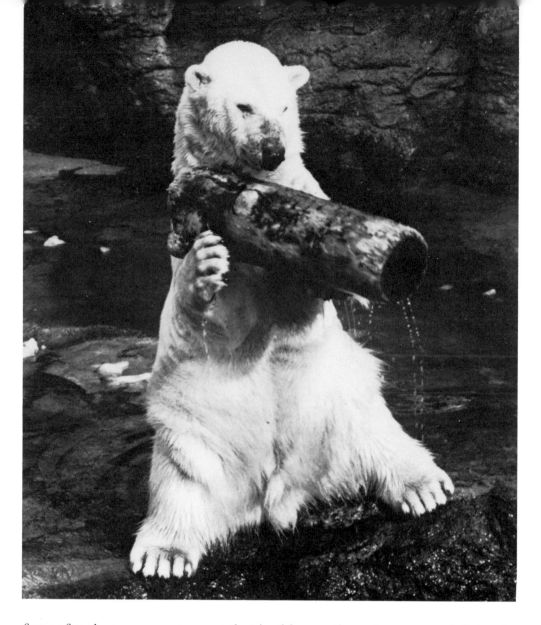

Bears often throw missiles in play, or at animals which threaten them.

form of tool use, we must accept that in this case the seal pups are pitiful tools.

Sea otters (*Enhydra lutris*) are altogether less alarming animals. Everyone loves an otter almost as much as the otters seem to love themselves, and an otter that quite definitely uses tools must have great appeal to us all. The tools themselves are stones, and they are used to break open shellfish that are too hard to be cracked with the teeth. This has an interesting implication, in that it is the healthy adults which possess the strongest teeth and jaws and so it is they who need to use tools least. The tools are needed especially by the very young and the very old, for in very old otters the teeth become badly worn. It seems likely that the infants are taught this behaviour, in which their parents seldom indulge, by their mothers as a step in their weaning.

The sea otter lives off the coasts of California and the Aleutian Islands, and it is not to be confused with the marine otter, a different species confined to the southern hemisphere. It is rather different from the more familiar river otter, and is much more fully adapted to an aquatic life. Its hind limbs are flippers rather than legs, it has fewer teeth.than its more terrestrial cousins, and it seldom comes ashore. Its young are born in the water and it sleeps tangled in seaweed, perhaps to prevent it from drifting far from home or to help it to stay afloat. It is a social animal, and more so than most otters, living not just in families but in groups of up to a hundred.

It finds its food on the sea bottom, where it collects mussels, abalones, sea urchins and similar invertebrate animals. While diving, it may pick up a stone, bringing it

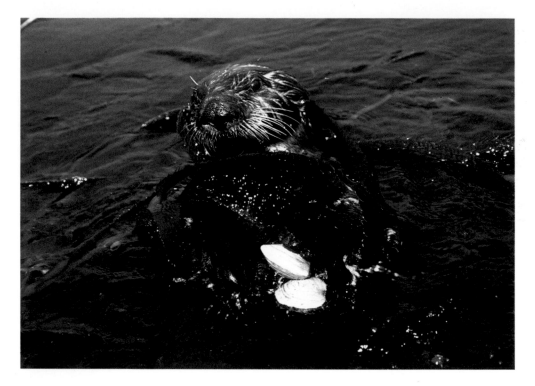

A sea otter in Monterey Bay, California, cracking two clams together to break their shells.

to the surface along with the shellfish. Then it lies on its back, places the stone on its belly and hammers the shellfish on it until the shell breaks. From time to time it will gnaw at it to see whether the shell is broken sufficiently for its occupant to be eaten, and if not the hammering will be resumed.

It might seem that this is nothing more elaborate than the use of an anvil, much as a thrush uses a stone to break open snails, but there are several reasons for supposing that the otter uses its stone in a way that is much more advanced. In the first place it chooses its own stone and then carries it to the surface. Otters have been seen hammering on the sea bottom, but water resistance makes this a more strenuous and less efficient business than hammering in the air. Once it has found a good stone an otter will keep it: individuals have been seen to dive to the bottom repeatedly, returning each time holding the same stone, even though it is not always used, as not all food items require hammering. The otter, which always lies on its back while it eats at the surface, does not relinquish its stone: perhaps it also uses the stone as a weight, just like a human diver. The stone speeds its descent, a useful device for an animal which collects food from the bottom, rather than chasing fish in mid-water like the river otter.

Monkeys of both Old and New Worlds, and of all types, use sticks and stones as tools for obtaining or breaking open items of food, and also as weapons. Many monkeys are renowned for their habit of throwing things from trees at intruders, and since the largest, most solid missiles they find in trees often turn out to be edible nuts, and since their aim is far from perfect, their aggression does not always achieve the effect they desire. Other species are more efficient, however: when baboons throw stones they often hit home.

Sticks are used as birds use them, to extract insects from recesses or to obtain termites. Chimpanzees especially like to indulge in 'termiting'. The stick is pushed through the wall of the termitary and withdrawn laden with insects, which are eaten.

They are also used as weapons, sometimes to kill or immobilize prey – a baboon will club a scorpion into immobility before breaking off the sting and eating its

owner – and sometimes to ward off intruders or other animals of the same species. Sticks are used as weapons most commonly by chimpanzees and gorillas, although they are more often brandished than actually wielded to deliver blows. A full-grown gorilla wielding a club must be a formidable adversary! In fact, gorillas are not aggressive and the theatricals are meant only to impress; unless it is cornered and has no line of retreat the gorilla withdraws after it has threatened.

Orang utans also will use sticks and stones as weapons, perhaps not so frequently as chimpanzees, but with greater cunning: many years ago, for instance, one escaped from London Zoo by smashing a skylight over its cage with a potted plant (history does not record how it came to have a potted plant in the first place).

The apes are expert at the use of containers. Orang utans will carry water in and drink from any suitable object. One female at Brookfield Zoo in Chicago was seen to fill a tub with straw, carry it outside her enclosure, and build a nest from it. They will also stack boxes or other objects in order to climb, but here the chimpanzees may just have the edge on them. They will stack three or even four boxes one on top of another, having first emptied them of their contents if necessary to make them easier to carry.

Much of this behaviour is concerned either with play or with obtaining food. Baboons, chimpanzees, orang utans and gorillas will all use sticks as rakes to haul in food items that are beyond their reach, some will use them to knock down items from above, and orang utans will even hook down a branch bearing a tempting fruit.

The most interesting of all the stories of primates and the lengths to which they will go to obtain palatable food concerns the Japanese macaque (*Macaca fuscata*). Although strictly speaking it does not involve the use of tools, because no implement was carried to the food, it does illustrate the versatility of which primates are capable and the ways in which new behaviours may be introduced. These macaques were made famous by the Japanese zoologist M. Kawai in a paper he wrote in 1965.

The macaques lived in the woods on Koshima Islet. Scientists studying them sought to augment their diet by supplying them with sweet potatoes, which they

A sea otter rests entwined in a piece of kelp to prevent it from drifting while it sleeps.

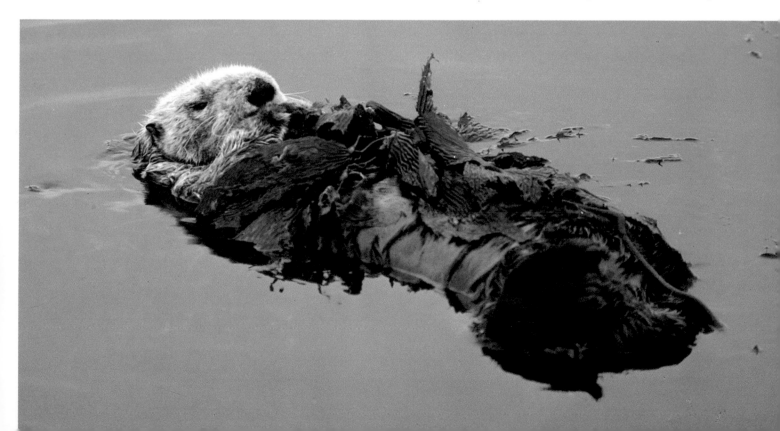

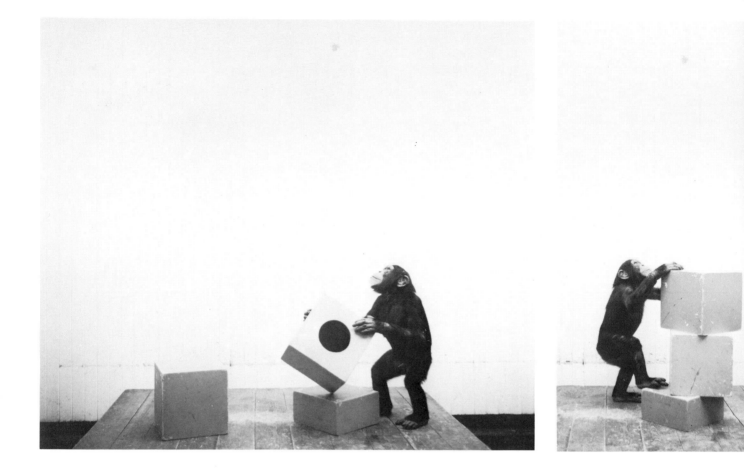

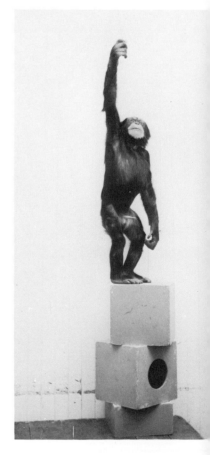

left on the sandy beach. Normally the macaques kept away from the beach, which was exposed, but after a time the food tempted them and they began to take it. However, it was not particularly pleasant to eat because it was covered in sand.

Then a two-year-old female called Imo discovered that she could improve her lunch by washing it in the sea or a nearby stream before eating it. It was only Imo who washed her food, and she made no attempt to persuade the others to do so, but little by little they began to imitate her. After ten years most of this population of macaques were washing their food. The exceptions were the adults more than twelve years old, and infants less than one year old. Presumably the old macaques were too old to learn new tricks. However, the inventiveness of Imo did not end there.

Two years after she had begun to wash her sweet potatoes she found another use for water. The scientists were also leaving wheat grain on the sand. This was tasty and nutritious food, but very tiresome to eat. The grain was scattered and the animals had to pick it up one grain at a time, together with a fair amount of sand. Imo found a much quicker way. She dredged up handfuls of mixed grain and sand, dropped the lot into the water, allowed the sand to sink, and then she scooped the floating grain from the surface. Again the behaviour spread, first among macaques of Imo's own age, then to their mothers and last of all to the adult males. This does not imply that the adult males were more stupid than the other macaques, it merely reflects the social structure. In macaque society the closest contacts are among animals of the same age and between mothers and offspring. Young macaques have very little to do with adult males, who remain aloof.

Once they became used to the beach, which at first was quite strange to them, the macaques became more and more confident. They learned to swim, and some

The chimpanzee collects the boxes it needs (*opposite left*), stacks them one on top of the other (*opposite right*), then climbs to the top to reach its prize.

of them even found that seaweed was edible and that they could swim to the sea bottom and gather it.

Other animals wash their food, of course, the best known being the North American raccoon. In fact it is uncertain whether raccoons are washing their food at all, because they could merely be placing it in the water to make it resemble in some way their more usual items of food, many of which are taken from the water. It seems that the 'washing' behaviour has been observed only among captive raccoons. The case of the Japanese macaques is very different: they moved from their familiar and safe woodland habitat to the beach, where they learned an entirely new way to obtain food. Perhaps this is how primates cope with new situations and how the use of tools develops.

Some chimpanzees will use stones as hammers to open nuts too hard to be cracked in any other way. What is more, they choose stones of a size and weight appropriate to the particular nut, and will carry them some distance before using them. They have been seen and heard cracking nuts in this way many times, and piles of nutshells have been found in particular places, suggesting that the chimpanzees used favourite anvils. It seems, however, that it is only in West Africa that chimpanzees have learned to do this. In East Africa they either eat their nuts whole – pointlessly, since they also excrete them whole – or break them by pounding them against rocks or trees. It is quite probable that some enterprising young chimpanzee, years ago, 'invented' the hammer, and that the knowledge was passed from animal to animal and then from tribe to tribe.

Still, the animals are doing no more than using as tools objects they can find lying around them. They may select them with great care, but the finished tool, in the form in which it is used, is supplied for them. The next step would be to manufacture their own.

Here the most intriguing observations concern orang utans, and of these the one that raises, but fails to answer, the biggest question is reported by Dr Beck. A male orang utan, confined in a zoo, was seen to pound one stone with another until it broke, then to take the broken stone and examine its flaked edge with apparent interest. That is as far as it went, but it came within a hair's breadth of making a cutting tool for itself and so launching itself into a version of our Stone Age.

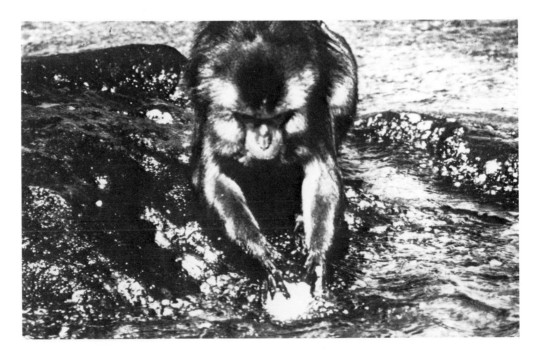

A Japanese macaque washes a sweet potato to clean the sand from it.

The orang utans are arboreal animals, much more so than either of the African apes, and they swing from tree to tree as a way of life. Perhaps it is not surprising, then, to discover that they will make swings where none existed before, or that they understand a good deal about ropes. Individuals imprisoned in zoos have been seen to use pieces of cloth as swings, passing them over the horizontal bars of their roofs and holding both ends. Others have been seen to plait straw into ropes – some have made ropes more than two metres (6 ft) long in this way – then fasten them to the roof bars and swing on them. Incidentally, captive orang utans sometimes show great ingenuity and use a variety of objects as levers in their favourite non-swinging activity, which is zoo cage demolition.

Both orang utans and chimpanzees will join two or more sticks together to make a single, longer stick. As many as five lengths have been joined in this way, and the results are used as ladders for climbing, as probes, or as rakes for obtaining objects that are out of reach. Sticks are also used by chimpanzees as levers to open banana boxes; but it is impossible for an ape to increase the length of a lever – and thus the force it can exert – by joining sticks end to end, because of the consequent loss of strength. They are often joined by removing the pith to leave a hollow end into which to insert the next stick, although at least one orang utan is known to have tried using straw to splint two sticks together, for its attempts were observed by Dr J. Lethmate, who described them in a paper published in 1977.

It may appear doubtful whether a single stick can be fashioned into a tool, for the branch of a tree is part of the tree and is not useful as a tool. To become a tool it must be detached, and the act of detaching it is a form of tool fashioning. Thus animals that tear up clumps of grass, break branches from trees, or in other ways detach

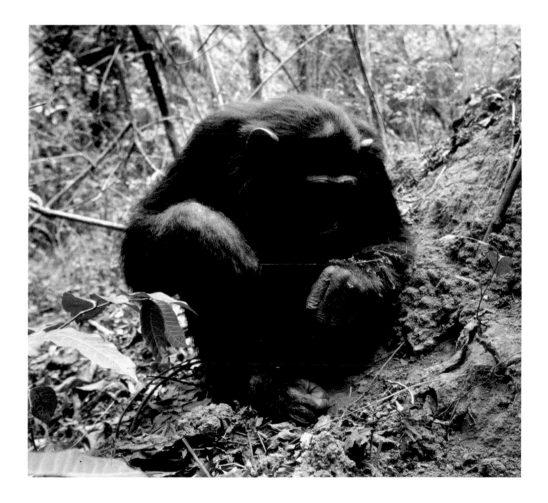

The chimpanzee inserts a stick into a termite mound (*opposite*). The termites take hold of the stick, whereupon the chimpanzee withdraws the stick and eats the termites (*right*). It is called 'termiting' and chimps are highly adept at it.

from their surroundings articles they then use to achieve an objective are fashioning tools for themselves.

Most animals select with some care the sticks they use, which tends to support the view that the choice and preparation of such tools is deliberate. Some primates, including chimpanzees, will use sticks wedged firmly into crevices or into the mesh of their cages as 'steps' by which they can climb more easily, and these must be chosen with the greatest of care. If they are too thick they will not fit into the spaces available; if they are too thin they will wobble and fall. If they are too long they will be unwieldy, if too short they will provide insufficient purchase for the foot. Animals observed as they construct their 'steps' very seldom make mistakes: there is little trial and error about what they do. They know precisely the kind of sticks they need, and collect only those which appear to suit their various purposes. Few have to be rejected.

We should not underrate the requirements for a good stick. Termiting, for example, involves more than mere stabbing: the stick must penetrate the nest wall, locate a gallery within the nest, then move along the twisting, turning passage. Finally, it must have a surface to which the termites will cling. All of this implies that the workers have a good knowledge of the materials they use. But it does not end there, for the branch torn from a tree is likely to bear twigs, leaves and in many cases a rough bark. It may be too long, and its end may be unsuitable. In such cases animals will strip twigs, leaves and bark, and sometimes they will bite the end of a stick into the shape they require. Apes are known to strip out the strong midrib of specially chosen leaves when they need an instrument to probe for insects inside very small cavities. When probing sticks are bent or damaged at the tip, apes often will either turn them around and use the other end or bite off the damaged section. Some chimpanzees have been known to bite and scrape the ends of sticks in order to sharpen them to a point, and one genius once bit off splinters from a piece of wood and picked the lock of its cage with them (Dr G. Jennison somehow came to hear of this, and described it in his book, *Natural History: Animals*, A. & C. Black, London 1927).

Apes also use 'sponges', made most commonly from leaves. These are chosen, picked clean, and then crumpled into a ball to make them more absorbent. The apes then use these 'sponges' either to mop up liquids, which they then suck from them, or to wipe dirt or other foreign matter from their own bodies. Sometimes they will wipe food from their lips with a leaf 'napkin'.

This, too, is an example of tool manufacture and use, and in one of its applications it may even amount to a kind of food preparation. Chimpanzees and orang utans will chew leaves and meat into balls, known as 'wadges'. These are used to wipe up liquids or the last crumbs of solid food, and it is possible that the wadge preserves, enhances or otherwise modifies the flavour of the food in ways the ape finds agreeable.

In the wild, animals rarely have access to materials other than stones, plants or the bones of other animals, but in captivity they will often use whatever they can find. The crow that used a plastic cup to carry water was improvising in this way, and apes will go much further. They have been known to unroll wire from a coil to make probes and rakes. This is not a particularly sophisticated process, but the animals were nevertheless altering the form of the material in a purposeful way, and this must count as tool manufacture.

Gorillas, chimpanzees, but most of all orang utans make hats, umbrellas and parasols from leaves, or from cloth if it is the only material to hand. It seems they find the rain keeps them awake at night, and rainfall is frequent and heavy in the forests where they live. During the day the tropical sun may also distress them. So,

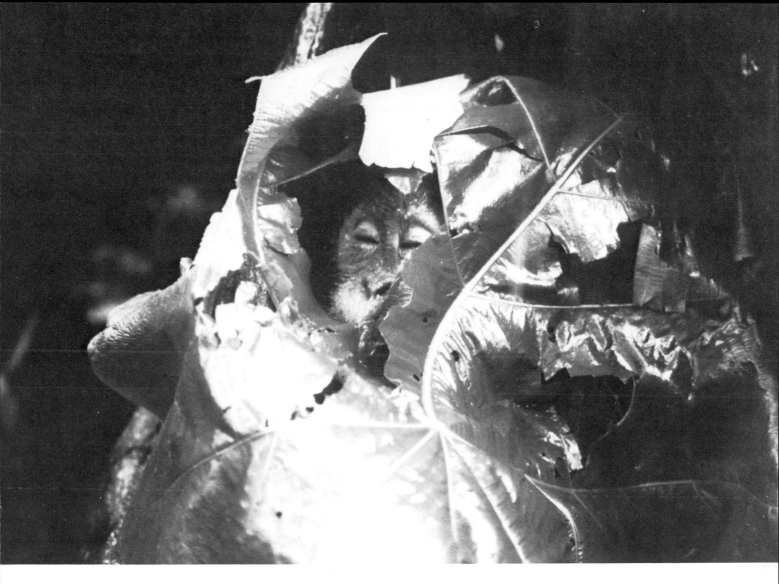

Even in Sumatra the nights can be cool and wet, so this orang utan has wrapped itself in a leaf.

before it goes to sleep, an orang utan will drape something over its head, and where it has a free choice of materials and is able to fashion its weatherproofing for itself, it is sure of spending a peaceful night with a dry head, or a peaceful siesta with no risk of sunstroke. If the sun is especially fierce, or the rain unusually heavy, an orang utan may make a shelter against it even when it does not plan to sleep. Such coverings appear to have other uses as well, of which little is known. They are used sometimes in play, sometimes as protection from stinging insects, and sometimes when individuals meet and in the presence of humans. It has been suggested that the apes may be trying to hide, although it seems unlikely that so intelligent an animal would adopt so ineffectual a strategy. Perhaps they just like to be dressed correctly on formal occasions.

On the whole, gorillas make and use tools much less and much less inventively than either chimpanzees or orang utans. However, even a chimpanzee failed the final test. The individual concerned was in the habit of making sticks for itself by breaking boards free from wooden boxes, then splitting them along the grain of the wood into thinner and thinner pieces until it had the kind of stick it wanted. One day it was given a box made from boards it could pry loose, but which were too tough for it to split. Clearly it needed the help of a tool, so it was shown how to use a small axe, then left alone with it and the wood. It was unable to find a way to use the axe to break the wood: it could not use a tool to make a tool.

Microscopic Metallurgists

MINING, you might think, is an exclusively human affair. After all, it is only we who depend on fuels to cook our food and to warm us, furless as we are, in latitudes higher than those in which nature intended us to live. It is only we who have found uses for metals, unless you count the chimpanzee who unrolls coiled wire (page 42), or the birds that have decorative uses for anything bright and pretty. Up to a point you would be right: it is only humans who collect fuels to make fires and who make artefacts from metals. But metals have uses quite apart from those our factories find for them, and so have the substances we use as fuels. In some cases they provide food, and in others they are waste products left after food has been taken from matter with which it had been combined.

We all eat metals and, more to the point, so do single-celled organisms. We are familiar with the form of anaemia that is caused by a deficiency of iron, which can be remedied by taking iron in the form of a compound, all packaged in a pill. It may not look like iron, but it is precisely similar to the iron from which the garden gate is made. Iron is only one of a number of metals that living organisms require in small amounts: they also need copper, cadmium, aluminium, calcium and sodium, manganese, magnesium and molybdenum, cobalt, nickel and zinc, and a number of others. These are obtained in the form of compounds, originally from the soil, which itself is formed from rock that has been weathered, broken into small particles, and mixed with the organic wastes of the organisms that live on and

opposite Deposits of sulphur in the Alcedo Crater, Isabela Island, Galápagos.

right A block of crystalline sulphur.

in it. Mineral substances are released from the rock chemically, and in many cases the acids with which they react to form compounds that are available to living organisms are produced by those organisms.

There is another biological mechanism at work in soil and water that also affects metals. Sulphur is one of the elements that are needed in relatively large amounts by all living cells, and it is most abundantly available in the form of metallic sulphides. Anything which can obtain its sulphur from the sulphide will have no use for the metal, which becomes a waste product to be excreted. Certain bacteria obtain their sulphur in this way, and incidentally assist in the great cyclical movement of sulphur which benefits all those living beings that need it but are unable to obtain it directly from inorganic sources. Certain large seaweeds play a crucial role in the cycle by releasing gaseous sulphur compounds into the air. Our factories also use sulphur, much of it in the form of sulphuric acid. Indeed, we have many uses for the element other than its dietary ones.

Few metals exist naturally in their pure, elemental form. The great majority are mined as ores, chemical compounds associated with a range of other compounds and bound into rocks. Some rocks are endowed with metals more richly than others. In years to come many of our metals are likely to be obtained from spherical nodules made from complexes of metals that occur in vast quantities on the sea bed.

Certainly some mineral ores are the result of purely physical and chemical processes operating in and beneath the earth's crust. Others, however, are believed to have been formed, at least partly, by the activities of microbes. It is possible that the seabed nodules are also partly the result of biological processes.

To some extent we can speculate about the mechanisms involved. If, say, a sulphur-seeking bacterium extracts its sulphur from a metallic sulphide, the metal it releases in the form of other metallic compounds will tend to accumulate nearby. We know that such bacteria are common in mud lying beneath shallow, still water, and obviously the subsequent fate of the metals will depend on the way the water circulates – even still water circulates – and on the chemical reactions to which they are exposed. This may well lead to their concentration in localized places, where they mix with the mud which accumulates and compresses the lower strata. The water evaporates, the mud becomes a sedimentary rock, and many years later the area may be mined. A similar process may take place on the sea bed. It is likely, therefore, that some of our rich mineral ores were provided for us by microbes.

Uraninite, natural uranium dioxide and the principal ore from which uranium is obtained. This piece comes from Cornwall.

This being so, might it not be possible to 'employ' the microbes in the task of extracting metals from places that are difficult for humans to reach? Instead of having to remove vast quantities of rock at great monetary and environmental cost in order to obtain valuable metals that exist within them at very low concentrations, might there not be microbes which would do the work for us with less disturbance and more cheaply?

In the last fifteen years or so the idea of using microbes in this way has received serious attention, and in some parts of the world it is being successfully applied. One of the sulphur-seekers, for example, releases copper in useful amounts. *Thiobacillus ferroxidans* lives among sulphides – known as 'pyrites' among mineralogists – and obtains its sulphur by oxidizing the metals to which they are bound. In the case of copper the oxide is soluble in water. The bacterium is found in waste heaps beside worked-out copper mines and the liquor that flows from the heaps contains copper at concentrations far higher than those found in many ores, and can be extracted without touching a single pebble. In fact, the waste tips lying beside the copper mines of the world contain enough copper to allow *T. ferroxidans* to flourish for many, many years and to remove almost entirely any fear we may have of exhausting the world's stock of this metal.

Pure gold, embedded in calcite.

Nickel can be recovered microbially, and possibly manganese, though the latter is so common that the technique is of little practical value.

Uranium has been mined with the help of bacteria for many years. The work began in Portugal in the 1950s, but today it is practised mainly in Canada, although other countries with uranium reserves are toying with the idea. Uranium is plentiful enough, but most of it occurs in highly dispersed form in hard rocks such as granites; it is difficult and costly to obtain, and will remain so until techniques are perfected for extracting it from sea water. There is no such thing as a rich deposit of uranium. However, if a rock face is inoculated with a culture of suitable bacteria they will begin to extract the uranium from it as uranium oxide. After they have been left on the rock for a suitable period of time the rock is hosed down with water and the water is pumped away to have its uranium recovered from it. It is a slower business than mining with great rock-crushing machinery, and so it is a little more expensive, but it is much gentler, and uranium is so valuable that we can afford to pay a little more for it.

Gold is another valuable metal that bacteria can be induced to discard. Because of its atomic configuration, gold is most reluctant to enter into reactions, and so it exists most commonly as the pure metal, although there are ores made from gold tellurides, and gold is often mixed with silver, platinum, copper or other metals. The hunt for gold is less exciting than the movies make it seem. Nuggets the size of eggs do occur, but they are very rare indeed. Most metallic gold occurs as tiny particles the size of sand grains, bound into matrices of hard rocks. Weathering causes grains of rock and gold to be washed into streams, and panning for gold is then possible, if rarely profitable. The miner accelerates the weathering process with the help of a rock crusher.

As with uranium, there are microbes that can, and in some parts of the world do, extract the gold more gently if more slowly, and there are other microbes still that will perform the even trickier feat of extracting gold from water containing soluble gold compounds, such as gold cyanide, that have been formed industrially as part of the gold refining process.

In the long run, the list of metals that could be extracted by such biometallurgical techniques would be limited only by the value of the metal recovered, for by recombining the DNA within cells it is becoming possible to 'programme' bacteria to perform any number of useful tasks. Once the bacteria are equipped with the appropriate genes they cost almost nothing to produce.

Hunters and Trappers

A FEW centuries ago, if you had explored the rivers of the world, you would have come across people trapping fish. You may still find them doing so in a few places, but for the most part fish traps have been replaced by sea-going trawlers and river-bank anglers.

You may also find an animal trapping for its food in very much the same way as humans do, or did, not in the great, famous rivers, but in small, unimportant rivers known only to those who live beside them.

We will meet the caddis flies again in the next chapter, for they are renowned for the cases they construct with great care to protect their soft larval bodies from the unwelcome attentions of predators. There are some caddis flies, though, which can afford to dispense with such protection, for they themselves are the predators, and they live inside their own traps.

opposite The common garden spider at the centre of its orb web.

right The 'fishing net' of a caddis fly larva looks very like a man-made net.

Those of the genus *Neureclipsis* are typical. Like many arthropods they possess silk glands, so they are equipped to produce webs, but these are made underwater, for it is an aquatic insect. The web forms a bag shaped like a sock, but very wide at the mouth and tapering to a narrow 'toe' at the lower end – a shape almost identical to that used by humans who make trawl nets, and who used to make fish traps.

Just as a trawl net must be towed (trawled) through the water, and a fish trap is likely to work only in flowing water, the caddis fly lives exclusively in fast-flowing streams. Like the trawl net, a caddis fly net is pliable and moves with the water. But a means must be found to hold the mouth open. The trawlerman achieves this by means of otter boards – boards fastened to the net mouth which tend to move outward when the net is towed. The caddis fly does not move its net, and so its problem is simpler. The mouth is pegged open by being secured to whatever rigid plants or stones are available in the right place. The lower end of the net is also secured in a position below the mouth, so that as the water flows through the net it billows out into an S shape. The larva spends all of its time down in the lower end where no predator can reach it. It is hidden from prying eyes, and has no need to venture out, for the net catches small particles of food which are swept down to it.

Of course, when we think of silken webs that are used as traps, spiders are the animals that spring to mind, but the webs of spiders have an evolutionary history all of their own and, sophisticated as they are, some spiders have abandoned them, and many more have never made them.

Bolas spiders, for example, are descended from makers of the familiar orb webs and similarly they secrete a silk and also a sticky substance with which some of the silk is coated. Instead of making a web, however, they produce a single line with a sticky globule at the end and, thus armed, they lie in wait for a suitable meal. Sometimes they help matters along by exuding an odour which mimics the sex attractants used by many insects, so luring an insect in their direction. When the prospective victim is within range, the spider swings the ball and strikes the insect with it. The insect sticks fast to the ball and is trapped.

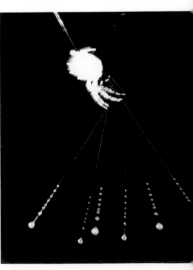

below The Australian bolas spider swings its thread at prey, which sticks to the adhesive globules at the end of the line.

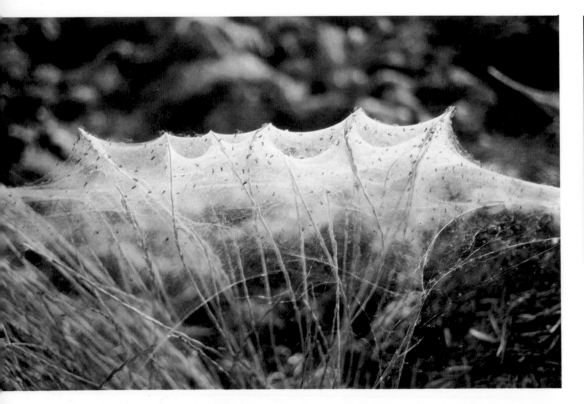

left These large hammock webs are made by the tiny spiders known as 'money spiders'.

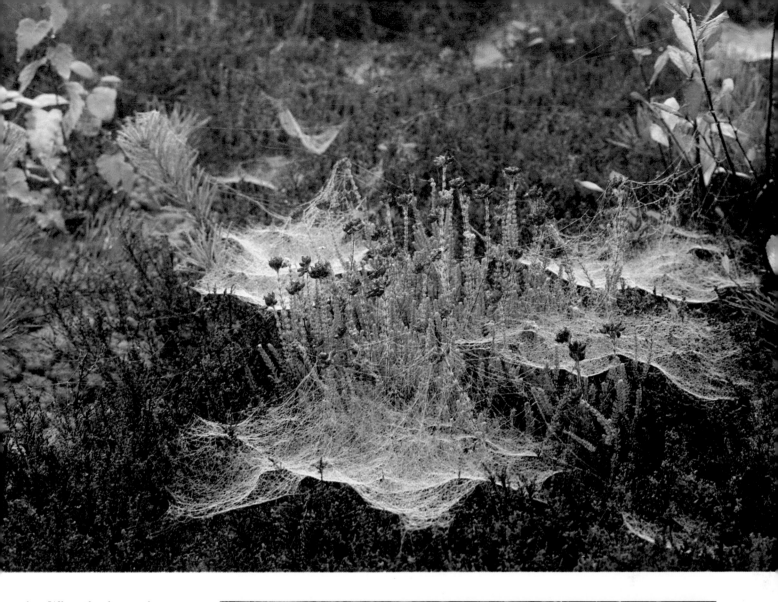

above When the dew makes them clearly visible, the heathland is festooned in spider webs.

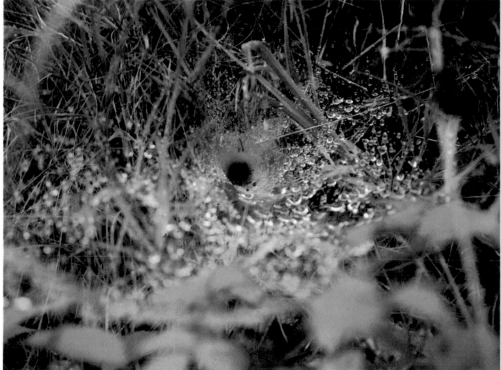

right The funnel web provides concealment and protection for its occupant.

Probably spider silk was used originally to make protective cocoons for spider eggs, and many spiders continue to use it for this purpose, dragging the eggs behind them. When the spiderlings hatch – for spiders are not insects, and their young pass through no larval stage – they jump on to their mother's back where they ride safely until they are old enough to fend for themselves. Lycosid spiders act in this way and may be seen scuttling about on the ground, dark and usually fairly small in appearance. They are also known as 'wolf' spiders, because they obtain their prey by chasing it. Even among such hunting species, silk may be used in catching prey. Some spiders run round and round their victims, paying out silk as they go, until the hapless insects end up trussed in silk and immobilized.

The most primitive of all webs are mere tangles of silk, the 'cobwebs' that lurk in forgotten corners and have no recognizable architectural plan. Hammock webs are more advanced, in the sense that the silk is used more efficiently. These are the webs which lie horizontally on and in hedges or tall grass, glistening in the morning dew. The webs are often quite large, especially when compared to the size of the spiders that make them, which are tiny and include many of those members of the family *Linyphiidae* which we know as 'money spiders'. The occupant or occupants, for sometimes the web will be used by both male and female spiders, live on the web, above it, or most commonly below it. Usually there are silken lines, sometimes in a tangle, above and below the hammock itself, and when an insect alights on or collides with any part of the web the lines are vibrated, the vibration is sensed by the spiders, and if it is the kind of vibration they associate with food they will investigate. Some of these webs, and the apparently formless tangles made, for example, by the theridiid spiders, have lines hanging below them that are almost invisible but are coated with a sticky substance. When they hang from webs made close to the ground they can catch ground-dwelling prey.

The orb web represents the peak of the trapping achievements of the spiders. It is not simply that the web is beautiful in human eyes. It really is highly efficient. Being two-dimensional, rather than three-dimensional as are the other kinds of webs, this single sheet covers the largest possible area with the smallest possible amount of silk. Elaborate as it is, it calls for only the most modest investment of material and effort by the spider, and therefore it can be renewed whenever it is damaged. Some spiders make a new web at the beginning of each day and eat it at the end of the day, but all other webs must be made to last longer. The economy is assisted by the fact that only some of the lines on the web are sticky. An insect colliding with the web is likely to pull one of the sticky threads on to itself.

No one knows why some spiders first begin to make orb webs, but we do know that the ability to do so is not learned and never was. Spiders inherit the ability to make their webs, and no matter how long a spider may live or how many webs it makes, its performance never improves. Indeed, it never varies. Sometimes the genetic programming contains an error which causes the spider to make webs with a fault. All its webs will bear the same fault for the whole of its life. It is possible, incidentally, to induce a spider to make distorted webs by using drugs to impair its perception and so to disorient it: spiders have been known to make webs of unusual design while under the influence of LSD and similar hallucinogens. As the effect of the drug wears off, so web-making returns to normal.

It is likely that hunting on the ground and web-making have developed independently several times and in both directions, wolf spiders making webs and web-makers like bolas spiders ceasing to do so.

The funnel webs you see in bushes and shrubs are refuges rather than traps. Victims are not lured into them. The spider emerges to deal with any animals which vibrate the funnel by touching the lines connecting it to surrounding

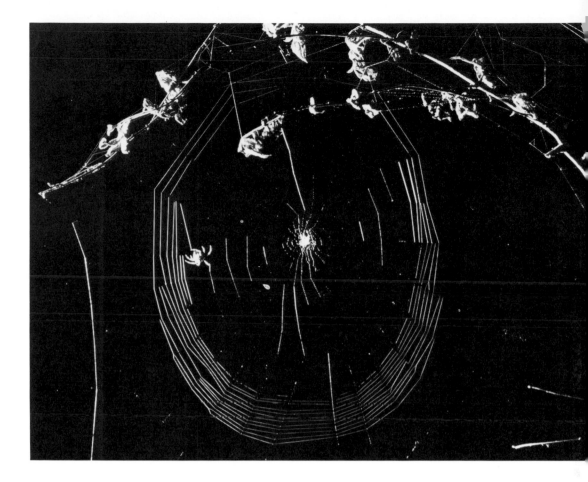

A garden spider placing its spiral of sticky thread to the partly finished web.

vegetation. If we suppose that at one time all spiders lived by hunting, emerging from crevices to pursue their prey, then the funnel is a special kind of crevice, and so is the hole in the ground which the spider digs for itself. If it then lines this earthen tunnel with silk it is a short step away from becoming a trapdoor spider.

The trapdoor spiders, known commonly but incorrectly as 'tarantulas' in America (the real tarantula lives in Italy, in the neighbourhood of Taranto, and is not a close relative), include some of the largest and hairiest of all spiders, but also some of the most primitive. The North American species are not venomous, despite the legends, although they are capable of delivering a painful bite to anyone who tries to handle them. One Australian and one South American genus however are very venomous.

There are several designs for trapdoors, inherited genetically, but the principle remains more or less constant. The spider lives inside a hole it has dug and which it has lined with silk. The silk stabilizes the sides and prevents them from caving in, which otherwise would prove a serious handicap in the very dry, fine or sandy soils in which it lives. The mouth of the hole is covered with a door which fits snugly and is coated with material from the immediate vicinity, so that when closed it is quite invisible. The door has a silken hinge, which prevents it flying away when it is opened abruptly. When it is hungry, the spider sits in its hole, immediately below the door, which it holds shut. It reacts to vibrations caused by the passing of a potential victim and in some species the early warning system includes silken trip lines that run from the door to surrounding objects. Any animal that touches a line vibrates the door and out comes the spider.

Spiders use their silk in many different ways. The jumping spiders, for example, use it only as a dragline. They stalk their prey, and to equip them for this task some

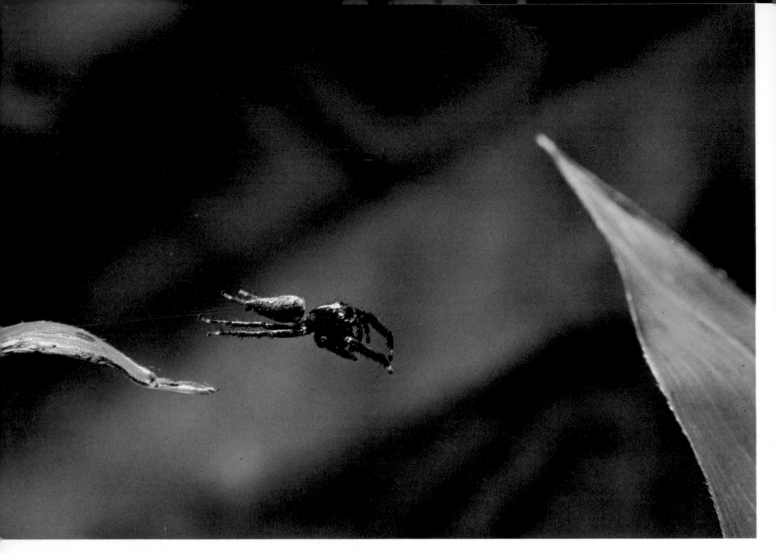

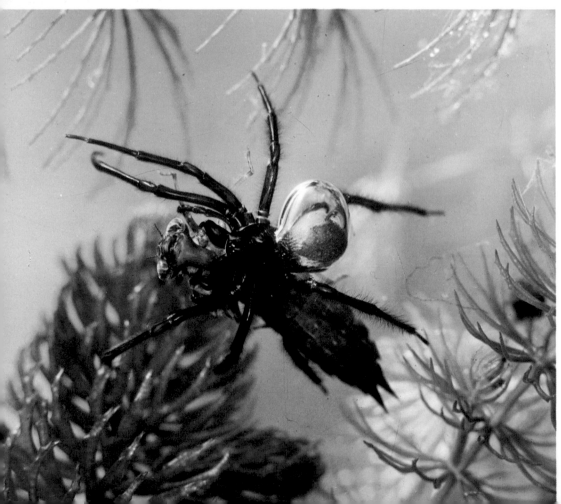

above Jumping spiders have elaborate and highly efficient eyes which enable them to detect prey and leap upon it with great accuracy. The dragline of silk prevents the spider from falling all the way to the ground should it misjudge its leap.

Spiders breathe air and cannot live under water. The water spider solves the problem by using its silk to make a net (*opposite*). This traps a bubble of air which the spider breathes while awaiting its prey. By transporting air below the water surface the water spider gains access to prey that is not available to other spiders. This one (*left*) has caught a hawker dragonfly nymph, one of the fiercest of freshwater invertebrate predators.

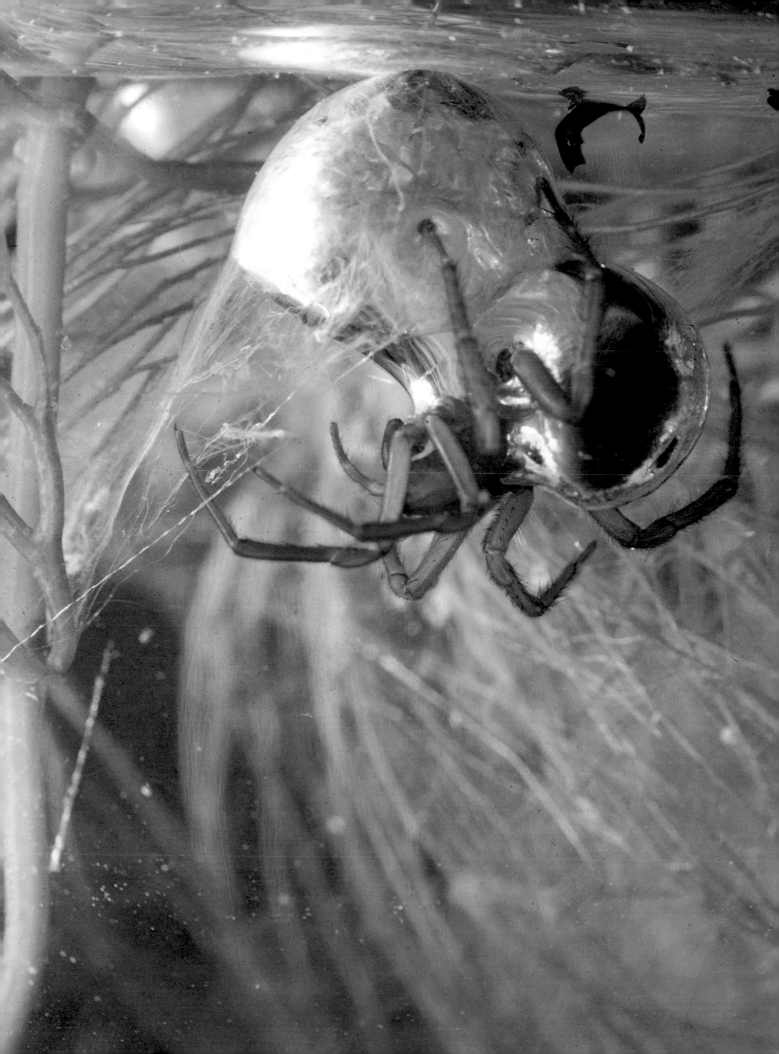

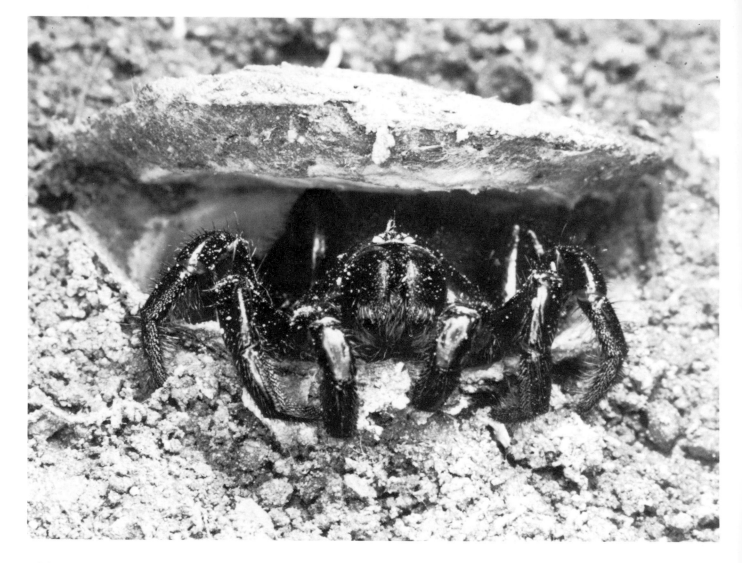

of their eyes are located well back in their heads, giving them a wide field of vision. A few primitive spiders have only six eyes, but the great majority have eight. When it is almost within range the jumping spider begins to produce silk, secures the end to some solid object, then pays out the line as it goes. It will take advantage of any cover as it stalks, but always it remains attached to its line. When it is within range it jumps, still paying out line, and since its jump may take it, and possibly its prey as well, off the edge of the surface on which the attack began, the silk provides a line by which the spider, with or without its victim, can return.

The water spiders are even more original, for they have invaded an alien medium. Spiders are land animals, and breathe air. They cannot survive in water. The water spiders, such as *Argyroneta aquatica*, which is found in fresh water all over Europe and Asia, take their air down with them. The spider has long hairs all over its body. At the surface of the water the hairs trap a layer of air close to the body and when the spider swims downwards the air is carried with it as a bubble. Below the surface it uses its silk to make an airtight covering attached to a plant, and when the 'tent' is ready it swims into it carrying its bubble of air, releases the bubble which rises but is held by the silk, and then sits inside its tent, breathing air and waiting for some insect larva or small fish to come within its range. It will then leap forward, in the manner of its ancestors from their crevices or trapdoor spiders from their holes, and seize the prey.

The trapdoor spider is totally concealed behind its camouflaged door, emerging to seize prey which comes too close. This one is in Jamaica.

Water scorpions are insects which lay no traps, but they, too, hunt in water. They manage to do this by hanging upside-down from the surface by means of their long 'tails', which in fact are breathing tubes. The larva of the great water beetle (*Dytiscus marginalis*) uses a breathing tube in the same way, but the adult swims below the surface, carrying an air supply trapped by its wing cases.

Many invertebrate animals digest their food outside their bodies. Their technique is to immobilize the prey using a venom, if they are carnivores, and then to inject digestive juices through any obstructive and indigestible covering, such as the hard exoskeleton of another invertebrate. The digestive juices work on the soft parts of the victim, or on the vegetable food, and when the food has reached a state in which it can enter directly into the body chemistry of the animal feeding upon it, it is sucked up in liquid form. This is the process used, for instance, by houseflies. We may find it disgusting, but it confers certain advantages: the animal can possess a very simple kind of mouth, for example, since it needs no jaws for feeding, although it may need weapons with which to capture and kill prey. Its manner of feeding produces no body wastes, at least, they are not produced in the body of the animal itself. They are left behind when the liquid food is digested. Thus the excretory apparatus can be minimal.

This is of particular importance to certain insects of the order *Neuroptera*, which includes the lacewings, snake flies, alder flies, mantispids – and the ant lions. Adult ant lions look rather like small dragonflies, having long wings and long narrow bodies, although they are not related.

Like all neuropterans, they are carnivorous both as adults and even more so as larvae. It is not at all unusual among insects for the longest and most important period of the animal's life to be its larval stage. The larva is simply an eating machine, and the time it must spend as a larva often depends on the amount of food it can obtain. In the case of the ant lions the larval stage can last for two years, and among dragonflies it can last for four or even five. When the larva finally assumes adult form it may need to live only long enough to mate and for fertile eggs to be laid. A flying insect is vulnerable to many predators, and so evolution has tended to favour those species which can mate and lay eggs quickly. In extreme cases the

Because the eggs of the ant lion are all laid in the same place, ant lion larvae (*below right*) are likely to occur in dense congregations. The 'craters' in this apparently lunar landscape (*below*) are in fact ant lion pits. The tracks were made by the larvae as they moved about prior to digging.

adults may not feed at all, and may lack mouth parts. The investment is concentrated on the larvae, and though simple, the feeding machines are highly efficient.

The larvae of all neuropterans have strong, large mandibles, with sharp teeth, and most of them hunt for prey. The ant lions, however, lie in wait for their victims. Even as adults they are not very mobile for, despite their appearance, they fly lazily and seldom for long at a time. They live in sandy regions, mainly in the tropics, although some species are found in continental Europe as far north as Finland.

The most spectacular member of their family, for which the name 'ant lion' is sometimes reserved exclusively, is *Myrmeleon formicarius*. This ant lion – 'the' ant lion – uses a pitfall trap.

The adult ant lions lay their eggs in dry, sunny places, and where conditions are favourable many may hatch and establish themselves within a small area, so that a particular patch of territory becomes, quite literally, a death trap for any small animal that must walk rather than fly. The larvae are minute when they hatch, and they never grow to more than about a centimetre in length. The ant lion larva has six legs, an abdomen that tapers almost to a point at the rear end and has a coating of bristles that point forward. Its tough head is flat at the front, with two immensely large mandibles that account for nearly a quarter of the animal's length. Translate the dimensions into sizes that are more familiar, and you must imagine, say, an animal six feet long (2 m) whose final eighteen inches (45 cm) are made up entirely of jaws and very sharp teeth. The ant lion larva is a formidable beast!

Its nervous system provides it with behavioural responses to stimuli, which include the only two reactions it needs for success. One causes it to jerk its head violently, the other causes it to snap its jaws shut.

The ant lion larva is a formidable predator. These are the extended mandibles, ready to snap shut the instant a victim touches them.

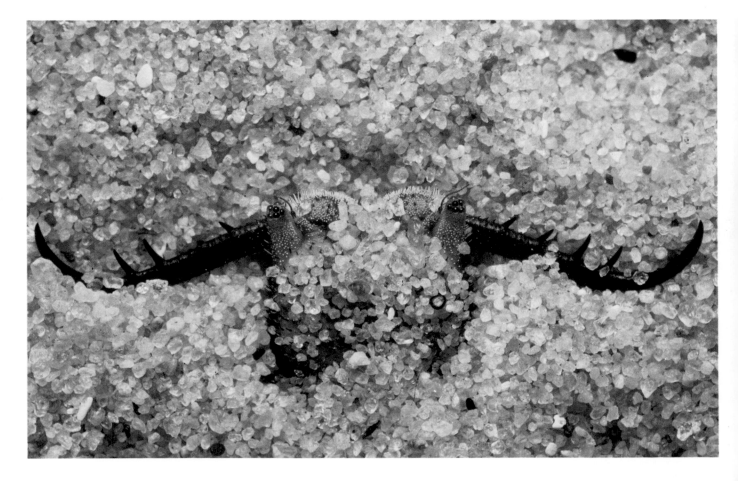

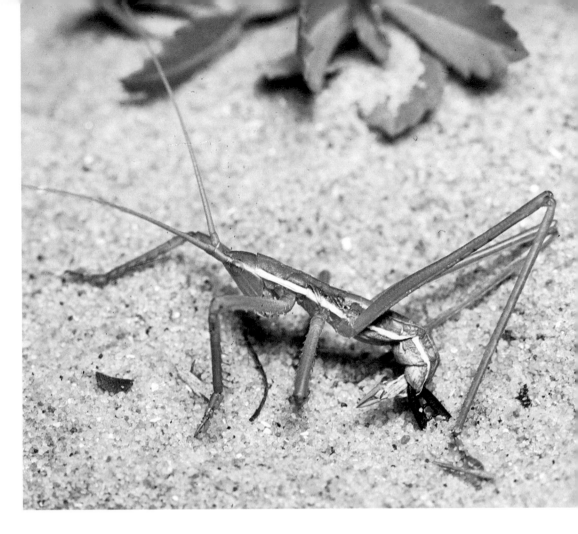

Although ants are the most usual prey, this ant lion has caught a grasshopper (*right*). The ant (*below*) has tumbled into the pit, and is now held firmly by the ant lion's mandibles.

Placed in the open on loose sand, which is the situation in which it may find itself when it hatches, the ant lion remains quite still, as though dead, for a time. The sun beating down upon it stimulates it to seek shelter, the stimulus being more urgent than its compulsion to remain still and so avoid drawing attention to itself. It seeks shelter by digging, making jerking movements with its abdomen and at the same time turning its whole body around its longitudinal axis. Because of the forward-pointing bristles, this activity makes it descend, rather quickly, into a hole. In fact it 'screws' itself into the ground.

As it vanishes below the surface, however, its head movement is triggered off by falling sand which it throws away from itself. Gyrating as it descends, it digs a shallow conical pit and when the pit is deep enough it buries itself almost completely and commences work. The only part of the insect that is above the surface is the mandibles, and they are held wide open.

Work consists of not doing very much at all, for there is nothing much it can do or needs to do. It just waits with its mouth open. A walking insect that approaches the pit too closely will lose its footing on the loose sand and fall in, being carried to the waiting jaws which promptly close. If the insect should avoid the mandibles and attempt to escape, the loose sand falling to the centre and so to the head of the ant lion larva will trigger its other working response. It will begin to jerk its head, throwing sand at its victim until it is dislodged and falls back to the mandibles.

It is all very efficient, if crude, and although insects do sometimes avoid capture, escape is not common, and may well lead directly to the next ant lion.

A similar trapping technique has evolved quite independently among some members of the family Rhagionidae, which are flies and belong to a different order from the ant lions. Most rhagionids are predatory both as larvae and as adults, but it is only in the subfamily Vermileoninae that we find larvae living just like ant lions.

They excavate pits, at the bottom of which they sit waiting for insect prey to fall to them, and they even throw sand at prey which attempts to escape. These flies are known as 'worm lions', the 'worm' presumably describing the larvae rather than their prey, while the 'ant' of the ant lions describes their most usual victims.

The neuropteran relatives of the ant lion dig no pitfall traps, but they are fiercely predatory nonetheless and some have evolved alternative strategies.

All hunters and the animals they hunt are engaged in a struggle that is roughly analogous to the arms race among nations of humans. Whatever the technique adopted by the hunter it succeeds most notably with prey that is slow, incautious or unobservant, and the individuals that evade capture are the ones which go on to produce larger numbers of offspring, many of which inherit their parents' skill at evasion. The neuropterans do not pursue prey, but lie in ambush, seizing any small animal that comes within range of those terrifying mandibles. In such a position, human hunters from time immemorial – there are cave paintings illustrating the technique – resort to disguise, and that is what some of the neuropterans do. Some use bits and pieces of the litter that lies around them, others pick up grains of sand, and they stick this material to the upper surfaces of their bodies until they are well concealed. The green lacewings of the genus *Chrysopa* are more original still. Their larvae feed upon aphids, particularly those which live with, and are guarded by, ants. The ants feed on the honeydew secreted by the aphids which produce in addition a white wax that forms a shield on their backs. The wax has a slightly woolly appearance, and so the insects are known as 'woolly aphids'.

An aphid which loses its shield may be injured by ants, or removed by them, and its reaction to the loss is to secrete more wax as quickly as it can before the guards notice. Thus the pilfering of a little wax is likely to pass unobserved. The lacewing larva would find it very difficult to move freely among the aphids, feeding upon them, with the ant guards in attendance. They are able to do so, however, by stealing their wax, fixing it to their own bodies, and so appearing to the guards like slightly odd-looking aphids. The ants let them pass, and so they feed. Other

This lacewing larva, covered with the bodies of its past victims as camouflage, attacks cabbage aphids.

chrysopid larvae, which do not feed on aphids, disguise themselves with plant material as an aid to their own hunting.

We should not be surprised to find that prey animals also camouflage themselves to evade capture. Indeed, such camouflage is often subtle, usually highly effective, and it has been the subject of much scientific study. Since it derives principally from skin or fur markings, which are inherited, and so beyond the direct control of the animals that benefit from it, such camouflage need not concern us here, but it would be unfair to the much maligned cephalopods, and in particular to the octopuses and squids, to overlook it entirely.

These are hunters, but they are more highly developed by far than any insect, which may come as a surprise when you remember that they are invertebrates and are classified as molluscs, related to snails, slugs and shellfish. They have the largest brains of any invertebrates, and eyes that are similar in structure to those of mammals.

Squids feed on fish, which they pursue, swimming very fast into shoals and grabbing their prey with their ten tentacles. They tear the prey to pieces with their jaws and eat it in what we would regard as a fairly conventional fashion. The octopuses live in lairs where they lie in ambush and then jump on top of passing prey. They feed mainly on shellfish, including crustaceans, and like spiders they digest their food externally, injecting venom to paralyse the prey and then digestive juices to produce a partly digested mass, which is then eaten. If business is slow, however, an octopus will go foraging, either swimming, crawling, or sitting on top of a rock to survey the sea bed. It will pounce on mats of seaweed and rummage for such morsels as may lie beneath it.

The cephalopods hunt, but they are also hunted – most especially the squids, which are prey to almost every carnivorous fish in the ocean. They are masters of diguise, which assists attack, but which is mainly defensive. Their camouflage is based in the first instance on an ability to change colour to match their background, a skill shared by many fish and developed in the seas to heights of sophistication that would shame a chameleon. Among their disguises there is one that makes them almost transparent, and this forms part of the second line of defence, used in conjunction with the ink for which they are famous. Everyone knows that cephalopods squirt ink which forms an opaque cloud in the water around them, and it is fairly obvious that this must be a defensive strategy. Its real use remained undiscovered for years, however, and the secret was betrayed almost by accident by an octopus living in a laboratory tank.

It had been thought that the ink formed a cloud which obscured the outline of the animal, so confusing its attacker, which found itself facing an animal which grew suddenly much larger, but which might turn out not to be there at all were a blow or a bite to be aimed at it. The truth is more curious. The laboratory octopus, startled by the sudden appearance nearby of a human, squirted ink, and a moment later it was found hiding in a far corner of the tank, where it had changed colour and was almost invisible against the background.

The cloud of ink is shaped very approximately like the octopus itself. The attacker is meant to divert its attention to the cloud and to attack that. While it is busy doing so, the octopus becomes transparent and swims as fast as it can, which is very fast, to a more secure spot where it can change colour to match the background. To all intents and purposes, the victim vanishes. The purpose of the ink cloud is to reduce conflict and not to promote it. In nature, among the hunters and the hunted, the trick is to eat without being eaten.

There are many predatory fishes that lurk in dark corners waiting to pounce on passing victims, and among their number there are a few which build their own

A spotted sea hare (a marine snail without a shell) discharges a cloud of ink to confuse and distract a predator.

lairs. One is the Asian fish *Gnathypops rosenbergi*. It is a jawfish, and like all jawfish it has an extremely large mouth built on equally large jaws, which enable the mouth to be opened very wide.

Gnathypops uses its mouth as a scoop, working like an earth-moving machine to excavate a hole in the sea bottom and dumping outside the material it removes. It stabilizes the sides of its hole with stones and shells, which it presses into the sand or mud, and at the bottom of the hole it works to either side to make a chamber. The final result is a shaft that descends vertically into a chamber, all lined with stone and shell, like masonry. The fish emerges cautiously from this safe lair when no large, hungry predators are around, to lie in wait on the sea floor for any smaller fishes to pass by, at which time its jaws come into action again. Should danger threaten, the jawfish retreats into its hole, tail first if time permits, but head first if necessary.

In general, the use of traps is not common among animals, but among those animals which do employ them, they have evolved into devices as efficient as they can be. The laying of ambushes is more common. Most predators, however, stalk or chase their prey. Clearly it is to the advantage of the hunter that it can follow the movements of its prey. Traps and ambushes, however skilful, depend ultimately on the chance passing of a victim, and animal trappers and ambushers suffer from a disadvantage they do not share with human trappers. Each animal can construct only one trap for its own use, whereas a human trapper can and does construct many, or in the case of commercial fishing a smaller number of very large traps.

In the end, traps and ambushes themselves are inherently inefficient. Up to a point they can be improved by better design – making them impossible to detect, for example, like the entrance to the lair of a trapdoor spider, or more economical in their use of materials, like an orb web, or they may be used more efficiently, like the pitfall traps of the ant and worm lions, which are reinforced by the sand thrown by their occupants at would-be escapers – but there is a limit. The deficiences of the method can be overcome only by increasing the scale of the operation, by making the traps and ambushes larger or more numerous. Some spiders have evolved in this direction by making very large webs that sweep a substantial area, but to go further would require collaboration among the hunters themselves.

Such collaboration is quite common among hunters that pursue their prey. It is rare among trappers, although some spider webs are occupied by more than one spider at a time. The most famous non-primate example of collaboration among

The giant jawfish (*Opistognathus rhomalens*) awaiting prey in the Gulf of California.

the ambushers is provided by the lions of the African savannah grasslands. We need to specify that it is these lions which collaborate, since lions in other parts of the world – they were distributed throughout the eastern Mediterranean region, including Greece, the Near and Middle East, and India, where a population is preserved in the Gir Forest National Park – probably were solitary.

The general pattern among African lions is that the females hunt and the macho males steal the kill from them. Many females hunt alone but sometimes some of them will lay an ambush. The females manoeuvre themselves into a position downwind of the herd of prey animals, making use of such cover as exists, and then lie motionless and wait. One or two lionesses then move upwind of the prey and drive the game towards the ambush, which consists invariably of females spaced apart so that in fleeing from one lioness a game animal is likely to encounter another. It has been observed that such collaborative hunting is twice as likely to prove successful as solitary hunting, and although the hunters must allow the males to take some of the food the strategy reduces substantially the chance of nursing or pregnant females or cubs going hungry.

The strategy has evolved among predators which face special difficulties. On the open grasslands cover for stalking is limited. This is of little importance to dogs, which are highly social animals, hunt in packs, and can run down their prey, but none of the cats is able to sustain a prolonged chase, not even the cheetah, and while lions can move quickly, the large grazing animals on which they feed can move more quickly. Furthermore, a lion whose attack upon a fleeing animal is misjudged may find itself in great difficulty, for unless it is brought down at once and subdued by the predator, a large herbivore may be quite capable of killing the animal that attacks it.

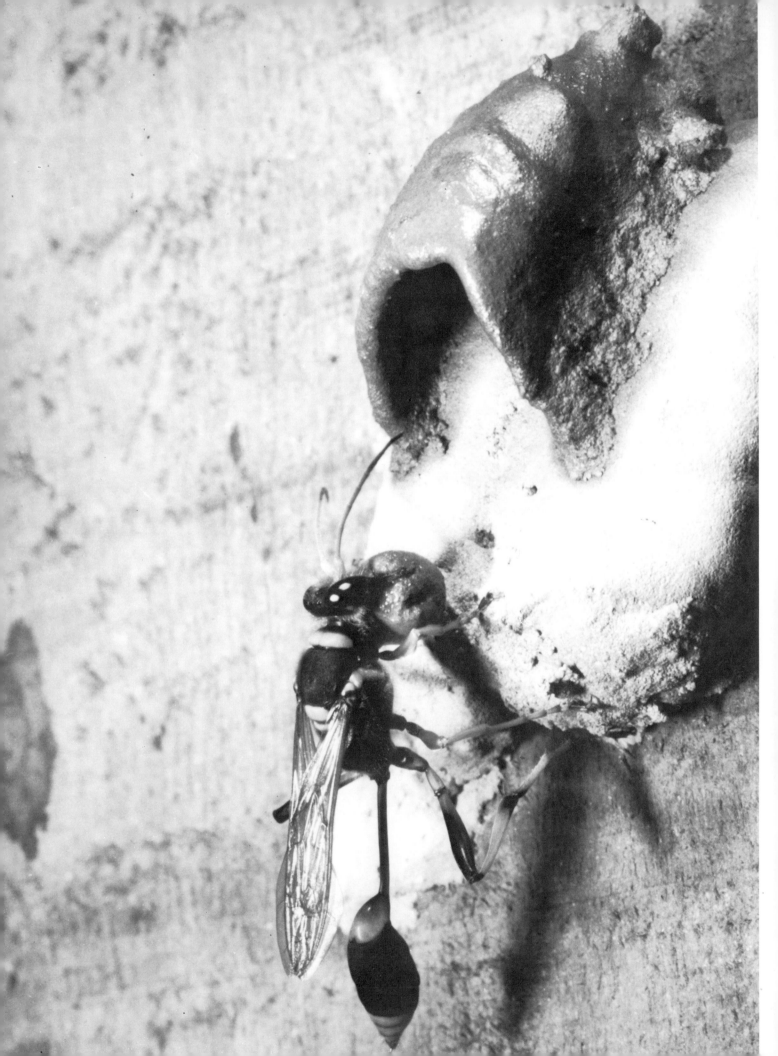

Builders

HYLA *faber* is a tree frog that lives in the forests of Brazil and Argentina, spending most of its time high in the crown of its chosen tree. It is much like any of the tree frogs that inhabit the warmer regions of the earth, except in one respect: the clue is provided by its Latin specific name. 'Faber' means 'maker': *Hyla faber* is a frog that builds. Its tools are the broad, spatulate final joints of its hands – features it shares with other tree frogs. When not in use for work, they help the tree frog grip as it climbs around its arboreal habitat.

Being amphibians, tree frogs can never move far from water which they need especially at mating time. Their eggs are fertilized outside their bodies, like those of fish: after the female has laid them the male releases his sperm over them. This process can work only in water, and the tadpoles which hatch from the eggs must remain in water, breathing with gills, until they mature into fully formed frogs.

Tree frogs, including *H. faber*, seek shallow water for mating. Once in suitably still water the male *H. faber* begins to collect small lumps of wet clay. It picks them up with its hands, a lump at a time, and carries them to its chosen site, where it builds a circular mud wall. Each lump is carefully placed in position and then smoothed, especially on the inside, the frog using the flat, broad tips of its fingers as trowels. The work may take two days or more and when finished the wall has a diameter of about 30 cm (1 ft) and rises some 10 cm (4 in) above the water surface. The frog has made an artificial lagoon.

Once the wall is finished the male stations himself at the centre of his lagoon and begins to call for a mate in his hammering voice that can be heard over a long distance. Like the majority of frogs he is most vocal at night. A female is attracted by his cries; she has taken no part whatever in any building, and as soon as she arrives spawning and fertilization take place in the lagoon. Then both adults depart for the trees and take no further interest in their offspring.

Amphibians exercise no parental care, but *H. faber* tadpoles have a better start in life than most amphibian larvae (apart from extreme examples such as the marsupial frog and Darwin's frog). Their lagoon contains little food for them, but it does provide excellent protection from the many predators that cruise in frog-inhabited waters and take a heavy toll of tadpoles. The lagoon contains no predators, and most cannot enter it. For their part, the young frogs are confined only by their size. As soon as they are big enough to cross the wall they are free to do so, and by that time they are old enough to take care of themselves.

Clay is an abundant, versatile building material, easy to obtain, easy to work and durable, at least for a short time. Our own distant ancestors found uses for it, and it is hardly surprising that other animals have adapted it to their particular needs, or modified their behaviour to take advantage of it. Birds, for example, need some kind of secure structure in which to incubate their eggs. Many build nests,

A mud-dauber wasp building, pellet by pellet, the cell in which it will lay an egg.

and many more use depressions or holes in rock, trees or soil, where thay may take over burrows excavated by mammals. The technique is perfectly satisfactory, but for one thing. In any particular area there is likely to be a limit to the number of suitable nest sites that can be found. Food may be plentiful, but unless birds can hatch and raise their young their population size will be restricted.

Certain ovenbirds have solved the problem with the help of clay, and have become highly successful as a result. These members of the family Furnariidae, live in the tropics of Central and South America. (The North American bird known as 'ovenbird' is in fact a kind of wood warbler and not a close relative.) The true ovenbirds are to be found in lowland forests, on mountains, and by the sea, and most of the 200 or so species of them nest in conventional fashion, in such natural hollows or holes as they can find. Six species do not, and the best known of these is the rufous ovenbird (*Furnarius rufus*).

These are territorial birds, which have a habit of perching on vantage points to survey their territories and warn off intruders. Their nests are often built in similarly high places – in trees or, where trees are lacking, on roofs, telegraph poles or even the tops of fences. At the same time they need holes and hollows, like any other ovenbird, so they manufacture their own.

The urge to begin nest building comes over them when heavy rains soak the earth and their world is enriched with inexhaustible supplies of soft mud. Both prospective parents take part in the building, collecting small lumps of wet clay, carrying them to the nesting site, and placing them in position. It is not merely a matter of picking up clay and pushing it into the developing structure – although that is work enough, for between them the partners must carry two thousand or more beakfuls of mud to build one nest. Binding material must be added for strength, and the mud is mixed with straw, grass, animal dung and such other fibrous substances as may be available. This is worked into the walls of the nest as construction proceeds, together with sand, which adds still more strength (just as in converting cement into concrete).

The nest begins as a pediment, a solid floor from which the walls will rise. The long side walls are slightly curved, and in one of them the birds leave an entrance hole about 10 cm (4 in) in diameter. They are joined above by a vaulted roof, and then a curved partition wall is built. This leads from one end of the wall with the entrance hole to the other, so that when the end walls are completed the structure contains two chambers. Access from the small antechamber to the large brood chamber is by a hole between the top of the partition wall and the roof, just large enough for the parents to pass.

When the building work is completed, after two weeks or more, the brood chamber is lined with dry grass. It is here that the eggs are laid, in a building that is secure from predators and looks curiously like an old-fashioned baker's oven, which is obviously how the birds earned their common name. This nest-building technique is so remarkable, and so impressed the first naturalists who observed it, that the name 'ovenbird' – the Latin *furnarius* means 'oven' – was applied to the entire family, regardless of their nesting habits.

The young birds leave the nest when they are five or six weeks old. By that time the rains have ended and the hot summer sun turns the nest into a real oven, inside which birds would cook. They cannot return to it, and a new nest must be built each year.

It is not only birds and amphibians that use clay, of course. So ubiquitous a building material has acquired its devotees even among the invertebrates. The hymenopterans – ants, bees and wasps – are dedicated nest builders and we will meet them again. One group of them, the potter or mason wasps, builds from clay.

The ovenbird *Furnarius rufus*, together with its 'oven' (*above right*), on top of a telegraph pole in Argentina. When the 'oven' is opened (*above*) two chambers are revealed, a smaller entrance chamber which leads to the large brood chamber, containing the nest proper. The entire structure is about 20 cm (8 in) in diameter.

There are at least 20,000 species of wasps in the world. Some are familiar to us because the non-breeding females among them have an ovipositor modified into a sting, but the wasps that haunt summer gardens and invade our kitchens and terrorize us in search of over-ripe fruit are but a few species among the vast hordes of wasps. Most wasps are very small, some barely visible to the naked eye, and we are hardly aware of them. All hymenopterans have biting mouth parts, and some are social, although social behaviour is less common among the wasps. What distinguishes the wasps from the bees; however, is not sociability, but the fact that all wasps are carnivores during at least one stage in their life cycle, while bees are vegetarians.

The difference is profoundly important, for while the bees devote their time to searching for and processing nectar, for themselves and for their larvae, the carnivorous needs of many wasp larvae have led the wasps in the direction of parasitism and reduced their size.

The great majority of wasps provide their young with a living but paralysed insect of another species on which to feed during the larval stage. If this strategy is

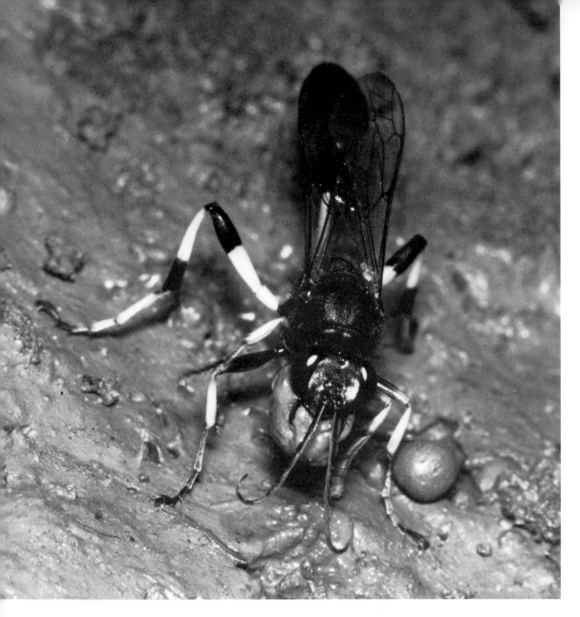

A mud-dauber wasp collecting mud with which to build a cell.

to succeed, the paralysed prey must be hidden in some secure place from which no rival can steal it. After all, a motionless caterpillar would not remain available for long if it were visible to insectivorous birds or mammals; and since the wasp egg must be laid in or on the food store, its loss would entail the loss of the wasp offspring. So parasitic wasps build secure, secret shelters in which their young can feed without risk of interference. The other consequence of this way of life is that each food store feeds only one wasp larva, so the adult female must find many hiding places and lay just one egg in each. This restricts the number of eggs which each female can lay and provision in the time available to her, but this limitation is more than compensated for by the greatly increased survival rate of her progeny. The parasitic wasps are highly successful.

The female potter wasp, like the ovenbird, and like ourselves, cuts corners. Although it may seem much more laborious to construct housing rather than simply to make use of the accommodation which nature supplies, by building shelters the wasps spend all their nesting time in useful activity rather than wasting much of it on fruitless searches for unoccupied cavities, which may or may not exist. By exploiting an environmental resource in order to modify the environment, the wasps, like humans, increase substantially the accommodation available to them. This amounts to a great increase in the efficiency of the animal concerned.

How can we speak of 'efficiency' and apply the term equally to humans and insects? It is quite simple. The environment supports larger numbers of builders

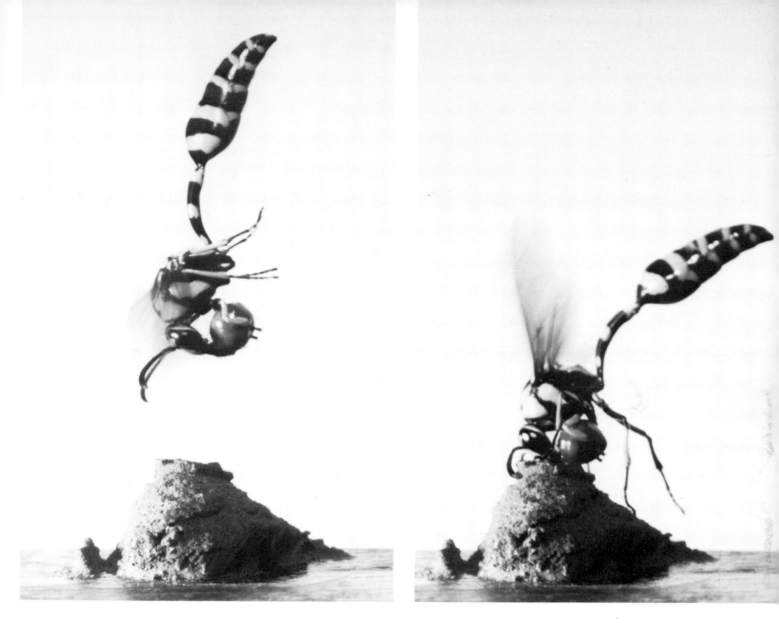

A potter wasp flies toward its partly finished cell carrying a pellet of mud (*above*) which is added to the wall of the cell (*above right*).

than it does of non-builders. Wasps and humans become more numerous than they would be otherwise. At least five, and perhaps more, stocks of wasps have taken to building nests from clay quite independently of one another, which suggests very strongly that the technique has real value.

There are two approaches to the work. Some wasps, most especially those of the family *Eumenidae*, collect dry, often compacted soil and mix it with water to soften it. The water they collect separately, swallowing it and regurgitating it as required, one load of water being sufficient for about five loads of earth. Other wasps, such as some of the *Sphecidae*, collect wet mud from the banks of puddles or ponds. In all cases it is wet mud that is carried to the nesting site, because the wasps that collect dry earth moisten it before they remove it.

The most advanced builders, and the true potter wasps, belong to the genus *Eumenes*, but their skill is matched by some North American *Auplopus* wasps and several tropical species. They build their nests in crevices in rocks – even, it is said, in the crevices provided by the incised lettering on gravestones – on twigs and branches of trees and shrubs, or, in the case of the North American wasps, beneath stones or fallen timber.

The clay is carried in the mandibles – the 'mouth' of the insect – and is placed in position using the mandibles and front legs. The wet earth dries quickly, apparently by design, because each pellet of clay is placed at a different point on the edge of the structure. This makes the nest dry out more quickly than it would do if

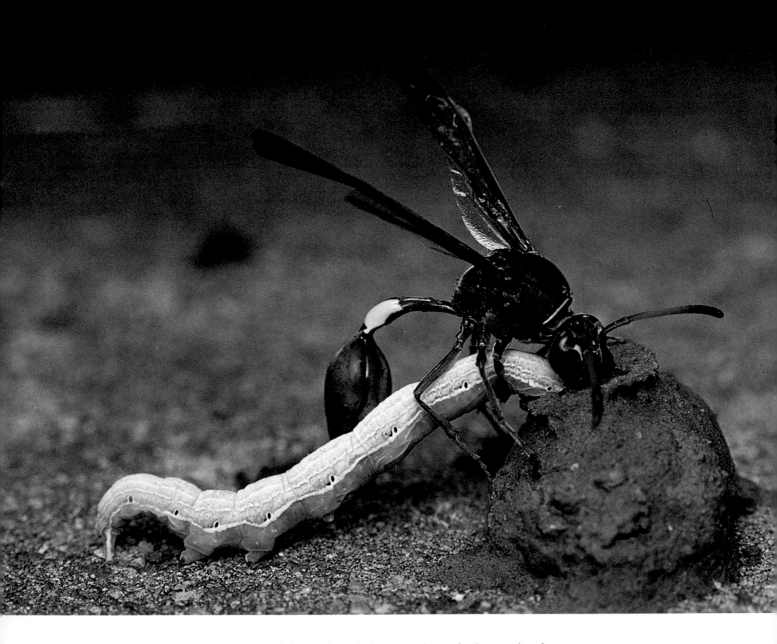

the wasp was to build up one part of the wall and then another, placing moist clay next to clay that had dried incompletely. When the pellet is in position it is made secure by being pressed down firmly. One wasp, *Paragymnomerus spiricornis*, bends its body over the pellet, pushing its head against the inner side and its legs against the outer side. The structure grows in the shape of a hollow container, more or less spherical or cylindrical with a narrow neck at the top, a little like a bottle.

It begins with a layer of clay that is smoothed out to provide a base. Then each subsequent pellet is shaped into a semicircle, the wasp working first at one end of the wall and then at the other, the semicircles interlocking on the outside. As the nest is built, most wasps leave the outside rough – although there are a few which smooth it. All of them smooth the inside. *Eumenes* wasps use their heads for this, pressing them hard against the inside surface until it is to their liking. Others use their abdomens – especially the final segment, which in *Auplopus* wasps in flat and smooth – as trowels. It is the upper, or dorsal, surface of the abdomen that is used. The 'waist' of a wasp is very flexible and the abdomen can be bent forward beneath the thorax, the wasp standing in a kind of 'jack-knifed' position while it works. Many ground-nesting wasps use their abdomens in this way to press the top crumbs of soil into place above their nests and so to seal them, and probably the builders have merely extended the application of this behaviour.

opposite The organ pipe wasp makes many cells, each of which is cylindrical in shape, then adds an outer coating of clay to produce a structure resembling the pipes of an organ.

When building is complete, the potter wasp places insect larvae into the cell after paralysing them with a sting (*opposite*). The final stage in the process is for the wasp to lay its egg in the cell (*right*). Then the cell will be sealed and left.

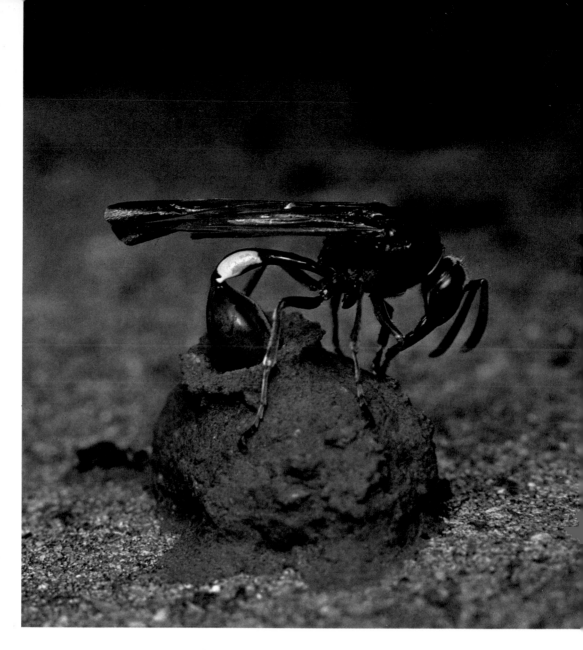

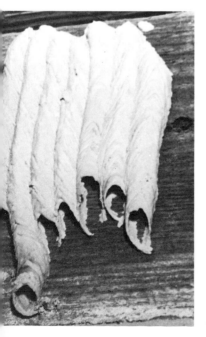

While they are working at collecting earth and water, carrying it, and positioning it, the wasps make a very loud buzzing noise. No one knows why they do this.

It takes a wasp one or two hours to make a nest of this kind. If it has started late in the day and cannot complete the job before nightfall, it will place a temporary cap over the top of the nest and start work again the following morning. It is not the difficulty of building by night which brings the day's work to an end so much as the problem of provisioning. When the nest is finished the wasp must find a few caterpillars or beetle grubs with which to stock it. She captures a suitable insect, paralyses it with a sting, carries it to the nest and stuffs it unceremoniously through the narrow neck. Then she goes off to find another insect. Finally she inserts the tip of her abdomen into the opening and lays one egg. The *Eumenes* wasps secrete a silky thread as the egg is laid. The thread dries immediately leaving the egg attached to its lower end, hanging among the store of food, so that the wasp larva may begin feeding the moment it hatches, and does not have to search for its food. Finally, the nest is sealed with one last pellet of clay – or a pellet of the faeces of other animals – pressed into the neck. The job is done, and almost immediately it is time for the wasp to begin the task all over again.

The wasp adds more nests beside the first one, to either side and above it, and

sometimes outside it, to form a second layer. One wasp, *Trypoxylon*, builds cylindrical nests side by side that in the end look like organ pipes, and it is known as the 'organ pipe wasp'. Usually the wasp considers its work to be done when it has made and stocked from four to ten nests, but there can be as many as twenty. When the small colony is completed, the wasp plasters over all of them, making an outer protective wall that in most cases, but not in the case of the organ pipe wasp, obscures the shape of the individual nests.

Does the wasp 'know' what it is doing as it builds or is it a mere automaton, performing endlessly repetitive tasks it is incapable of changing? The potter wasps have been used many times to seek answers to this question. If holes are made in the nest while the wasp is building it, the builder will repair them, altering its routine completely in order to do so. On the other hand, when a scientist removed a colony of nests just as the wasp was starting the final plastering, it continued to plaster, despite the fact that the nests had vanished. The building behaviour of the wasps is innate, in that they are not taught it, but its acquisition is due to the fact that natural selection working over countless generations of wasps favoured those which provided the most effective protection of their offspring. While the ability to build is inherited, it is as much a form of adaptation to the environment as is the diet of the wasp or its colouration, and is not totally inflexible. The wasp can respond to small changes in its environment, and since this happens constantly it would not survive for long if it could not.

The potter wasps build for their young, but do not live in their nests themselves. Other animals build homes for themselves, and the ability to do this begins, in evolutionary terms, among the simplest and most ancient of organisms.

All of us are familiar with molluscs – the shellfish and land snails – that instead of excreting the surpluses of calcium and carbon dioxide which they acquire in their diet and as a by-product of respiration respectively, allow them to react to form calcium carbonate, which they deposit as crystals above their horny outer covering, so manufacturing shells. These protective coverings are undoubtedly built by the animals, but since the work of building is governed by their body chemistry and involves chemical restructuring of the building materials, we cannot include them in our list of animals that build. Yet, to match their sophisticated habits, we would have to eat rock fragments, process them inside our bodies, and then release them again as preformed building materials that formed themselves automatically into walls and roofs!

Not all the shelled animals are large. The *foraminiferans*, for example, are so small that many of them can be seen only under a powerful lens or even a microscope. These marine animals produce lime shells, or 'tests', and until 65 million years ago were far more abundant than they are today. Our limestones and chalks, including the chalk cliffs of southern England, are made from the compressed remains of their tests. Today, although some live among the plankton, drifting not far below the surface of the oceans, most live on the sea bed, and among them there are a few which do not grow tests, but manufacture them.

These tiny animals possess nothing that we would recognize as a sense organ. They are quite blind and deaf, and yet they build substantial shelters for themselves from materials they collect from their surroundings. One of them, *Psammosphaera rustica*, uses sponge spicules. Composed of silica, these are the remains of the structures made by sponges, and *P. rustica* uses the longest of them – no more than two or three millimetres – to make a frame, with some of the ends projecting to prevent the finished 'house' from sinking into the soft mud on which the animal lives. Once the frame is finished, spicules, each of precisely the correct length, are inserted to fill the spaces until the completed work is a hollow

Vermetus arenarius is a Mediterranean tube worm which constructs an outer coat to protect its soft body.

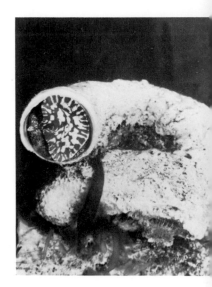

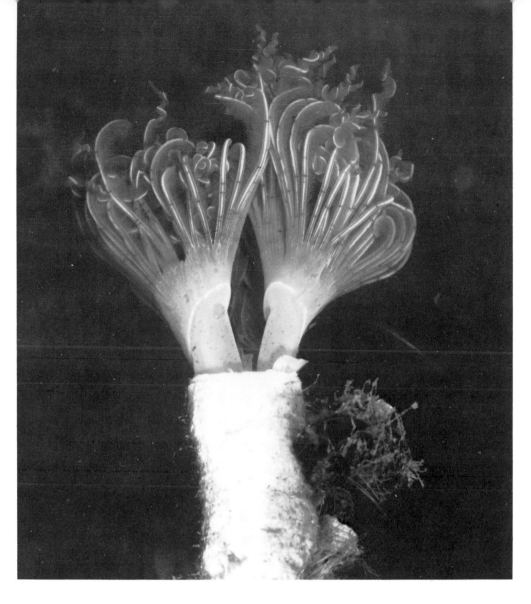

The tentacles of *Protula intestinium*, a serpulid fan worm, form two opposing half circles. They bear cilia which beat to fan water into the funnel at the centre and so to the body of the worm, where the particles in the water are separated. Some are taken as food, some are used in tube construction, and the rest are rejected and expelled back through the funnel.

polyhcdron, almost spherical, inside which the builder lives. We know nothing at all about the way in which a literally senseless animal builds so elaborate and secure a structure, but build it it does.

An amoeba is a distant relative of the *foraminiferans* – they both belong to the phylum *Sarcodina* – but it is a much simpler, single-celled protozoan that feeds by wrapping itself around particles and engulfing them. It moves by means of pseudopodia, limb-like extensions of itself that push forward in any desired direction and are withdrawn and disappear when they are no longer needed. Some amoebae have shells, produced like most shells by the reworking of substances ingested along with food, but there is at least one genus of amoebae, *Difflugia*, which does no such reworking.

Along with its food, *Difflugia* ingests grains of sand and other small mineral particles. These move from the interior of the cell to the exterior and so to the outer part of the cell wall, where they become embedded in a substance secreted by the cell and accumulate to form a complete outer covering. Since the amoeba has no way of shaping the particles it uses, and since their size and shape are rather random, its shell has an uneven surface. It is a little crude but its shape is regular, approximately that of an egg. There is an opening at the smaller end through which the occupant pushes its pseudopodia, by means of which it can crawl about like a snail. The same opening must serve it for respiration, feeding and excretion.

It works very well, and the amoeba is well protected against the many predators which stalk the fresh water, damp soil and mosses of its habitat. However, there is a

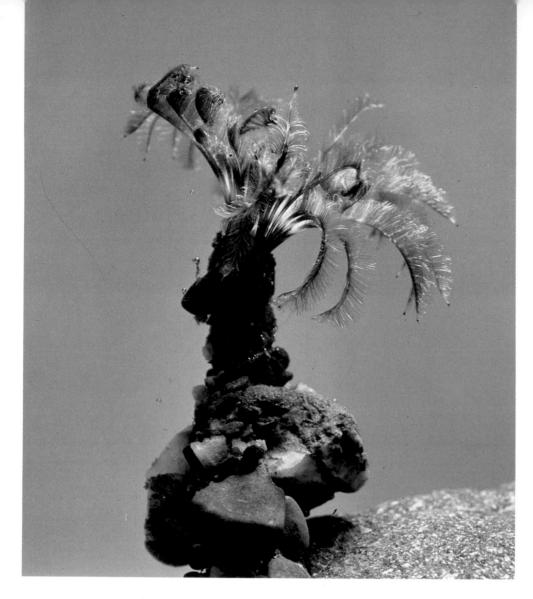

problem. Protozoans, and the amoeba is no exception, reproduce by cell division. They do not lay eggs or give birth to young, but divide, one cell becoming two. A naked amoeba manages this easily. Its cell contents arrange themselves in an appropriate pattern so that each daughter cell will possess the necessary faculties, the cell wall narrows to a waist that joins, and the cell becomes two cells. How is this possible for a protozoan which lives inside a rigid structure to which it is attached quite firmly by the cementing substance secreted at its cell wall? What happens is that some of the cell is pushed out through the opening in the shell, and assumes the bottle-like shape of a *Difflugia*. It remains quite still, while small grains of minerals are passed through the cell wall to its surface to make it into a tiny *Difflugia* 'bud' attached to the parent. At this point the cell contents divide to equip the daughter with all that it needs, and when that process is complete the tiny new *Difflugia* breaks away from the parent to lead a separate existence.

Difflugia solves this problem very neatly, but its curious method of construction allows it to evade the other main problem that faces shelled animals, namely how to grow inside a shell. They generally achieve this simply by growing more shell and adding it to the existing one. This leads to some structural complexity if the owner of the shell has to carry it around its habitat, and hence to the elaborate whorls and spirals that creep around our gardens and seashores. The baby *Difflugia* needs no such strategy. As it grows its surface area increases, the particles with which it is coated move apart, and new particles are inserted to fill the gaps between them.

Even some worms are able to construct dwellings for themselves. The

above The tube of a marine bristle-worm, *Pectinaria koreni*.

above left Branchiomma *vesiculosium*, a fan worm or 'feather duster' worm. The spots are simple eyes which are highly sensitive to sudden changes in light intensity. If an object shades the worm it will withdraw into its tube at once.

polychaetes, or bristle-worms, are numerous and have adopted many different ways of life in or beneath the sea bed, and two families, the Eunicidae and the Onuphidae, build tubes. The bristle-worms concerned secrete a cementing substance from glands situated on the lower (ventral) side of their segments. Some of them include lime in their secretions, which hardens around them, but others, the 'bamboo worms', use their cement to hold together sand grains, and still others use a little of both techniques to produce tubes made from sand mixed with lime. The tubes themselves are usually buried in the sea bed either vertically or horizontally, but the quill worms of the onuphid genus *Hyalinoecia* make fine, narrow tubes shaped just like the quills that give them their common name, and they can move their tubes from one place to another. The worm selects its building

The fan worms are often spectacularly beautiful. This group consists of a sabellid worm, which makes a tube from sand grains, and several smaller serpulid worms, whose tubes are calcareous.

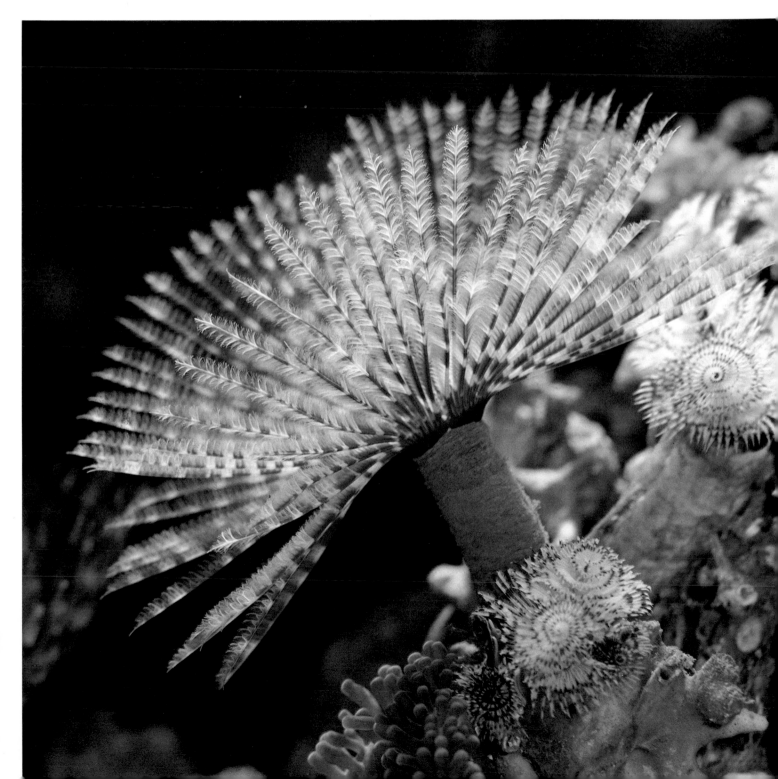

materials, picks them up with its mouth, and puts them where it wants them. Altogether the worms can cement together prodigious quantities of materials, partly because they are numerous, but mainly because some species live in colonies, sometimes comprising millions of worms, which construct honeycombs of tubes of almost reef-like proportions.

Bristle-worms have mouths much better adapted for the job of building dwellings than the more familiar earthworms. Even so, a limbless animal needs special techniques to assemble materials. *Sabella* is a fan worm and its method is fairly typical. It sorts through the grains and bits and pieces of material which it finds lying around it and selects those of a suitable size. Just below its head *Sabella* has two sacs into which the chosen grains are placed. The sacs secrete a mucus which mixes with the grains and when building is in progress this mixture is squeezed out in a thread and pushed through a groove in the worm's collar. As the mixture emerges, the worm rotates very slowly while the groove in the collar shapes the thread and attaches it to the edge of the tube. Like its fellow bristle-worms, *Sabella* secretes more mucus along its ventral side, so that as it spirals its way forward the newly made tube receives a further coating on its inside.

The bristle-worms are carnivores, and to the human eye very beautiful. They never leave their tubes, but feed from the open end by means of tentacles with which they trap their prey and carry it to their mouths. The fan worm is one of the most beautiful, because its tentacles have small outgrowths, called 'radioles', that look like very small pine needles. Some people call fan worms 'feather dusters' or 'Christmas tree worms'. Their tentacles are very mobile. While the animal is feeding, they twirl, twist and wave constantly, fanning food towards the mouth below, but if danger should threaten they are withdrawn into the tube instantly and the worm itself may retreat deep within its refuge. It is not easy to dislodge a bristle-worm from its tube.

The caddis flies perhaps are the best known shell makers. The adult insects are somewhat undistinguished and look rather like dull moths, although they are not moths at all. Most of them live near water, and spend their days hiding in crevices, emerging at dusk to fly. The majority spend their larval lives in water, where most

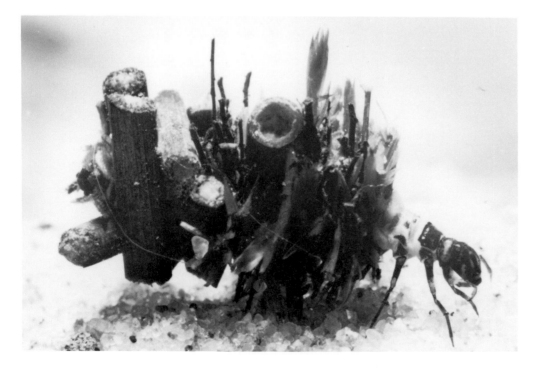

A caddis fly larva, its head projecting from its case but its soft body well protected with indigestible sticks.

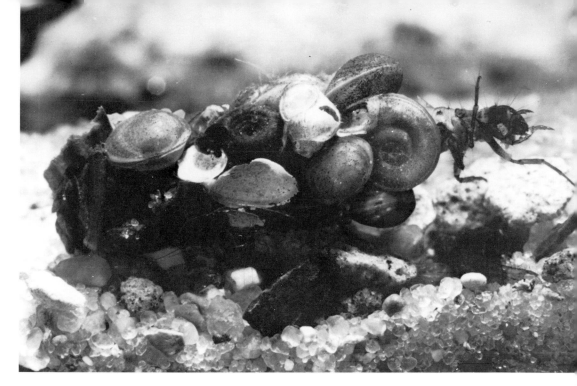

Each species of caddis fly has its own preference for materials for tube construction. This one uses snail shells and small stones, which weight it to the bottom of fast-flowing streams.

Larvae of the caddis fly *Limnephilus vittatus*, safe inside their cases made from sand grains.

aquatic carnivores feed on them – a circumstance the caddis fly larvae themselves seek to change.

Most caddis fly larvae are omnivorous, though there are some predatory carnivores among them, which we met in 'Hunters and Trappers'. When they hatch from eggs contained in masses or strings of jelly, much like frog spawn, their first need is to protect their rears. The larva hatches with a hard head equipped with powerful jaws, and its thorax is softer but still fairly hard, but its abdomen is totally unprotected and, what is worse, to many water dwellers it is juicy, tasty and nutritious.

Like so many invertebrates, the young caddis fly has near its head a gland which secretes a substance that sets to form a sticky, silky thread. By extruding its sticky silk and turning itself around as it does so, the larva is able to wind the thread round and round its body to provide an outer adhesive layer. This done, it selects bits and pieces of sand grains, gravel and other material which it places around itself to make a protective casing. It does this quite deliberately, and the design of the case differs from one caddis fly species to another, but within each species it is always the same. You can identify a caddis fly species by the design of the casings its larvae make, although not all species make them.

The case is open at both ends, the opening at the rear end being very much smaller than that at the front, and by moving its body inside the casing the insect is able to draw water through the case in a constant flow. This is vital, because it breaths by means of gills along the sides of its body. As the insect grows it adds new material at the front of its case to give it more room, and often it will remove material from the rear end. As the case always tapers, by adding more at the front than it removes from the back the caddis fly can make it both longer and wider.

The larva can move about, taking its case with it, because its legs and head protrude at the front. There is little risk of it inadvertently moving completely out of its case because at the tip of its abdomen there are two strong hooks that are kept permanently attached to the silky lining. For the same reason, a predator that encounters a caddis fly larva finds it very difficult to dislodge the occupant from its armour. Unhappily for the larvae, there is a counter to this. Some fish, most notoriously trout, and many birds, simply swallow the caddis fly, case and all, digesting what they can and excreting the indigestible casing.

At least one caddis fly, *Anabolia nervosa*, has discovered the solution to this

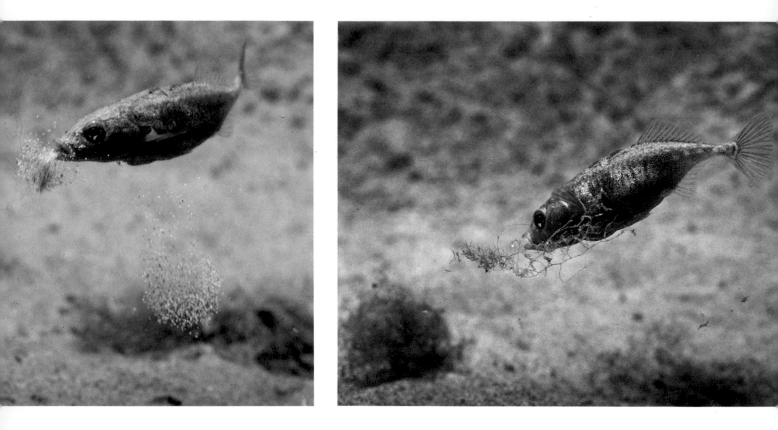

problem. It adds twigs to its case. These stick out at the sides like irregular bristles and make it impossible for a predator to swallow, and as a result their owner can and does feed openly with trout all around it. The twigs provide it with access to food that is denied to other caddis flies.

The ability to construct a case brings other benefits as well. Most small animals find it almost impossible to live in fast-flowing streams because they tend to be carried away by the current. They must find sheltered places, often beneath or behind stones, or cling very tightly to some kind of anchorage. It is far from easy to feed in this position. Certain caddis flies are able to supply their own anchors by including larger, heavier stones in their casings.

Many fish make nests, of course, although the technique for most of them is extremely crude and does not qualify them for consideration as true builders. The sticklebacks are among the exceptions, however, because they construct quite elaborate nests. There are several species of sticklebacks, distinguishable mainly by the number of spines on their backs, but all of them live in much the same way and their nests differ primarily in their choice of sites.

It is the male that does the building. During the breeding season this rather drably coloured fish develops bright colours that centre on the brilliant red of its underside. It seeks shallow water, and on a depression on the bottom if it is a three-spined stickleback (*Gasterosteus aculeatus*), or among weeds clear of the bottom if it is nine-spined (*Pungitius pungitius*), it constructs a nest much like a bird's nest, from bits of twig and other plant material that it weaves and sticks together, the glue consisting of a secretion produced by its kidneys. Once it has finished building it defends the nest and the surrounding area against rival males and waits for females to approach. When they do it performs an elaborate courtship dance during which it displays its breeding colours. If the female responds, she is enticed into the nest, where she will lay some, but not all, of her eggs. The male fertilizes them, the female departs to lay more eggs in other nests, and the male resumes his wait for females. If

When nesting, the stickleback male begins by removing sand to make a depression on the bed (*above left*). The nest itself is made from plant material which the male collects and takes to the depression he has made (*above*). He then glues the nest together with a secretion from his kidneys (*opposite left*), and defends against everything except female sticklebacks. In this case (*opposite right*) a passing snail is perceived as a threat.

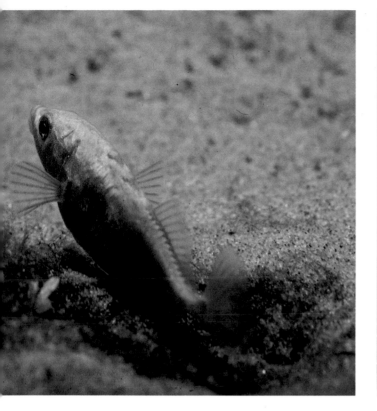
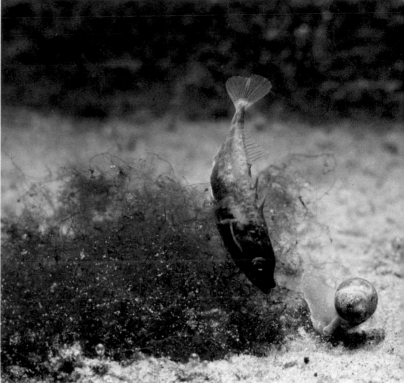

he is successful he will attract a number of females to the nest, which will come to contain an assortment of eggs. He stays with the nest, fanning water through it to keep the eggs well supplied with oxygen and, depending on the temperature of the water, within four days to four weeks the eggs will hatch. He continues to guard the larvae, which do not stray far from the nest, for about a week. After that they begin to seek food in the plants nearby and their father loses contact with them.

When we think of animal builders, though, it is birds that come to mind first. The cup-shaped nests in trees and hedges, the looser, bigger nests in high trees, the mud nests glued firmly to the eaves of houses and barns, are familiar enough, but while many birds nest in this kind of way there are many more that make no nest at all, and many that nest in burrows dug in the first place by burrowing mammals and then abandoned. Of the nest builders, some have quite extraordinary techniques.

Consider, for example, the South American trogons, which nest in holes, and among them the white-tailed trogon (*Trogon viridis*), which makes the holes in which it nests. This seems hardly remarkable until we learn that the birds make their nests in hollow wood. They actually peck away the wood from a living tree, choosing wood of just the right hardness. If it were harder they would be unable to bite it. If it were softer it would not provide enough structural strength for the brood chamber. A scientist once observed a pair of these birds making their nest, male and female working alternately, and he timed them. It took the pair of them less than an hour; each had a two-minute rest during their work, and each partner worked for exactly half the total time.

The hornbills of Africa also nest in holes, although they do not excavate them, but their nests are curious less for the manner of their construction than for the way they are used. It is the female who chooses the hole in which her brood will be raised, and when she has decided on a particular hole she sets to work to seal its entrance with mud. When the entrance is reduced to an opening barely large enough for her to pass through, she enters the chamber and uses her own excreta

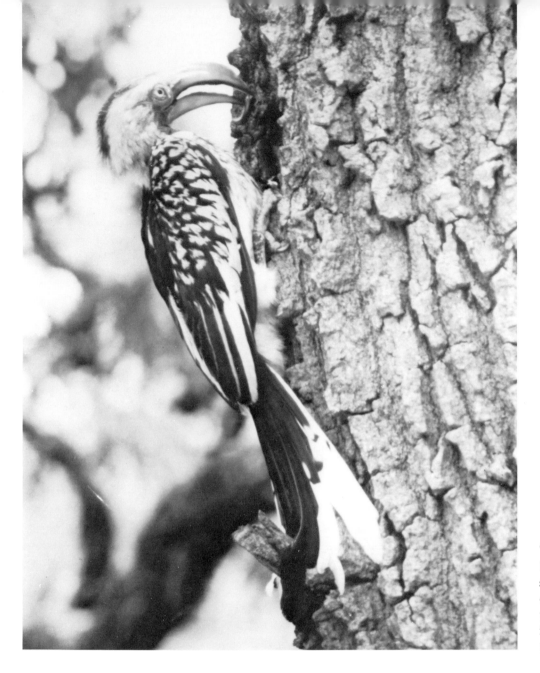

The female hornbill incubates her eggs and raises her chicks sealed inside a nest, dependent on her mate for food. This male yellow-billed hornbill is passing food to the female through the tiny opening.

and any mud that has fallen inside the nest to complete the job, until all that remains of the entrance is a tiny slit. Now she depends utterly on her mate, who feeds her through the slit.

She lays up to five eggs, which take about three weeks to hatch, and the male visits her about thirty times a day with food. The female pushes her excrement through the slit to keep the nest clean, and when the young are hatched their excrement is used to reinforce the mud that blocks the entrance. When there are young to feed as well, the thirty or so visits the male has been making each day increase to as many as seventy.

What happens next varies from one species to another. The red-billed hornbill (*Tockus erythrorhynchus*) spends a total of about forty days in the nest, then breaks open the hole and escapes – although it can take up to four hours to remove the hard, baked mud. As she leaves, however, the fledglings, still in the nest, close up the hole behind her. She joins her mate in bringing food to them. It takes them several days to complete the work of blocking the hole, and when they are ready to leave the nest, a few weeks later, they must break out by themselves. Even then, the young do not leave the nest all at the same time. The bigger, stronger ones go first, those which remain closing up the hole again each time.

The female silvery-cheeked hornbill (*Bycanistes brevis*) spends the whole of the incubation and fledgling period inside the nest. Altogether this amounts to about a hundred days, and the male provides food for the entire family throughout.

Perhaps the most remarkable of all avian builders are the 'big feet', or Megapodiidae, ground-dwelling birds rather like turkeys which live in Australia and New Guinea. They build huge nests, but the hen does not incubate her eggs by sitting on top of them either on the nest or inside it, for the nest itself is an incubator.

Like our family farmyard chickens, to which they are related, the 'big feet' do indeed have very large feet, with which they scratch for food on the forest floor. Their feet are their tools, and in most species it is the cock who wields them at nesting time. The biggest feet of all, compared to body size, belong to the scrub fowl (*Megapodius freycinet*), a bird the size of a partridge, and it builds the largest bird's nest in the world. It can be 5 m (16 ft) high and 12 m (39 ft) in diameter. The brush turkey (*Alectura lathami*), whose eggs are about three times the size of hens' eggs, builds a modest structure by comparison, a mere 3 to 4 m (10 to 13 ft) in diameter and about 1.5 m (5 ft) tall.

The key to the technique lies in the fact that if they are to develop properly the eggs must be incubated at a temperature very close to 35°C, which is more or less the temperature inside a good compost heap, and in tropical climates compost heaps are rather easier to make than they are in cooler regions. The birds have the ability to recognize this temperature precisely by sampling material in their bills, and not only can they make compost heaps, they can manage them so that a constant temperature is maintained inside them.

The cock builds the heap somewhere in deep shadow, sometimes in a natural depression in the ground. It takes him several weeks to assemble the material he needs, though his method is not subtle. Like all fowls, he scratches to his rear, and in this way he throws assorted vegetation at the heap, which grows and grows. The heap is soaked in rain, it contains some soil, the climate is warm, and composting conditions are ideal. Now and then he climbs to the top of the heap and stamps it down to compact it, and when it reaches the right size it begins to heat.

At first it heats strongly, much too strongly for the good of any eggs, and the cock will drive away any misguided hen who seems interested in it. Only when it reaches the required temperature will he consent to mate. He samples the heap at frequent intervals, by digging a hole in it large enough for him to reach well into it with his head. He takes a bill full of the contents, which he then spits out again. If the heap is not warm enough he closes up the hole he has made and adds more material. If the heap is too hot he digs more holes to ventilate it. Finally, when he is fully satisfied, he calls for a female, mates with her, and then digs a hole into which she lays one egg, which he covers with the compost.

This process is repeated at intervals over the next few weeks, and when all the eggs have been laid the hen departs, taking no further interest in the proceedings. The cock stays with his heap, sampling it and regulating it for the following two and a half months, which is the time it takes for the eggs to hatch.

When they hatch, the chicks dig their way to the surface – a task that can take them hours – and go off immediately in search of food. The cock ignores them completely and they ignore him. The chicks are nidifugous, that is to say, they hatch covered in downy feathers and are able to fend for themselves at once. The day after they hatch they can fly.

It is the mallee bird (*Leipoa ocellata*) that has carried the mound-building style of nesting to the limit, and the limit is imposed by the climate. Where the temperature fluctuates widely the heap requires much more management to maintain a constant temperature, and the mallee fowl, which lives in the semi-arid Australian

bush, spends up to eleven months of each year at the business of reproduction. It is, you might say, its full-time profession.

The birds begin work in the southern autumn, in April or May, by digging a pit about 1 m (3 ft) deep and 4 to 5 m (13 to 16 ft) across. Then they scavenge the neighbourhood for vegetation with which they fill the pit, the male and female working together. By the time they have finished, the rains usually begin and the contents of the pit are soaked thoroughly. In dry years the vegetation will not ferment, and the birds do not lay eggs. Once it is moistened, the vegetation is covered by a thick layer of sand. It begins to rot and to heat, taking several months to reach the required temperature. If all goes well, egg laying begins in August. The

The nest of the mallee fowl is a huge compost heap, the female laying eggs singly in holes dug in the heap. This bird is filling in one of the holes, which might have been made to test the temperature, or might already contain an egg.

When it is necessary to test the temperature the mallee fowl digs a hole and samples the heap with its bill. It can recognize the temperature needed for incubation within very fine limits.

The pair of birds work together on the maintenance of the heap, ensuring that the temperature remains optimal for the eggs.

male digs a hole, the hen lays an egg, and the male covers it, the operation being repeated every few days until about a dozen eggs have been laid. Before each laying the hen examines the hole to make sure the temperature is right. If it is not, the cock must fill it in and try again in another part of the heap.

In spring, shortly after the laying is completed, the heap is fermenting vigorously, and to prevent overheating the birds make ventilation holes. As the weather grows hotter this is insufficient, and material is removed from the top of the heap during the day and replaced again at the end of the day. In the full heat of the summer, even this is not enough. Sand is removed from the heap each morning, spread on the ground to cool, then replaced on the heap and covered with a thick layer of material from the sides of the heap to provide further insulation. It takes the birds two or three hours of work to perform this each day, and all the time they are testing the temperature inside the heap.

As summer passes, the temperature begins to fall, and by this time the fermentation of the heap has finished and only the sun can keep the eggs warm. Late each morning the heap is dismantled to leave just a thin layer of sand over the eggs, which are warmed by the midday sun. The sand that has been removed is spread out to warm, and turned constantly to allow it to heat evenly and then, later in the day, all of it is replaced. The birds spend five hours each day at this work.

In all, incubation takes up to seven months and with the four months it takes to prepare the heap there is little time left for other activities. After the chicks have hatched the adults may go their own ways for a few weeks, but many males spend the whole of their lives within a few hundred metres of their heaps, and the partners mate for life. They play no part in the upbringing of their chicks which, like those of other megapodes, are able to fend for themselves the moment they hatch.

What is remarkable is the accuracy with which the birds can measure the temperature inside one of their heaps. They have been studied extensively by Australian scientists, who inserted thermometers into heaps and then added heaters so that they could alter the internal temperature. It was found that the birds would react at once to changes of less than $1°C$.

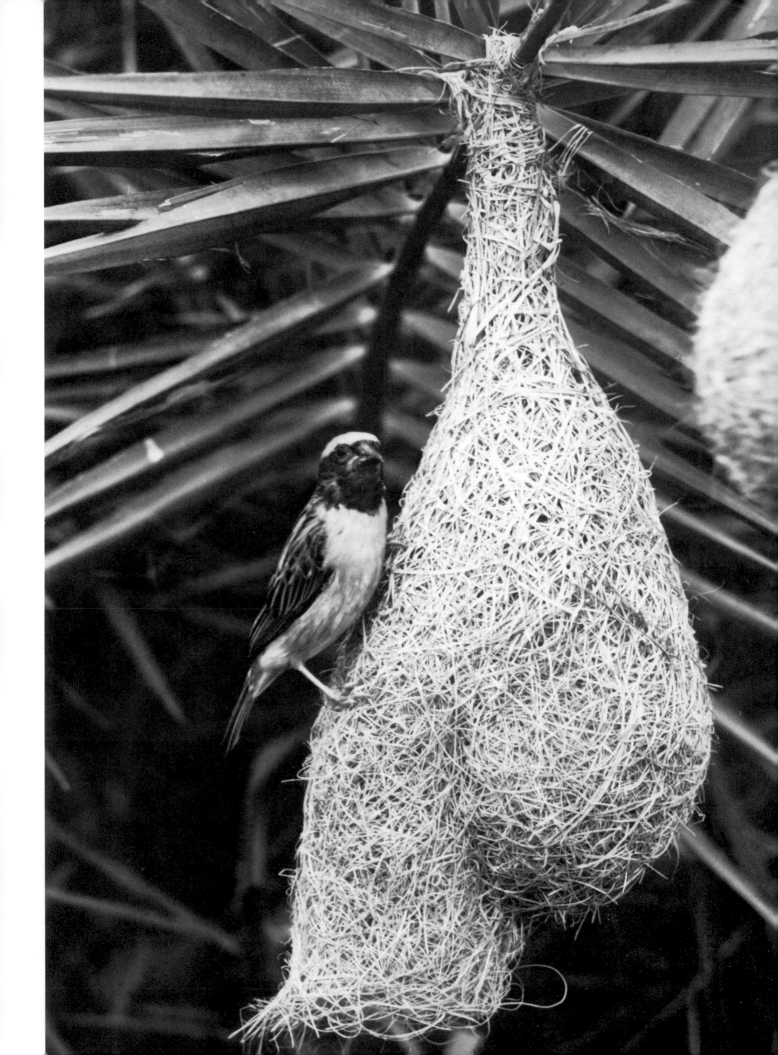

Weavers and Tailors

THE weaver ants are not easy to observe. They live high in the crowns of trees in the tropical forests, within which they are widely distributed. There are several species. *Oecophylla longinoda* lives in Africa, *O. smaragdina* in south-east Asia, various *Polyrachis* species throughout the Old World tropics, and *Campanotus senex* in South America. They are remarkable among insects not only for their unusual method of nest construction, but also because in making and repairing their nests they use tools. In fact, were you or I to attempt to make the structures they make, almost certainly we would approach the task in the same way, although there would be one important difference.

The nests themselves are made from leaves, but these are not collected from the litter on the floor, or cut from the trees on which they grow. They remain in place, attached to their trees and alive. The ants draw together adjacent leaves to construct a chamber. The design varies from one species to another, from the simplest nests that consist of just a few leaves attached loosely to provide a rough kind of shelter, to robust 'tree-houses' containing several chambers.

As we would expect, the nests are made by a highly co-ordinated team of worker ants or, more correctly in this case, by several teams.

The operation begins when the ants select a site for their nest, and a particular leaf, which must be very close to a second leaf. The first team seizes an edge of a leaf, gripping it with claws on their rear legs. If the edge is jagged, members of the second team use their sharp mandibles to trim it to a smooth edge, taking away the small fragments of debris and releasing them to be carried away by the wind. The ants gripping the leaf now use their mandibles to grasp the edge of the leaf that is facing them, so there is a row of ants forming a bridge along the full length of two leaves. Again, should the edge of the second leaf be ragged, members of the second team will trim it. It may be, of course, that while the ants are able to bridge the gap between the leaves in one place, somewhere else the gap is too wide and the worker is left leaning precariously into space. For the ants, this is a minor problem. Another ant joins the bridge team, is gripped at the waist by its struggling colleague, and reaches across to hold the leaf in its mandibles. If the gap is too wide even for two ants, as quite often it is, a third or a fourth will if need be join, each ant gripping the one in front, until the gap is bridged.

The two leaf edges are to be joined, and as soon as both of them are being held firmly, the ants bridging the narrowest part of the gap begin to draw their edges together. The other ants follow suit, and so the edges are brought together and held in place, as you or I might align two edges of paper we wish to tape together.

The ants do not possess tape, but they do possess larvae – their own young – which secrete silk. At this point in the proceedings, with the edges positioned, the third team of workers appears on the scene, and each member of this team carries a

A weaverbird (*Ploceus phillipinus*) with its nest. The entrance tube is at the bottom.

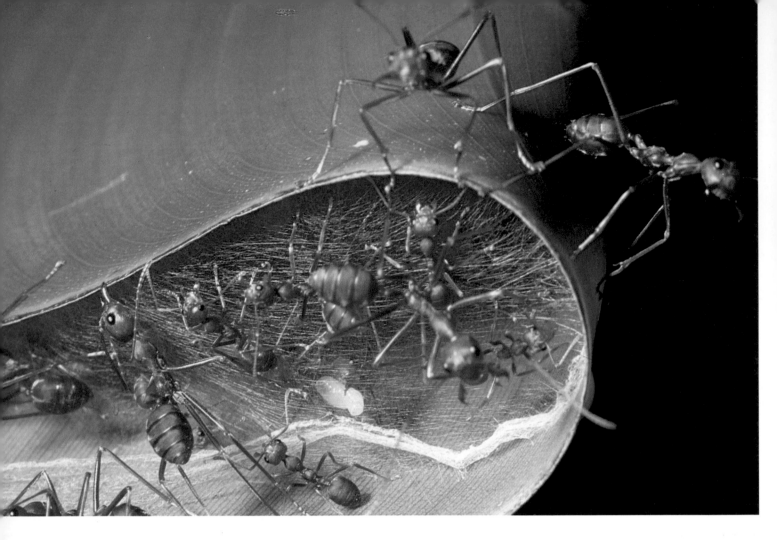

grub. The worker presses the mouth of its grub hard against one leaf. This compels the grub to secrete silk. All silk is secreted as a viscous liquid which sets hard almost immediately on exposure to the air, but which is sticky while it remains liquid. The silk is stuck to the first leaf and as the grub is carried across the gap to the next leaf the silk continues to emerge from it as a thread, which is stuck to the second leaf. The grub is then carried back and forth from one edge to the other, and its silk stitches the leaves together.

Of course, this is not the customary way for invertebrate animals to use their silk, although it has been turned to many uses, from traps to balloons. It is also used by the adults of some species to make sacs in which eggs are protected, and by many larval insects to make the cocoons in which they pupate. *Oecophylla* and *Polyrachis* ant larvae never make cocoons for themselves, probably because all of their silk is consumed in nest building and repair. *Campanotus* larvae do spin cocoons, but no one knows whether all of them do so or whether it is only those individuals which have not served as tools in nest building.

The weaver ants should really be called tailor ants, for their behaviour cannot truly be described as 'weaving'. As tailors they are not alone, for some birds make their nests in a rather similar fashion.

Despite its name, the long-billed spider-hunter (*Arachnothera robusta*) does not hunt spiders. It merely steals their webs, which it uses to supply the thread it needs when making its nest. The nest itself is a fairly conventional affair, made from coarse plant fibres somewhat tangled together and pressed into the desired shape. It is interesting because the bird builds it beneath a large leaf, from which it is suspended by a system of slings made from spider web. The nest is in the shape of a tunnel, wider at one end than at the other. The narrow entrance is close to the tip of the leaf; the wider, sealed end, containing the brood chamber, is opposite.

Oecophylla weaver ants at work. A leaf has been bent over and its edges are being sewn together using silk extruded from an ant larva.

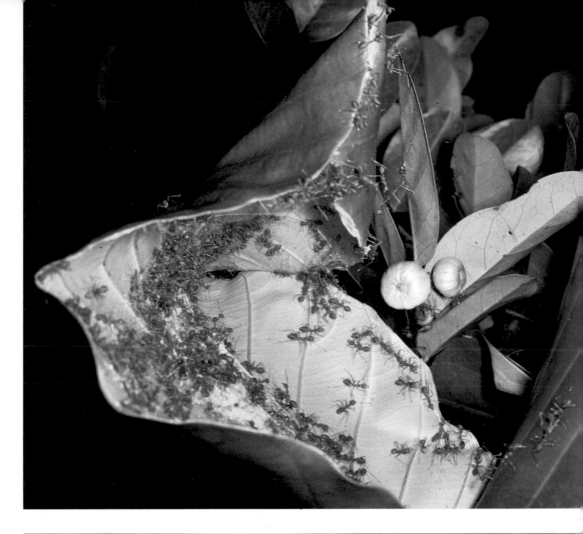

Weaver ants making a nest from a single leaf. The ants draw the edges together with their legs and mandibles.

When sewn together, these leaves (still attached to the branch) provide ample accommodation for a colony of modest size.

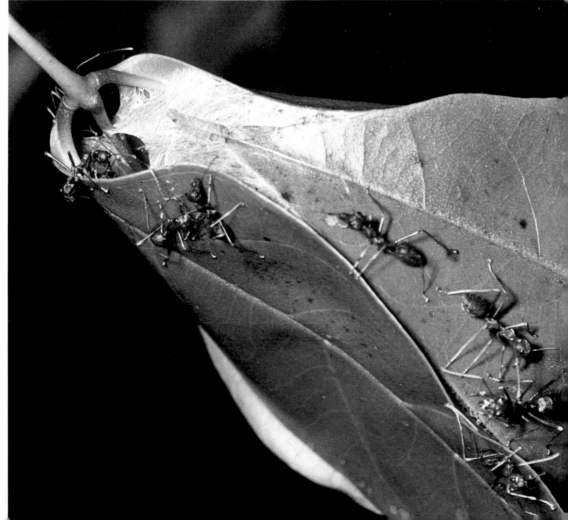

The nest seems to be built a section at a time. First the builder collects spider silk. It attaches this firmly to the leaf, possibly using its own saliva as a glue, by pricking it into the leaf on either side of the midrib and leaving the rest hanging down beneath the leaf. When a few such slings have been placed in position, the bird collects nesting material which it pushes in among the silk. When one section is completed the next is begun. The finished nest is about 45 cm (17 in) long, varying in width from about 10 cm (4 in) at the entrance to about 20 cm (8 in) at its other end.

The tailorbird (*Orthotomus sutorius*) is popular in southern Asia, partly because of its nesting technique and partly because it frequents hedges and gardens. In India it is one of the most common garden birds. Although it is so well known, its nests are not often seen because they are almost invisible deep within the densest vegetation. Even the bird may be familiar by name rather than by sight, for although it has no fear of humans it is small and rather nondescript as it moves about on and in the hedges. It is related to the thrushes and warblers. Like the weaver ants it uses living leaves, which remain attached to the plant. Usually a tailorbird uses only one leaf, but sometimes two will be joined together, and the nest is built inside a bag, or cradle, as a lining.

The leaf itself must be large. The bird uses thread made from cotton, bark fibres, or silk either from spider webs or from cocoons, and it will make use of any other suitable material it finds. It has been known to use string. The fibres are usually short and the tailorbird splices them together to make longer pieces.

Its sewing begins by making small holes with the sharp tip of its bill along the two leaf edges it plans to join. It sews, using its bill as a needle, and pushing the thread through hole after hole. When it reaches the end of a length of thread it may make a knot to prevent the end from slipping, although many of the fibres it uses have splayed ends that make this unnecessary because they can easily be spliced. It all sounds simpler and more elegant than it is, for while the bird takes only about four days to make its nest, this includes time wasted when threads break or the leaf tears, and work must begin all over again.

The nest proper, lined with cotton, wool, down and other fibrous materials, is made inside the cradle, but because the cradle is made from a living leaf, which remains in position, the nest is protected against the weather, rain running off it, and it is almost impossible to see.

There are other warblers and thrushes that will stitch leaves together occasionally, but that do not use sewing as a routine technique. The fantailed warbler (*Cisticola juncidis*) of the Mediterranean region is a shy bird whose nest lies hidden in dense undergrowth or among tall reeds or grasses. Its principal nesting material is grass, and sometimes it will use spider silk to stitch grass leaves together, through holes it has made with its bill.

The penduline tits, close relatives of the common European and North American titmice, make baskets so strong that in Africa the Masai people use the local brand as purses, and in parts of Europe children use them for slippers. Their disadvantage, so far as the birds are concerned, is that although the nests themselves are robust, they can be dislodged by strong winds and so lost. It takes these small birds three to four weeks to build a nest and so losses are expensive.

The male does most of the work, then courts a female who helps to complete the nest and who remains to incubate the eggs while her mate starts building again and seeks another mate. The technique is that of basket weaving, but even more sophisticated because the builder knots in short strands of fibre, rather as a carpet weaver might knot in the threads that form the pile.

The male begins by selecting the twigs to which the nest will be attached. In the

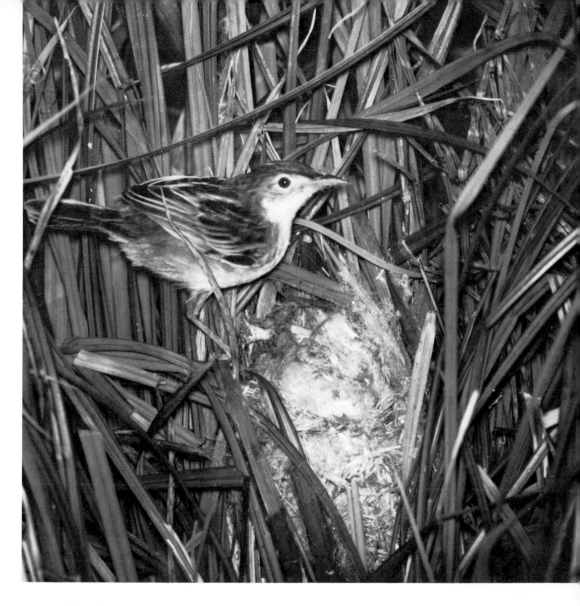

The Indian fan-tailed warbler (*Cisticola juncidis*) makes its nest in a tussock of grass, building it into the structure and using spider silk lined with down for the nest itself. The entrance is at the top.

case of *Remiz pendulinis*, the penduline tit of eastern Europe and Asia, these will usually be of willow, poplar or birch, they will not be far from water, and they will be from 1 to 10 m (3 to 33 ft) above the ground. The bird uses grasses and downy plant material, which he twists on to the end of the chosen twigs until he has made a hoop, from which the nest will hang. Then material is woven to make two strips that join at the bottom, so adding a kind of cradle to the 'handle'. Finally, the back is closed and then the front, except for the short entrance tube, which slopes downward and is added last.

The basic structure is made by weaving long fibres back and forth, the bird pushing the ends through the meshes with its bill, and then shorter fibres and downy plant material are pushed into the weaving, making the nest rather pale in colour, and thickly insulated. The female, who helps complete the building, then goes on to line the nest to her taste.

There are about ten Old World species of penduline tits, comprising the family Remizidae, and there is one that lives in the arid country of the south-western United States and Mexico. Although all the remizids use the same general method there are variations from one species to another, although almost no variation within any particular species.

The kapok tit (*Anthoscopus minutus*) of Namibia, whose name is derived from the supposed resemblance between its nest and the fruit and seed of the kapok tree, builds a nest with an entrance reduced to a small slit. Sometimes the departing bird will close up the entrance entirely, by pulling up a flap, hinged to the bottom of the

The penduline tit (*Remiz pendulinus*) begins its nest with a hoop, which is then strengthened at the bottom (*above*). When finished the nest contains many downy seeds, giving it a whitish, fluffy appearance (*right*). Work on the nest is completed by the addition of a short entrance tube.

opposite Tailorbirds, common in Indian gardens, make nests inside cases formed by sewing together living leaves. These chicks are of the species *Orthotomus sutorius*, found throughout India except in the harshest deserts.

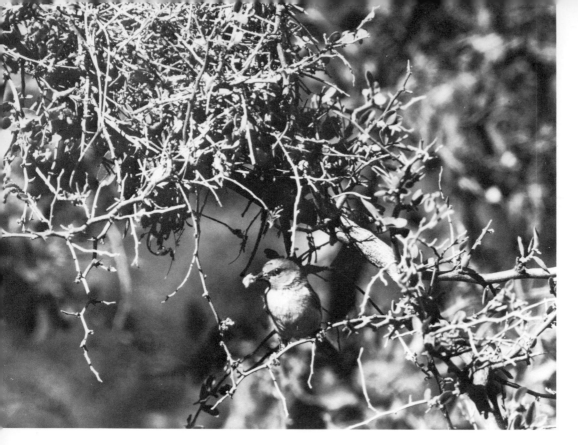

The American verdin builds its nest deep inside a thorn bush, and uses the bush itself in the construction. This bird is carrying material to the nest it is building at the top of the picture.

entrance, which lies inside the entrance tube pointing to the rear. Below this true entrance there is a much larger false entrance, which leads to a small, empty chamber. The purpose of this entrance is unknown. It has been suggested that it is meant to deceive predators, or that it is used by the bird for resting when it is no longer incubating eggs.

The American member of the group, the verdin (*Auriparus flaviceps*), is no more than 10 cm (4 in) from bill to tail and it builds a spherical nest about 20 cm (8 in) across. It uses thorny material obtained from the semi-desert scrub in which it lives, and lines its nest first with a layer of grass and then with down, so that the occupants are protected from the thorns. The thorns themselves protect the nest from predators, for the method of construction leaves them projecting from the outside of the nest in all directions, resembling a kind of super-hedgehog. For further protection the verdin builds its nest right in the middle of a thorn bush.

These birds weave, but the most expert of all are the weaverbirds. There are almost a hundred species of them living in Africa and Asia. Grouped together as the family Ploceidae, with several subfamilies, they are related more distantly to the familiar sparrows, which also weave their nests in a rather chaotic way. The largest of the weaverbirds is about the size of a starling, but the majority are smaller. The most familiar of the African species is the common village weaverbird (*Ploceus cucullatus*), which nests near to buildings and so has been observed closely, and which can be kept in captivity, where it will continue to build nests as it would in the wild.

The weaverbirds prefer green as a colour for nesting material. By selecting green they are more likely to obtain vegetation that is fresh and pliable, and if they are offered strips of flexible plastic in different colours they will use the green first. In the wild they use grass or palm fronds, if necessary torn into strips of a convenient width.

The nest is built by the male, who begins at a forked twig, where he perches while he works with the first strip, which is doubled back on itself. Half of the strip is wound round and round the twig and then from the twig to the other half of the strip. He continues to perch in the same place, holding the loose end of the strip

Ploceus velatus, the masked weaver, builds a very elaborate nest. This bird has just started work around a forked twig (*below*). The weaverbirds start by making a framework on two or more twigs, then weaving on to the frame (*bottom*). This is a golden palm weaver (*Ploceus boyeri*) at work.

Male and female weaverbirds work on the nest together (*below right*), but the red-headed weaver (*Malmibus rubriceps*) departs from custom by using only twigs, detached from the tree and fastened together by their bark, a little of which is stripped back from each twig.

with his feet while he weaves the other end in and out using his bill. Because of the position he adopts, his weaving changes direction frequently, and because he is holding with his feet the strip he is attaching to the twig, he ends by making a loop. Working down both twigs of the fork in the same way, the loop is closed and when it has been closed at the top it becomes a full hoop. From this point the bird uses the hoop as its perch.

The twigs it has chosen will have been projecting downward, at an angle of about thirty degrees from the vertical, with the fork at the top so the hoop will be inclined at a similar angle. This is important to the bird, because now it will perch so that the hoop tilts towards it, and it will weave outward in front of itself, starting at the top. If someone bends the twigs and fastens them so they tilt in the other direction, the bird will move to the other side and work from there. As it works, and the work proceeds in definite stages, the weaverbird makes true knots. In the first stage the strip that binds the hoop to the twigs is knotted, ends being passed through loops and pulled tight. In the second stage, where the hoop is strengthened and extended to provide the base of the nest itself, strips of material are twined by being pushed through the existing material, back and forth as in sewing, leaving secure loops to which warp strips can be attached in the third stage. In this, and in the subsequent stages, the nest is woven, strips being formed into interlocking loops. As the nest grows, the bird shapes it, using its head and body to push it into position.

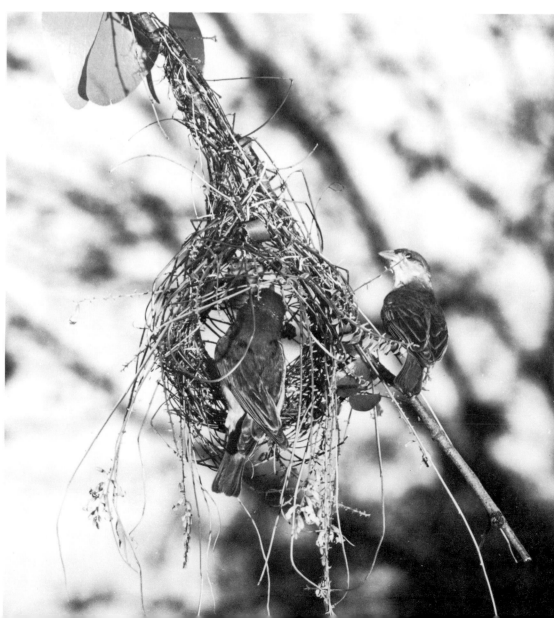

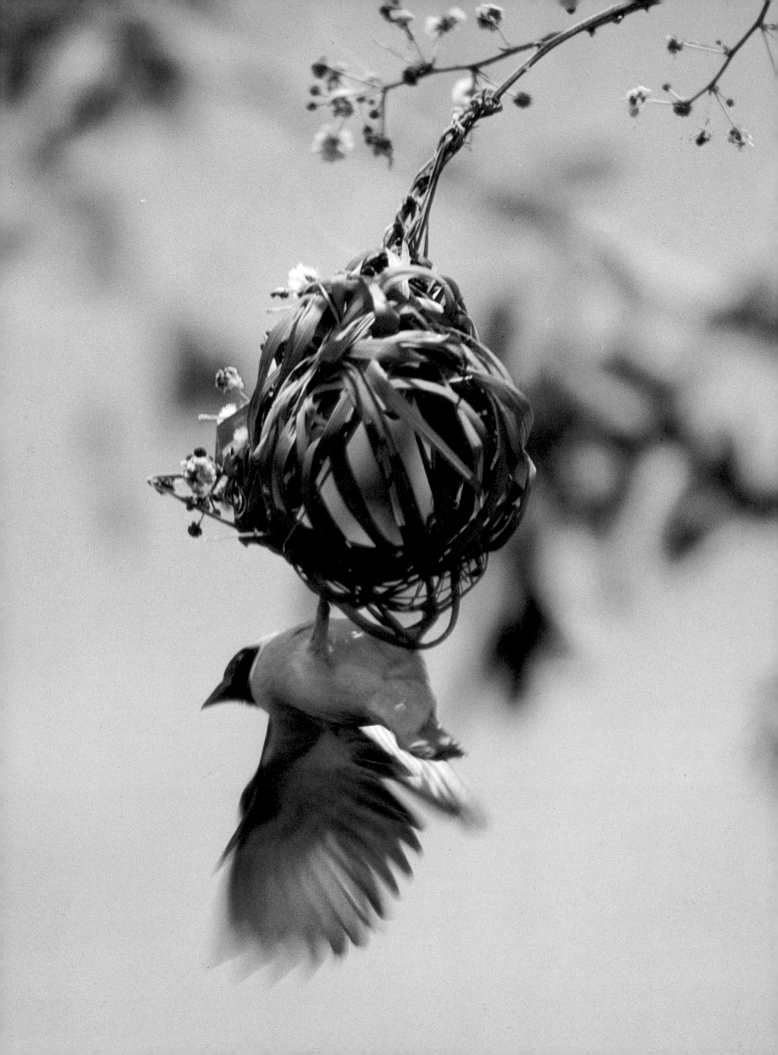

opposite A male vitelline masked weaver (*Ploceus vitellinus*) displays in order to attract a female to inspect his partly finished nest and, if the work is satisfactory, to help complete it.

right Many weaverbird nests have a long entrance tube pointing downwards. This nest belongs to a pair of black-necked weavers (*Hyphan turgus nigricollis*).

below Nests may be built on any suitable structure, and often in groups. These nests of the Cape weaver (*Ploceus capensis*) hang from a tree over a river.

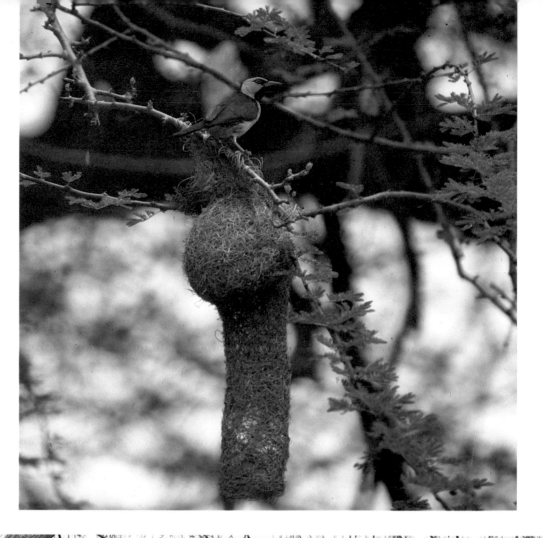

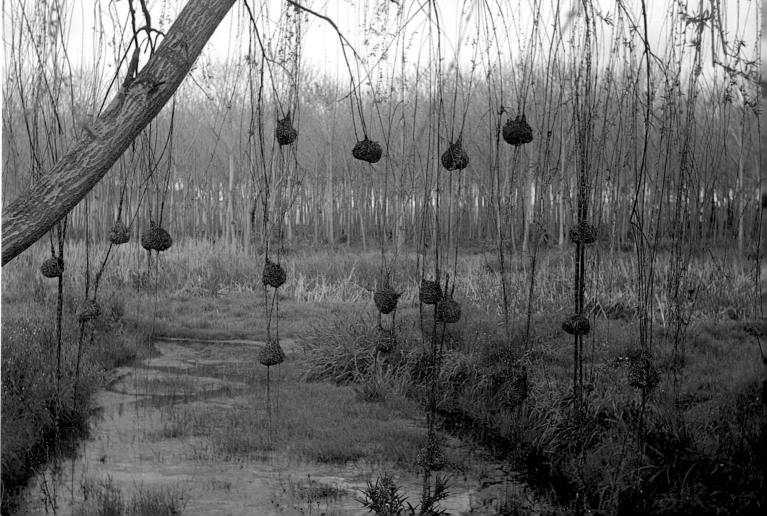

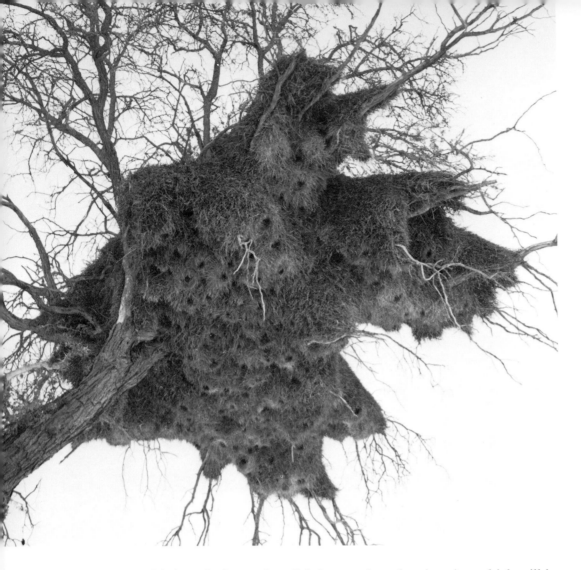

Sociable weavers construct individual nests sharing a common roof. As nests are added each year the 'estate' grows larger and larger.

The weaverbird works forward until it has made a closed cavity, which will be the brood chamber. Perched on the bottom of the open edge, it works towards itself, making a second and smaller chamber that curves over itself and ends with a small entrance pointing downwards. The smaller compartment forms an antechamber.

At this stage, the nest more or less finished, the male will hang upside-down at the entrance, flap his wings, and utter a special call. This may or may not attract a female. If he does catch the eye and ear of a prospective mate, she will call and inspect his nest. If she is satisfied with his work she will line the nest, the two will mate, she will incubate her eggs in the nest, and the male will leave immediately after mating and start building a new nest, to which in due course he will seek to attract a new mate.

If he is unsuccessful and attracts no female, or no female that is prepared to put up with his standard of work, the nest will begin to deteriorate. The green strips will dry and turn brown, and before long the nest will have no chance of finding favour with even the least houseproud of females. At this point there is only one thing to do. The male demolishes his nest completely, and starts all over again.

Male weaverbirds begin nesting while they are still fledglings and long before they are sexually mature. At this early age their nests are crude, but they improve with practice. Although the birds receive no instruction in nest-weaving, in some sense they learn by experience, at least to the extent of developing the dexterity and coordination needed to weave a good nest, and with which they are born.

Different species of weaverbirds have their own styles, which vary a little from one to another. Some, like the quelea, or dioch (*Quelea quelea*), produce a spherical shape with a horizontal entrance near the top. Others build ovoid nests with tunnel

entrances that point downwards. The most skilled of these, and perhaps the most skilled of all the weaverbirds, is Cassin's weaver (*Malimbus cassini*), which lives in the central African rainforests. Its entrance tube may be 60 cm (23 in) long and is made very neatly from finely woven fibres. No one is certain of its purpose, but it may afford protection against tree snakes, which have a partiality for eggs and young birds. The red-headed weaver (*Malimbus rubriceps*) uses twigs, which it fastens to one another by knotting strips of bark peeled back from them.

Like their cousins the sparrows, weaverbirds are fairly social and their nests are not found singly but in colonies. Indeed, since the way in which the male seeks to attract females is a type of lek behaviour, developed still further among the bowerbirds described in 'Interior Decorators', sexual selection would not work unless the nests were grouped together and females could move among them to choose the ones they preferred. A lek is a territory which a male occupies and into which he seeks to attract females for mating. The females move between the leks, observing the displays of the males, and mate with the males they find most attractive.

The sociable weavers (*Philetairus socius*) have taken their propensity for sociability to its logical conclusion. In the arid lands of Namibia, where it may be that shortage of suitable trees encouraged the birds to congregate, they build communal nests, in concept not unlike the long-houses built by some Indonesian and Amerindian humans.

They prefer camel-thorn acacia trees, and the birds collaborate to build the roof. This is dome-shaped and constructed from straw, grasses, thin twigs and such other fibres as the birds may find; completed, it may measure 7 m (23 ft) or more from one side to the other. When the roof is finished the birds separate to build their individual nests below it, with entrances pointing downwards. Commonly there may be some thirty of these nests, representing sixty adult birds, but more than a hundred flight holes have been counted in some nest colonies. It is said to be the most spectacular of all bird nests.

The sociable weavers live in their nests all year round. During the breeding season, which occurs during the rains, all the nests are occupied by couples or family groups. Since the nests are used year after year, males do not use their building skills as a means of attracting females and it seems likely that the birds are monogamous, possibly mating for life. For the rest of the year the birds share nests, sleeping several to a chamber, and many of the nests remain vacant.

This behaviour provides an important clue to the value of communal nesting. Winters in Namibia can be cold, and by huddling together near the centre of a large nest mass, which provides insulation, the birds are able to maintain a fairly constant and comfortable temperature.

The nest is not threatened seriously by predators, but after many years of use, which involves adding more nests and more material to repair earlier nests and the roof, it is not unknown for the weight of the nest to break the branches that support it, and for the entire structure to fall from its tree.

Vacant nests within the colony may be taken over by small parrots, or other small birds, which exist there as squatters and are ignored by the weavers. Such behaviour is common, and many birds will nest alongside birds of a different species, even to the point of building their own nests at the edges of the nest of a much larger bird. Although the different species have no direct contact, in some cases advantages are conferred. A small bird may be protected by the presence of a large bird next door, for example. In the case of the tenants of the weaver nest, however, the advantages appear to be one-sided, and most probably the weavers tolerate an unprofitable relationship which they cannot prevent.

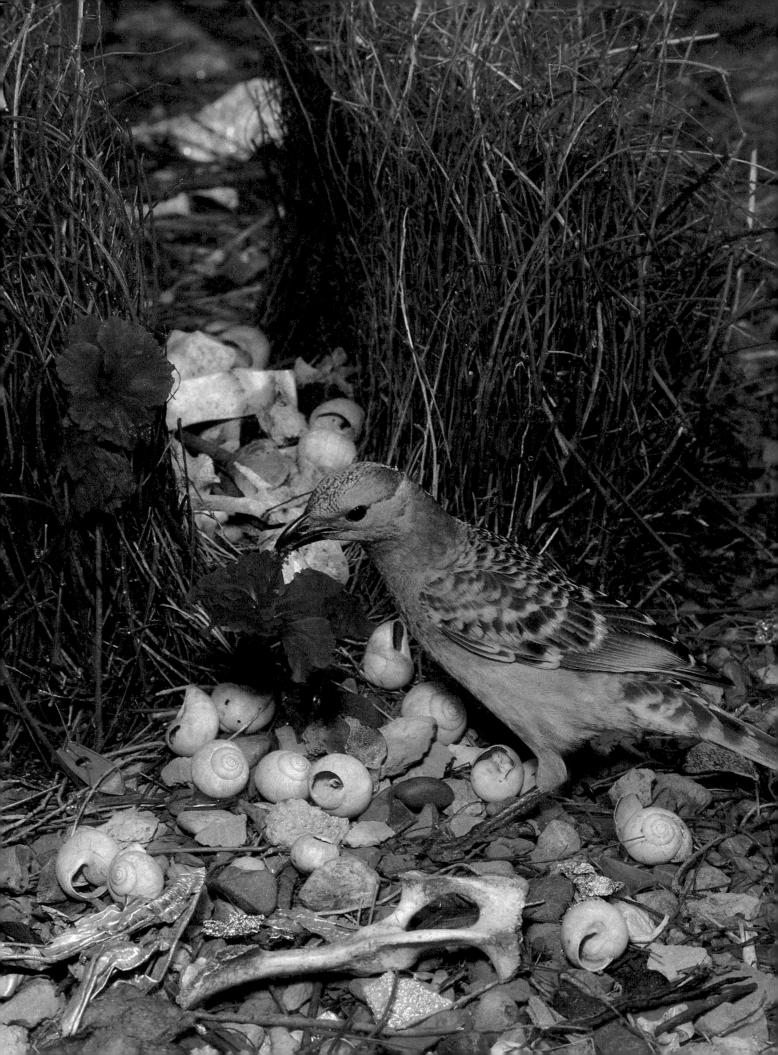

Interior Decorators

THERE are many species of bird in whose courtship the male seeks to entice females by displays of one kind or another. The weaverbirds display their nests, the females choosing the builder of the best one. Other birds use the fine plumage of the male, often displayed in a ritual dance, as among the game birds, for example, and the familiar peafowl. It is among the exotic birds of paradise that the display of male plumage reaches its most acrobatic and the plumage itself is most splendid.

The bowerbirds of Australia and New Guinea are close relatives of the birds of paradise and their males are only a little less handsome, but their courtship ritual is perhaps the most extraordinary in the whole of the animal kingdom. The males build bowers that surround or form the backdrop to a stage on which they perform their courtship dances. The bowers are not nests in the usual sense. The nests are built by the females, after mating, and they are humdrum affairs situated in trees. The courtship bower is always on the forest floor.

There are ten species belonging to the bowerbird family (Ptilonorhynchidae) that live in New Guinea and about seven more in Australia. The birds themselves are some 20 to 35 cm (8 to 14 in) long, the females are drably coloured, and not all bowerbirds make bowers, any more than all ovenbirds build ovens. The Australian regent bowerbird (*Sericulus chrysocephalus*), for example, builds a bower only occasionally – but its black and orange plumage makes it the most handsome of all Australian birds and perhaps it has no need for further embellishment.

opposite The bowerbird's courtship performance is one of the most extraordinary in the animal world. The male builds a bower leading to a stage on which the courtship dance takes place. The structure and decoration varies with each species. Here the great bowerbird uses the bones of small animals and brightly coloured flowers.

right The satin bowerbird decorates its bower with blue beetles, shells, and other objects.

The gardener bowerbird (*Amblyornis inornatus*) is more drab and it does build a bower. It lives in the montane forests of New Guinea, and its construction technique is elaborate. The centre of its bower is a young sapling, which provides support for a robust roof made from woven stems, usually of orchids, that forms a dome reaching to the ground everywhere except at the front, which remains open. The sapling thus becomes a central column, and there is an opening to either side of it leading to a chamber at the rear. The bird presses pieces of moss firmly against the column and decorates these with brightly coloured beetles, shell fragments and flowers. One gardener bird that was observed placed a vertical row of yellow flowers down the centre of the column, bright blue beetles to one side of the flowers and fragments of snail shell to the other side. In front of the entrance a more or less semicircular area is cleared, carpeted with moss, and its boundary marked by a row of bright berries, or flowers. The vegetable matter is replaced by the bird as it fades. Its 'hut', about 1 m (3 ft) in diameter, is rainproof and well able to withstand most of what the tropical climate can do to it.

Macgregor's gardener bower-bird, of Papua, builds a 'maypole' – a decorated column surrounded by a dancing floor, with a parapet of moss around its edge.

The satin bowerbird (*Ptilonorhynchus violaceus*) is the best known member of the family, for it is abundant in the forests of eastern Australia. Females and young birds of both sexes are an olive colour and males may begin to display and to build bowers while still in their juvenile plumage. Usually in their fourth year they acquire the lustrous dark blue or black plumage of the adult male.

Construction duly begins with the selection and clearing of the site about 1 m square. This is on the forest floor, in a place that is not too shaded. The bower itself begins as a double line of sticks, about 25 cm (10 in) long, forming an avenue. At the end which receives most sunlight the bird makes his dancing stage by carpeting an area with grass and twigs. This done, the decoration can begin.

The inside of the walls of the avenue is painted with the blue juice of berries: sometimes the bird will pick up a piece of bark at the same time as it picks up a berry, crush both in its bill, and then use the bark, soaked in juice, like a paint brush. The bower and the stage are decorated with flowers, shells, beetles and any bright objects the bird can find, but for preference most of them will be blue. Probably this is because blue shows off its own plumage to the best advantage, for juvenile birds prefer greens and yellows, as do females, which in this species also build bowers which they use for play.

It takes the bird only a few days to build its bower, but repair and maintenance occupy much of its time over the weeks during which it is in use. Flowers wilt, fruit rots, and both must be replaced. The rains wash the paint from the walls, and this must be renewed. What is worse, decorative items are stolen from an unguarded bower by neighbours, and they must be replaced, also by larceny. An ornithologist once measured the extent of the thieving among satin bowerbirds by placing a number of marked pieces of blue glass where the birds would find them. Before long the pieces had been taken and he found them in bowers nearby. After that the pieces migrated repeatedly from bower to bower.

Once the male has attracted the female he may be quite possessive about her. When a female was seen to leave the bower of her mate and enter the bower of a nearby juvenile male, the mate destroyed the bower of his rival and carried away its contents to decorate his own, an act of vandalism that was not resisted by the younger, less senior bird.

The Lauterbach bowerbird (*Chlamydera lauterbachi*) varies the pattern of the satin bowerbird by adding to the basic avenue of parallel rows of sticks two more rows that seal the ends and convert the avenue into an enclosed rectangle. The great grey bowerbird (*Chlamydera nuchalis*) joins the twigs of its avenue at the top, so that they form a true bower with an arched roof. Bowers may be quite large: that of the

great grey bowerbird is about 1 m (3 ft) long and up to 0.5 m (1½ ft) high, but bowers have been known that were almost 2.5 m metres (8 ft) high, with a platform on top which formed the dancing stage.

Just as the style of construction varies from species to species, so does the choice of objects with which the bowers are decorated. The satin bowerbird prefers objects that are blue, at least the adult males do. The great grey bowerbird prefers yellow and white. The gardener prefers blue, yellow and red. The 'sepulchre bird', or spotted bowerbird (*Chlamydera maculata*), collects the bleached bones of small mammals. One such bird was found to have assembled more than 1,300 bones. The sepulchre bird, like the satin bowerbird, paints the inside of its avenue using charcoal or plant material, which it crushes in its bill and mixes with saliva to make a paste. Decorative objects are chosen, it seems, on the basis of their size and colour, and clearly they must be small enough for the bird to remove them. This leaves plenty of scope. There are stories of bowerbirds taking car keys, coins, tin mugs and even, so it is said, the glass eye of a man who kept it in a cup while he slept.

Whatever their technique, and whatever their choice of colour, the courtship ritual is fairly standard. With the bower complete the male begins to call for females. Bowerbirds do not have what we would consider an attractive song, but it is loud, and the birds are talented mimics, so it is highly variable. Indeed it is likely that much of the bowerbird song is imitated from the songs of other species. No one knows why birds imitate other birds, but they do, and have also been known to include in their songs the barking of dogs and fragments of tunes.

When a female approaches, the male runs back and forth inside his stage, picking up first one of his treasures and then another, offering them to the female. The

A great grey bowerbird displays on his lek, showing the pink crest on the nape of his neck.

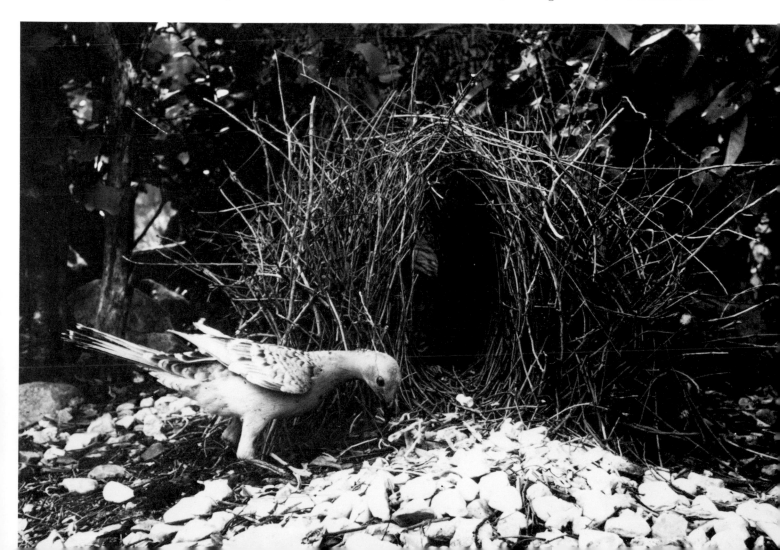

A satin bowerbird with his partly built bower consisting at this stage of an avenue of twigs (*below*). He displays to a female by strutting around his bower (*bottom*).

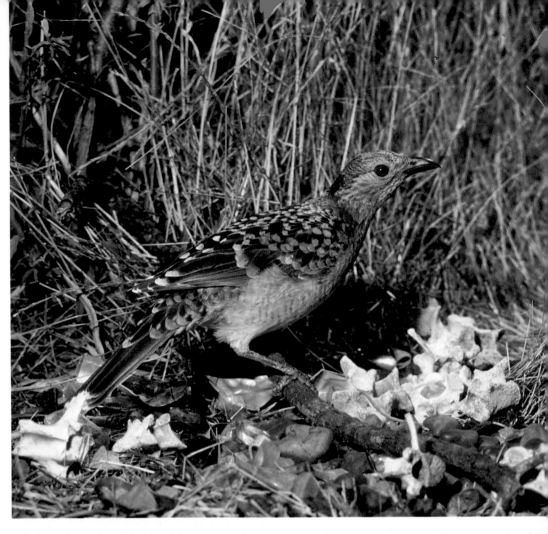

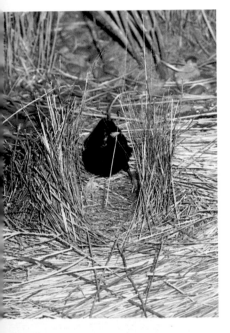

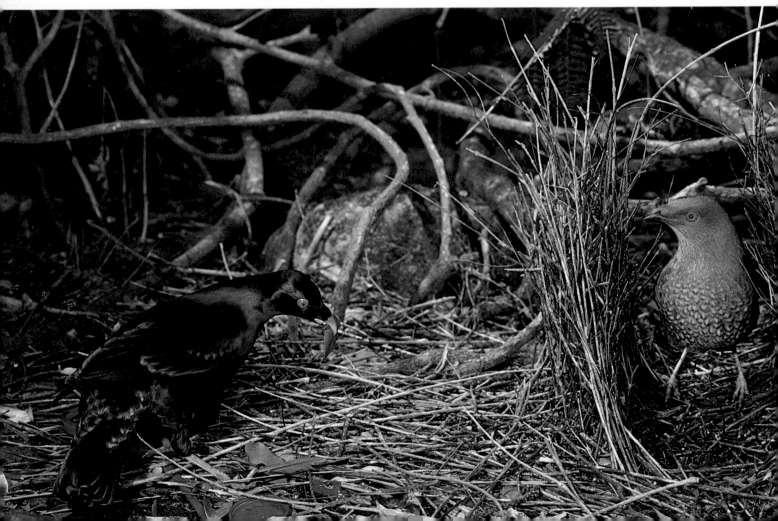

opposite The spotted, or 'sepulchre' bowerbird uses the bleached bones of small animals for decoration.

right A golden bowerbird (*Prionodura newtoniana*) at work on his bower, a conical hut around a column.

female appears to find the bower itself and this behaviour strongly attractive, but there is no question of the proffering of gifts having any connection with food. Even when the items themselves might be edible, they are never eaten. The climax of the display comes with the male revealing such plumage as he possesses, often quite suddenly. If the female succumbs to his blandishment she will enter the bower where, in many species, mating takes place.

Once the mating season ends the birds lose all interest in their bowers, which have served their purpose, and it is hardly surprising that when bowers were first seen by Europeans they mistook them for shelters made by children in their play. We can see why children might build such structures, but why should birds?

The area around the bower is part of what is known technically as a 'lek', a small territory that is defended by a male and into which females are enticed for mating.

That is its only purpose and it is quite distinct from the kind of territory that many species defend and within which they find food and secure shelter. The lek exists only for courtship, and most birds that select mates by means of a courtship ritual do so within a lek.

Obviously, the males are competing among themselves for females and part of the secret of success for a male is to have a lek past which most females must go as they move from male to male making their choice. This leads to the concentration of all the leks in the smallest possible overall area, and the same area is often used year after year by the local bird population. The best leks, and so those occupied by the dominant males, are close to the centre, where they receive the largest number of female visitors. Subordinate males establish leks further and further from the centre according to their status in the hierarchy, and females seem reluctant to mate at all with a male whose lek is isolated from those of his fellows. Clearly he is likely to make an unsuitable father. As old birds grow weaker they are displaced by stronger rivals, and as birds die those below them in the hierarchy compete for their leks.

In most cases, however, a lek need consist of no more than a suitable space. The bowerbirds take the behaviour much further, and at some cost to themselves. A bird that devotes so much of its time to building, defending and maintaining a bower has that much less time to devote to feeding. While this is not really important, since the males suffer no evident ill effect from their activity, it is difficult to see how it can contribute to their survival. After all, the male that inherits the ability to construct the most splendid bower does not, as a result, father the biggest or strongest progeny.

There is no real answer to the question, but there are theories. Suppose that among a particular species the females find certain male traits sexually attractive. In the case of bowerbirds, let us suppose that this trait involves the offering of gifts within a lek. A male which does not behave in the approved fashion is unlikely to find mates for the simple reason that a female who mated with him would place her own male offspring at a disadvantage were they to inherit their father's aberrant behaviour. They would not offer gifts, and so although their mother may have found their father attractive despite this failing, it is unlikely that other females would be so tolerant. Were they to do so, a situation might develop in which one group of females inherited an outlook that caused them to find attractive males that did not offer gifts, and a group of males existed to please them, while a second group of females preferred the gift donors, and a group of males existed to please them. The two groups would interbreed rarely, if at all, because a member of one group would not attract members of the other. In time, over many generations, it is likely that the separate groups, reproductively isolated by their behaviour, would become distinct species.

In either case the acquisition of mates depends strongly on conformity to the general form of behaviour. That being so, and all the males conforming, the problem emerges again because the females must still choose. In some species the males fight, although the fight is usually ritualized and no injuries are inflicted, but among the bowerbirds it is the building and stocking of bowers that forms the basis for selection, and the male with the best bower will be the most successful. Since many of the details of his technique, as well as its general framework, are likely to be inherited, his male progeny may be good bower builders like their father, and the females will continue to prefer the best builder. So, over generations, bowers will tend to become more elaborate in ways that females find attractive. Not only does this encourage conformity, it also allows individuals to learn, to improve their technique by observation of their rivals and, of course, to improve their bowers by

Berries woven into the bower of the fawn-breasted bowerbird.

The avenue-bower of the fawn-breasted bowerbird, who displays with berries in his beak.

means of theft. It is a runaway form of sexual selection that is favoured by building bowers.

No one is sure why the females choose the most splendid bower, but it may have some relevance to survival. The male which spends most time working on its bower demonstrates in a convincing fashion that it can thrive while devoting correspondingly less time to the business of finding food or avoiding predators. It is showing not only that it is better than other birds at building, but that it is better at securing the necessities of life. Its progeny, the message suggests, will inherit a superior building capability that will be associated with a superior ability to find food while avoiding becoming food for others. The female is making a genuine selection of the best male from those on display.

So the bowerbirds continue to build their bowers and to use them for just the same purpose as humans might, and each species produces slightly different work. One gardener (*Amblyornis subalaris*) makes a little stockade around the edge of its stage, while another (*A. inornatus*) makes a garden of mosses, flowers and berries, and a third (*A. macgregoriae*) outlines its stage with a moss parapet, but builds no hut, only a decorated column with twigs sticking out from it in all directions at the centre of its circular area. The golden bowerbird (*Priondura newtoniana*) builds a hut around a column, but its hut is conical in shape. The great grey bowerbird (*Chlamydera nuchalis*) displays a pink crest on its neck in the course of its dance, while the fawn-breasted bowerbird (*C. cerviniventris*), which has no crest but may be descended from a crested ancestor, uses a similar display, but with a red berry held in its bill.

The behaviour that produces the bowers may be ritualized, its purpose purely the propagation of the species, but the bowers themselves are artefacts of great beauty.

Animal Metropolis

EVERYONE can recognize a bumble bee. Most people can recognize a honeybee, although at a quick glance there is a risk it may be mistaken for a wasp. For most of us that completes our listing of the bees, and our knowledge of their way of life extends no further: bumble bees are solitary and live alone, whereas honeybees are social and live in hives.

In fact there are about 20,000 distinct species of bees throughout the world. The smallest of them measures a mere two millimetres (about one-sixteenth of an inch) in length. The largest is about three centimetres ($1\frac{1}{4}$ in) long. The great majority of the bees are solitary, but both the true bumble bee and the honeybee are social. However, not all bumble bees are what they seem, for some are actually cuckoo bees, and live as brood parasites.

There are several species of bumble bee, often distinguished by the colour of the last segment of their abdomens, as 'red-tailed', 'buff-tailed', or by some other colour, but all of them live in much the same way. Bumble bees appear first in the early spring, and can be seen flying in an apparently leisurely fashion, with pauses to rest between flights. These early bees are the queens – the egg-laying females – which have spent the winter in hibernation. As their year begins they have two requirements: nesting sites and food. Like all bees they feed only on pollen and nectar which they obtain from flowers, but they must find enough food not only for themselves, but for their first broods of larvae. Probably they will not lay eggs until food becomes plentiful.

They nest in holes, often vacated by mice or voles, although they will nest on the surface if no suitable hole is available. The nest is made from grass or other plant material worked into a tight ball. Inside the nest, the queen makes a cake of 'bee bread', from nectar and pollen she has collected, and when the food is ready she lays up to twelve eggs on it. Then she seals both eggs and 'bread' inside a wax container, shaped like a pot. Close by she makes a further container which she fills with honey as an emergency food store for use in bad weather. After that she remains with the eggs, sitting on them to keep them warm, until they hatch. The larvae feed first on the 'bee bread', which they find the moment they emerge, but once that is gone the queen feeds them on honey which she makes herself, and, if necessary, on the honey from the emergency store. Eventually the larvae complete their growth and pupate, and the first task of the year is completed.

The bees that emerge from pupation are infertile females and much smaller than their mother because of the diet they have been fed in infancy, and their main role in adult life is to tend further batches of young. The queen continues to make wax

opposite Worker honeybees on the comb containing their brood.

below The nest of a bumble bee, built in a deserted mouse nest.

cells containing eggs and 'bee bread', but she does not remain to tend the larvae. Each generation of bees appears quickly, so that in a year there can be many generations. The eggs hatch after about five days, growth is rapid, and the new adults emerge within about two weeks of hatching. The infertile females die after a few weeks and, as generation succeeds generation, the workers become larger owing to better nutrition in infancy, for they are fed by their older sisters who spend much time foraging on their behalf.

In autumn, fertile males and females are produced. They mate and the new queens fly away to seek a hole in which to hibernate, while all the other bees die. The social organization is complex, the nest an institution that is well managed for the raising of young, but at the peak of its production a bumble bee nest is unlikely to house more than about a hundred insects.

The cuckoo bees, of which there are very many species in the world as a whole, specialize in the bees they exploit and often resemble them closely, which is why it can be difficult to distinguish between the bumble bee and the cuckoo bee. The females can be recognized by the hairiness of their abdomens. The abdomen of a bumble bee is concealed entirely by hair, but that of a cuckoo bee is more sparsely covered and the chitinous plates of the exoskeleton can be seen. The female cuckoo bee emerges from hibernation several weeks later than the bumble bee, by which time the first bumble bee workers are tending the new larvae.

The cuckoo bee enters the bumble bee nest. If the workers try to resist her she kills them. They are small and their stings cannot penetrate her skin, and before long they come to tolerate her. She lays her own eggs, which are tended by the bumble bee workers, and from this point fewer and fewer bumble bee eggs are reared. Sometimes the cuckoo bee kills the bumble bee queen, sometimes she eats the bumble bee eggs, and in one way or the other the cuckoo bees take over the nest completely.

While a bumble bee colony may consist of about a hundred individuals a honeybee colony consists of from 40–80,000, and while a bumble bee nest lasts for only one season, a beehive may last for several years, with many individuals surviving the winter.

Clearly, the hive of the honeybee, accommodating as many insects as a fair-sized town accommodates people, requires sophisticated organization, based on the cooperation of its members – a subject to which we will return in 'Teamsters'. The business of the hive is the feeding and sheltering of its inhabitants and the raising of new generations. Since a worker is likely to live for no more than an average of six weeks, unless she emerges late in the year and overwinters, the continuance of the colony requires a constant stream of new recruits.

The hive itself is built inside some natural hollow, often a hollow tree, and so its outer walls are supplied at the start. They may require patching, however, to keep out draughts, and such repair work provides much employment, especially in autumn when cold draughts become more noticeable and the other activities of the hive are less urgent.

The process begins with the finding of a site for the hive. Because the hive is contained within fixed walls, new hives must be made when old ones become overcrowded, and it is crowding that stimulates swarming. Incidentally, this periodical division of colonies also increases the likelihood that a particular colony, or more specifically the genes of the family represented by that colony, will survive. Bees are no less vulnerable to disease and natural disaster than other animals, and hives can be and are destroyed.

The swarming bees gather, often on the bough of a tree, clinging to one another with their queen at the centre, while scouts fly off in all directions in search of a

A bumble bee colony in mid-season, showing wax cells at varying stages and workers in attendance.

suitable home. When one is found the scout informs the swarm of its direction and distance, and the bees move to it at once. They must work quickly, because they can carry with them only as much food as their own stomachs will hold, and before they can start collecting, storing and feeding themselves, adequate accommodation must be provided and the queen must begin laying.

They build principally with wax, which is produced by glands on the underside of four segments of the abdomen of each worker and is secreted into 'wax pockets' between the segments, from where it is extracted as small flakes. They also use propilis – 'bee glue' – which is a resin they do not produce for themselves, but collect from sticky buds and other plant sources. The propilis is used as a glue, sometimes mixed with wax, and it helps to seal cracks and to cement together the internal structure which consists of the combs, made from wax and mounted vertically, their plane aligned with the earth's magnetic field. Each comb is a single wall with cells built on to either side.

The cells themselves are almost perfectly hexagonal. The shape has not evolved without good reason. In building the cells, two requirements must be satisfied. The space available must be enclosed using the smallest amount of building material yet providing the barest minimum of space to each cell so that the number of cells may be maximized. At the same time the completed structure must be strong enough to

When it is time to move, the honeybee queen waits, often on the branch of a tree, surrounded by the swarm of her workers, while scouts locate a suitable new nesting site. The operation must be conducted swiftly, for the bees have no food other than that in their crops.

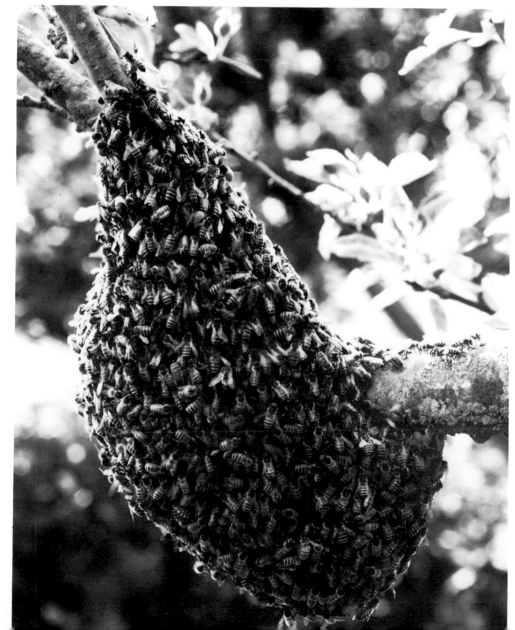

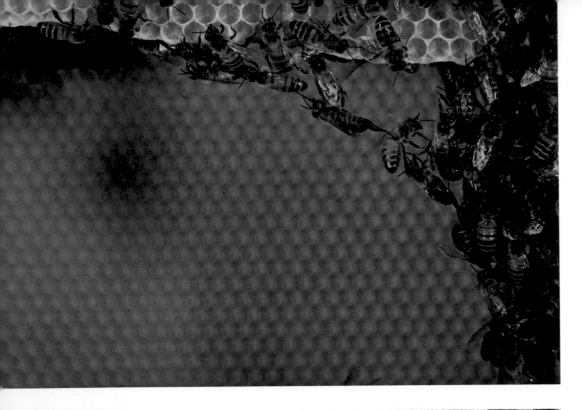

While building the comb the bees each work for a short period before being relieved. The work is highly coordinated, and each bee performs its task precisely and without instruction.

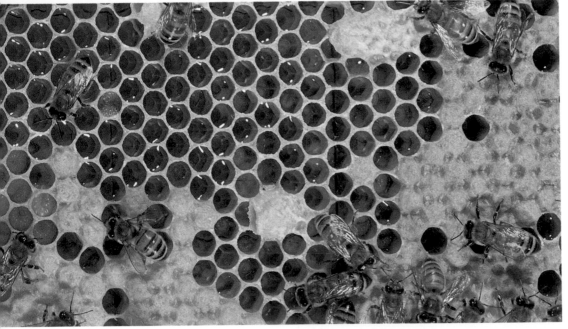

Worker cells are all of the same size and constructed in a way that uses the minimum of wax. Queen cells (here there are three) are much larger.

bear the weight of a considerable quantity of honey. The hexagon is the only geometrical shape that satisfies both. Because they work with wax, the bees must maintain a temperature at the 'building site' of 35°C (95°F), which is usually much higher than the ordinary air temperature. Below this temperature the wax is not secreted and existing, old wax becomes too hard to work. If the temperature rises much above this level the bees themselves succumb to heatstroke.

They link their bodies first to form chains and then a solid mass, while the work proceeds below in the warmth generated by the many bodies. The cells do not project from the base wall horizontally, which would make it impossible to fill them with honey, but at an upward angle. Usually work begins at the top, in two or three places at once, each bee working for no more than about half a minute before retiring and being replaced by a colleague who continues from exactly the point her predecessor had reached, the cells taking shape in small complete groups,

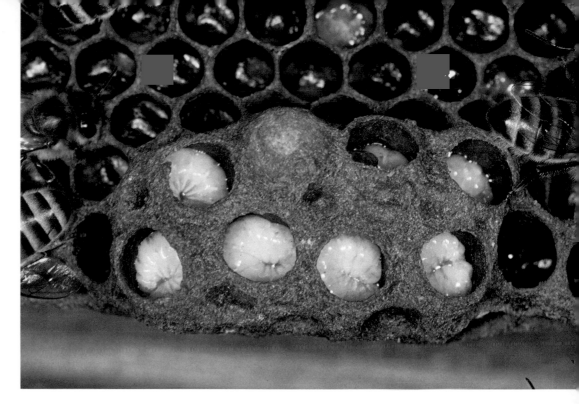

Cells for drones (sexually active males) are a little different, being slightly larger than those for workers.

sharing walls. The thickness of walls and the dimension of cells are maintained with a high degree of precision, but the cells are of two types, one for workers and a smaller number of larger cells for drones, the sexually active males.

The division of labour within a beehive is not precise. The workers labour, but each individual may perform any of the tasks, often specializing in different activities at different ages. The drones are not equipped to collect food and are fed by the workers, spending most of their time in idleness, except on warm, sunny days when they may venture out on orienting flights. They fly strongly and probably travel several miles. If they encounter a queen on a nuptial flight they will mate with her, and for them mating is a terminal activity, for their sexual organs are torn from their bodies and retained by the queen, a mutilation they do not survive. The drones cannot sting – in any case, the sting is a modified ovipositor – and only if the hive has no queen are drones allowed to survive the winter or a period of food shortage. The workers will drive the males from the hive rather than waste scarce resources on them. After all, they can adjust the feeding of the larvae and make more males at any time.

Because we use the word 'queen' for the member of the colony with the largest body, we tend to assume that bees are governed by some kind of monarchy. It is certain that the hive could not function for long without a queen, but power does not reside in her. Her function is to mate and lay eggs. When she reaches an age of two or three years – she is capable of living for about five – and her egg production decreases, the workers kill her and make a new queen for themselves. The power is held by the workers, not by any individual worker or particular group of workers, but by all the workers together, living in perfect agreement about what needs to be done and how it should be carried out.

There are social species in all three groups of hymenopterans – the ants, bees and wasps. Perhaps it is our familiarity with the honeybee which leads us to suppose that by and large bees are social and wasps are not. This is quite untrue. The real difference between bees and wasps derives from their manner of feeding, not from their social habits, and as many wasps are social as bees. They do not produce wax, however, and wasp nests are made from paper.

The paper is made by the females, who scrape small fragments of wood from exposed wooden surfaces with their mandibles, and then mix the wood with saliva

to form pellets which are drawn out and laid in place. As they dry so the wood fibres are bound together in irregular patterns, with single fibres lying in all directions across one another. This is precisely the way in which humans make paper. The raw vegetable fibre is pulped to separate its constituent small fibres, the pulp is diluted with water to the consistency of a thin gruel, and then laid over a mesh to allow surplus water to drain from it. After it has been pressed and dried the paper consists of irregularly aligned fibres packed together, and is very strong.

Wasp nests are most commonly made in trees or suspended from tree roots in underground chambers. Sometimes a wasp will make her nest among the roof timbers of a human dwelling or barn. The important thing for the wasp is that there should be a space with some structure above it from which the nest may be suspended, for wasp nests hang downward.

Construction begins with a vertical stem to which the wasp will add a horizontal platform, so that it looks rather like an umbrella held upside-down. Then the individual cells are added on the underside of the platform. The cells are usually hexagonal, like those of bees and for the same reason, but wasp combs are mounted on a horizontal rather than vertical plane. The cells completed, the wasp surrounds the comb and stem with several layers of paper, bringing the pulp a pellet at a time, walking backwards while it spreads it along the edge of the envelope, until the comb is enclosed in a more or less spherical sheath with an entrance hole at the bottom. Then the wasp lays her eggs, one in each cell. The eggs are sticky and the wasp places them against the paper walls of their cells, to which they adhere.

It is from this point that the most important difference between wasps and bees becomes apparent, for unlike bees, which depend exclusively on plant nectar and pollen, the larvae of all true wasps are carnivores. Thus, although the adults often enjoy sweet, syrupy substances, the food they must collect for their young consists of caterpillars, grubs of other insects, and any soft-bodied small animal, served after the food has been chewed to a pulp. The young wasps remain in their cells until they are adults, so their food is brought to them, and the downward-facing openings to their cells are left open for this purpose. When the time comes for the wasp larva to pupate it secretes silk with which it makes a cap for its cell. The adult wasp bites through the cap in order to escape.

The young adults may belong to one of three castes. Most – and all of those which emerge early in the season – are infertile female workers, a few are males, and a very few are fertile females. In this they are little different from bees, and it is the workers who take over further building and maintenance, and the rearing of the young. The cells are substantially made, and as one wasp breaks through the cap and leaves, a new egg is laid in the vacant cell, so that before long cells contain wasps at all stages of growth.

There is much more building to be done in a wasp nest than in the hive of a colony of honeybees, because it is only the mated queens which survive the winter among the wasps, and a complete nest and complete colony must be produced afresh each year. The first workers to emerge must begin at once to construct more combs, and in order to do so they must remove part of the enclosing outer walls and extend them. The nest grows outward and downward as the season progresses, but it retains its generally spherical shape and the entrance hole is always at the bottom. Eventually there may be up to eight tiers of combs, and the nest may house some 20,000 individuals.

As summer nears its end the wasps make special large cells in which they rear male and female sexual forms. When these reach maturity the colony has served its purpose and its members disperse. If food is scarce while the sexual forms are being raised, other larvae will be sacrificed by being thrown out of the nest.

Wasps use paper rather than wax to build their cells. This worker is chewing wood to a pulp which, mixed with saliva, will dry to make paper.

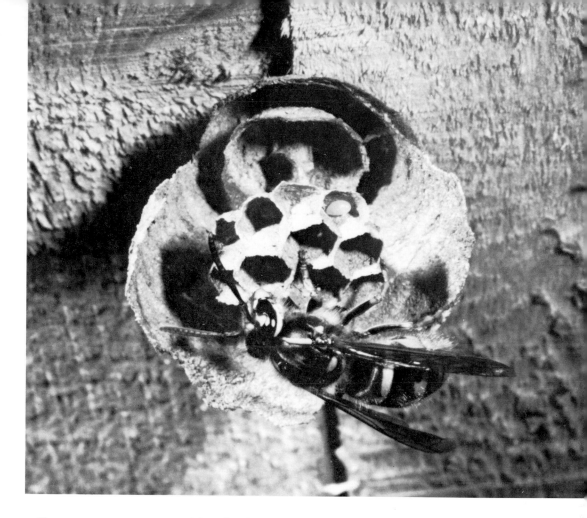

The start of a wasp nest in the roof of a house. What matters to the wasps is that there be a solid support with a space below, so the nest can be suspended. In this case the nest is well advanced, and an egg is already laid in one of the cells.

The interior of a wasp nest. Like bees, the wasps remain in their cells from egg to adult stages and are fed on the larvae of other insects. The paper cells are renovated and used again and again.

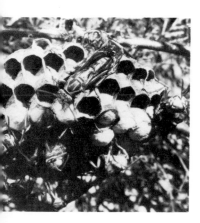

Because wasps are capable of inflicting an irritating sting, humans tend to persecute them, especially in autumn, when they like to congregate around picnic jampots. In autumn such persecution has little effect, since the wasps are about to die anyway, but earlier in the year it is harmful, for the innumerable insect larvae on which the wasp workers feed their younger sisters include many that would otherwise be garden or farm pests. During the breeding season the adults crave sweet things just as strongly as they do later in the year. The difference is that while there are larvae to be tended, the wasps have little time for other activity. Sometimes they will sip nectar from a flower, although their short tongues cannot reach the nectar of most flowers, and they also feed on a sweet exudate produced by the larvae, whose diet supplies them with more sugar than they need or can use. It is only when the last of the larvae have grown up and they have time to spare and no grubs to feed them sugar that the workers cast envious eyes at the sandwiches.

Inside the wasp nest the temperature must be maintained at a constant 30°C (86°F) because this is the temperature needed by the larvae. The outer layers of paper provide effective insulation, but this alone is not enough. A special group of workers collects near the combs to engage in intense muscular activity which generates heat, and the larvae, too, wriggle in their cells as best they can to keep themselves warm.

There are many species of social wasps, and just as there are cuckoo bees, so there are cuckoo wasps, although their behaviour is somewhat less disastrous for their hosts. They merely lay their eggs in the nest of the host species, which raises the larvae for them.

It is among the ants, though, that social behaviour is most highly developed and totally accepted. All ants, and there are some six thousand species of them, are social. There is no such thing as a solitary ant, and the size of an ant colony may vary widely, from twenty members to a million or more.

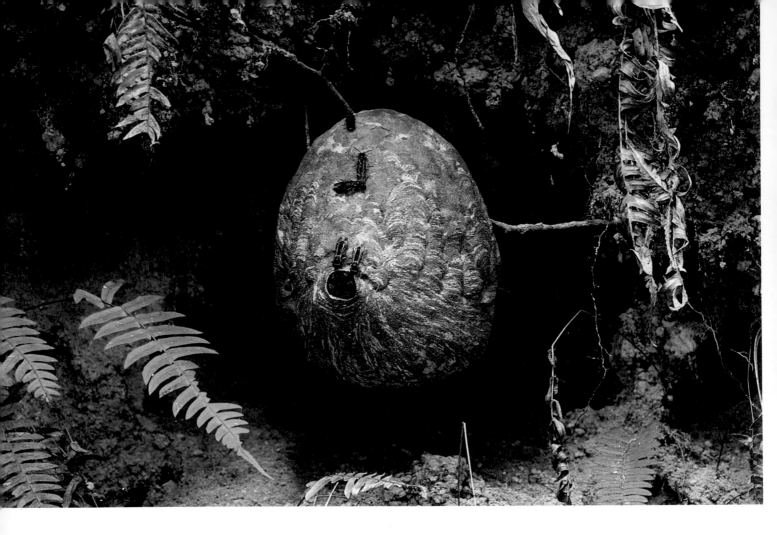

As with bees and wasps, ants produce sterile female workers and fertile males and females. It is only the sexual forms which grow wings and, when the weather conditions are right, they take off on a short, frenzied nuptial flight, many thousands emerging from neighbouring nests at precisely the same time, seeking mates. After mating the ants land and the males die. The females shed their wings, which they no longer need, and start nesting. They may return to the nest from which they came, where they will be accepted readily. They may find some suitable crevice in which they can seal themselves, or they may enter the nest of another ant colony, even one of a different species, where they may find a quiet corner into which they can burrow and, again, seal themselves from the outside world.

Inside their chambers they lay their eggs and tend them for a few months or even for a year, feeding the larvae on surplus eggs and now and then eating an egg themselves, until the young reach maturity. When this happens, the new ants break open the chamber and take over the tending of the young and the building of the nest. Except for the fact that the nest may be located within an existing colony, the pattern is much like that found among social bees and wasps.

As the workers emerge, however, differences between these and other hymenopterans become more evident. Within the worker caste there are many sub-castes, in which individuals are specialized for particular roles. Unlike bee or wasp workers, worker ants may live for several years. They are by no means expendable, and neither are their queens. A queen of the ordinary garden brown ant (*Lasius niger*) has been known to live for twenty-nine years, and queens of other species are known to live for fifteen to twenty years. A queen mates only once in her life, and yet these aged queens continue to lay fertile eggs until they die. This means that the sperm they collect during their nuptial flight is stored in their bodies and maintained in a fresh and viable condition.

A nest of vespid wasps (members of the family Vespidae).

A nest of common wasps forms intricate swirling patterns. The cells lie below the outer casing.

The earth mound (*above right*), surrounded by bracken and grass, conceals a nest of wood ants. They make use of any suitable material. These ants have incorporated some blue plastic in their nest (*above*).

During her life, once she has mated and raised her first brood, the queen does nothing but lay eggs, but the eggs hatch into larvae that are treated differently from bee or wasp larvae. They are not confined to cells during their development, but are moved about the nest to the place where the temperature and humidity are most favourable. If you disturb an ant nest and expose larvae or pupae – the eggs are so small you might not see them – you will see how quickly workers arrive to carry the young to safety. The nest is a labyrinth of passages and chambers, and many of the chambers contain piles of larvae or pupae.

Most workers spend their time tending the young, but the nest provides other occupations to which some of them devote themselves. Among those species that feed on items that may be hard, such as seeds or tough-skinned insect prey, there are specialists who crush and break food for the others. To do this they have much enlarged mandibles, strong muscles with which to operate them, and heads enlarged appropriately. Known popularly as 'soldier ants', these crushers do participate in the defence of the nest when the need arises, but that is not their principal activity.

Among ants of the *Colobopsis* genus, which live inside the trunks of trees, there are some that act as gatekeepers. Their heads are greatly enlarged, flat at the top, and are coloured to match the wood inside which they live. They block the entrances to the nest with their heads, and at the same time disguise them, so that only an ant may know where they are. Most of the entrances are so narrow that nothing larger than an ant can pass through them, and one large ant head will block them, but there are some entrances which are larger. If they are only slightly larger the ants make paper in the manner of wasps, and use this to reduce the opening until it is small enough for an ant to block it. If the entrance is too large for this to be practicable, several gatekeepers will collaborate to block it.

Not only do they seal the nest to prevent draughts, they are very selective about admitting applicants for entrance. The ant which wishes to enter the nest must tap with its antennae on the top of the blockhead, tapping out a code peculiar to that nest. If it gets the code right, and if the gatekeeper also recognizes its smell as that of the colony, it will be admitted. Otherwise the gate remains firmly closed. We saw other ant specializations in 'Pastoralists and Farmers' and 'Weavers and Tailors',

and there are more. Among some ants there are larger and smaller workers, the larger workers tending to work outside the nest, the smaller ones inside. Such adaptations reflect the many differences in lifestyles to be found among the species of ants and their nests, too, range from the simplest and smallest to the largest and most complex.

One of the most impressive of all nests is that built by *Formica rufa*, the common red ant of Europe and Asia, which lives in coniferous woodland amid what look like great domes of pine needles. These are the ants which play a crucial role in the life cycle of the large blue butterfly, which begins its larval life feeding on wild thyme but which, after its third moult, is found by the ants and carried to the nest, where it is tended in return for a sweet substance which it excretes. Sheltered by the ants the caterpillar grows, pupates, and leaves the nest as an adult.

A red ant nest may house hundreds of thousands of individuals and may extend as far below ground as its visible dome rises above it. It may begin in a rotting tree stump, for the ants are able to tunnel through decayed wood. The construction always begins by tunnelling downward, making chambers and galleries whose sides are stabilized by a kind of mortar, made from soil mixed with body secretions. Once work has begun, and a number of entrances have been made, the ants block the openings to the outside world, using pine needles, small twigs, and other bits of local debris which can be dragged into place. Some of the smaller fragments are taken below ground and used to line chambers and passages. As work progresses, more and more material is brought to the roof of the nest, some being carried to the highest point, the rest being dropped at a lower level, so that the covering acquires its domed shape.

Work never ends. Entrances must be blocked in cold weather, and opened again in warm weather. Galleries and chambers must be made, abandoned, and refurbished for new uses, and new construction is needed now and then to extend the nest. Material from the lower levels of the nest is carried to the surface, dropped, and replaced by fresh material from the dome, which is taken below ground. This constant recycling of nesting material prevents bacterial and fungal decomposition that otherwise would turn the nest into a compost heap. The dome catches the sun, and this helps to warm the nest.

There are other ants which carve their nests inside the trunks of trees, working around the annual growth rings to construct a series of concentric walls to their broad, vertical galleries. Others, building inside trees that are hollow already,

The entrance to the nest is sealed by the head of a gatekeeper. The approaching ant must be recognized by the gatekeeper before it will be permitted to enter.

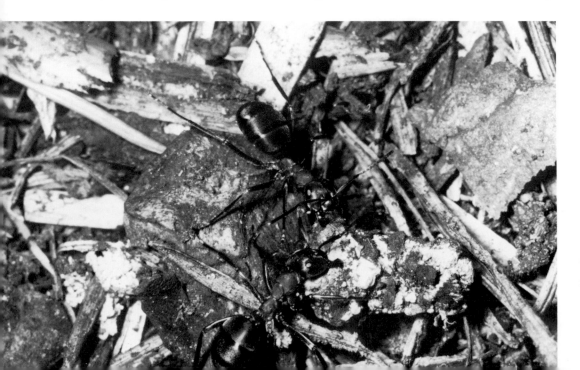

Wood ants collecting material for nest-building.

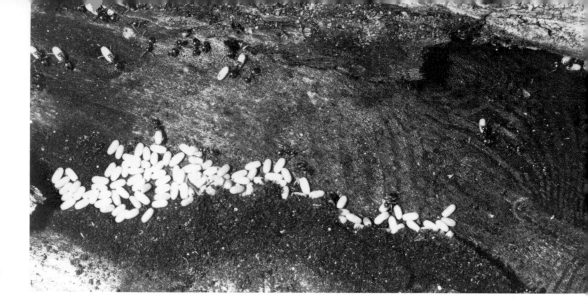

In an ant nest the eggs are not kept in cells but are tended by workers, who move them from place to place as circumstances demand.

make their nests from paper, using wood fibres bound together with a sugary secretion, one group of workers supplying the wood, a second group the 'glue', and a third group doing the actual building.

An ant nest is often elaborate and extensive, but unlike the bees and wasps, ants have not evolved an effective way to regulate the temperature inside the nest. This is a troublesome and not very efficient business. If we are to see nests whose internal climate is controlled within very fine limits we must turn to the termites.

Termites are not ants, although they look a little like them. They are more primitive insects, related to the roaches, and may be regarded, loosely, as social cockroaches. They are soft-bodied, but have biting mouthparts, and their society requires, if anything, more specialization than occurs among the hymenopterans.

Their principal enemy is the ant, and probably it is to escape from ants that they have adopted their very secluded way of life. They build their nests and rarely emerge from them. Where termites must cross a terrain in which they cannot tunnel they build shelter tubes. Despite their dislike of daylight, they build their nests above ground as mounds which may be several metres high.

They live in all warm climates, but most abundantly in the tropics, where severe climates make it necessary for them to regulate the temperature and humidity inside termitaries that may accommodate two million or more insects. Compared to a termite nest, the largest ant nest seems puny.

The two most immediate problems concern the protection of the nest against tropical rain in the humid tropics, and against scorching, dry heat in the deserts. Both problems have been solved.

Some species of the genus *Cubitermes*, which live in tropical rainforest, build umbrella-shaped roofs on their mounds, with overhanging eaves. Other termites go even further and build their mounds as single, narrow columns beneath a series of large, circular roofs, like pagodas, to protect food stores against the rain.

In the Australian desert, the compass termites (*Amitermes meridionalis*) deal no less ingeniously with the risk of heat exhaustion and dehydration. Their mounds are up to 5 m (19 ft) tall and 3 m (10 ft) long, but they are very narrow, slab-like affairs. One of the narrow faces receives the midday sun and the broad faces are exposed to the rising and setting sun. The termites are able to orientate their building in this way probably by being sensitive to the earth's magnetic field.

Having prevented the weather from washing the mound away or from cooking its occupants, the termites now face a third problem. Two million insects, all of them breathing, will asphyxiate unless there is some way to exchange the air.

The *Macrotermes* and *Odontotermes* termites of Africa build air-conditioned mounds and, unlike bees, which often face a similar problem of ventilation, they do not rely on workers with flapping wings to act as fans. Indeed, they cannot, for

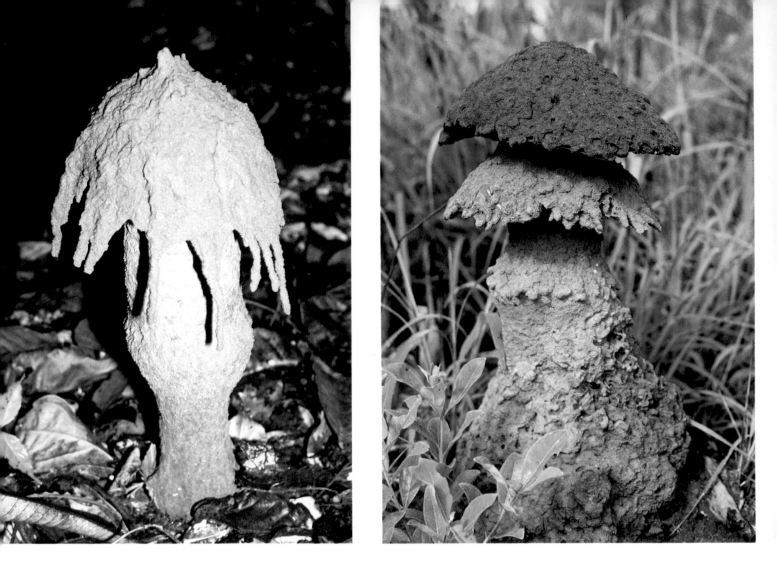

except when they leave the termitary to mate, termites are wingless. Their mounds, up to 4 m (13 ft) high, have chimneys, which look like factory chimneys in some species, and are the outer manifestation of a subtle and very efficient system.

The central structure of the nests stands on supports and is braced by lateral 'beams' extending to the outer walls. There is a large air space below the central structure, and above it another space, which becomes the chimney at its upper end. The nest proper – the central structure – is almost spherical and is cased in two walls with narrow air spaces between them. Cylindrical 'pipes', up to ten centimetres thick, run from the air space at the top of the nest into large ridges which are built vertically from the top to the bottom of the outside of the mound. Inside these ridges the 'pipes' feed into channels that become smaller and smaller, and more and more numerous, until at the bottom they join together again into more pipes, which feed to the lower air space. The ridges themselves are made from porous material through which gases can diffuse.

The air inside the nest is heated by the activity of the termites themselves and also by the growth of the fungi on which they feed. The warm air rises, and leaves the termitary through the chimney and the upper part of the ridges. Its place is taken by outside air, which diffuses through the ridges, into the ducting system, and is cooled as it enters. Being cooler than the adjacent air, it sinks through the ducting until it enters the lower air chamber and the air spaces surrounding the nest.

This system, made entirely by insects which even entomologists call 'primitive', using sand, soil, bits of vegetable matter and their own excreta as their only building materials, would win the admiration of any modern architect. What is more, the innate patterns of behaviour which lead to its construction are by no

The canopy of this umbrella-like structure (*above left*) shields the termite nest from the tropical rain of West Africa.

Cubitermes termites build a series of roofs for weatherproofing, giving a pagoda-like effect (*above right*).

Not a graveyard (*opposite above*), but the home of Australian compass termites. The broad sides of the mounds catch the sun in the early morning and evening, the narrow sides being exposed to the hot midday sun.

opposite Two African termite mounds, showing the size they can reach. The magnificently fluted structure (*right*) contains the 'chimneys' which provide air conditioning for the interior of the nest.

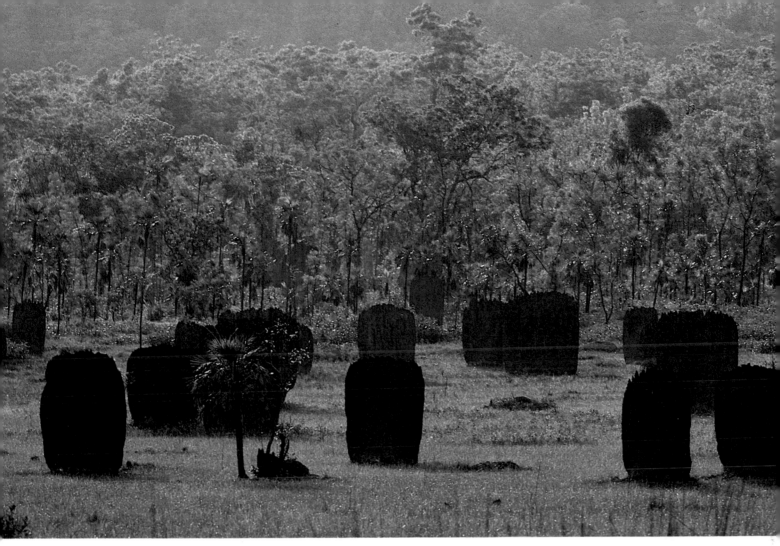

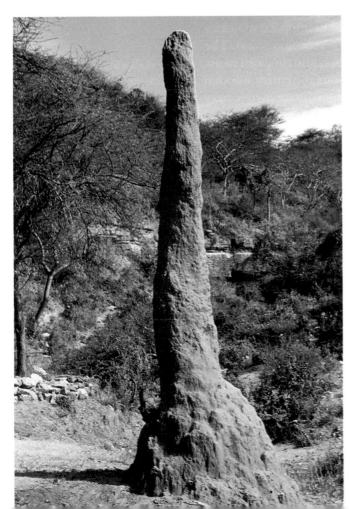

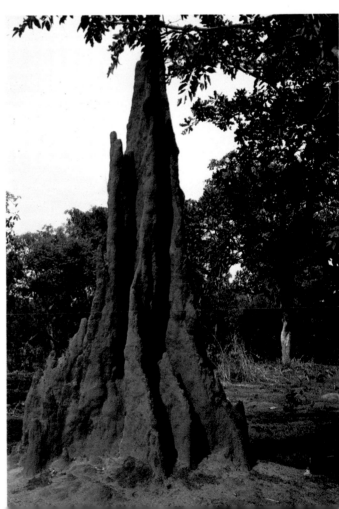

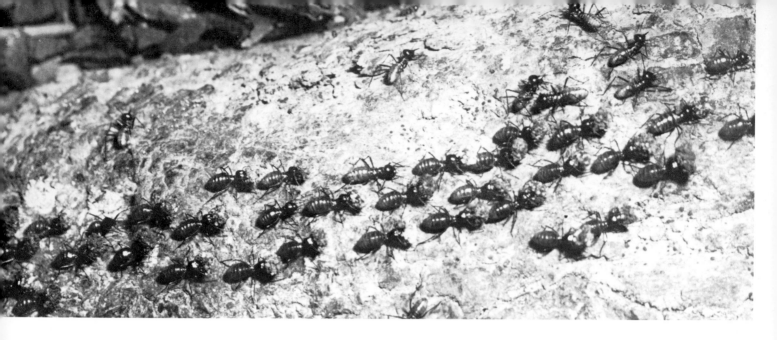

means rigid. Scientists once tested the termites by covering part of their mound with plastic to disrupt the ventilation system. In two days the termites had built a new and novel replacement, consisting of structures at the top of their mound made from even more porous material, and the ventilation resumed its normal working.

Termites will even build paved roads, probably at least partly because in doing so they impart a scent by which other members of the colony are guided. Some, including the chimney-building ventilators, *Odontotermes*, make their pavements from soil particles mixed with saliva. Others use pellets of their own excrement, flattened and dried hard, as paving stones. The great success of the termites is due partly to their social organization and to the buildings that house their colonies; but it is also due to their method of feeding, and this is made possible by a remarkable form of collaboration – a true symbiosis – by which termites and other animals live together.

In the tropics, some termites feed on fungi as we have seen, but the great majority of these insects feed on dead plant material – dry grass, dead leaves, and wood. The forty-five North American species all feed on dead plant matter, and they can cause appalling destruction. It is not unknown for termites to devour the entire wooden structure of a house, working from the inside, so that the unfortunate owner may have little advance warning of the sudden and complete collapse of his or her home.

Dead leaves and wood are very indigestible. The termites bite off small fragments, which they swallow, but they do not digest them. Digestion is the task of the micro-organisms which live in the termite gut, where they form a complete community consisting of species that digest the wood and obtain nutrients from it, others that prey on them, and still more that consume the wastes. No one has ever managed to identify all the members of these populations, so large and complex are they. What is known is that the microscopic community is to be found only in the guts of termites – its members cannot survive anywhere else – that all termites carry such a community, and that the symbiosis has existed for as long as the termites themselves. The micro-organisms benefit because the termite protects them with its own body, and supplies them with food. The termite benefits because nutritive products from all this activity pass through the gut wall of the insect and so sustain it. What is more, they enable it to thrive on one of the less promising among animal diets.

They attack houses in colonies of thousands or even millions of individuals. Each insect eats little, but together the huge colony has a correspondingly large appetite. The insects crawl into wood through small cracks and crevices, seeking shelter from the light, and once concealed they begin to feed and at the same time to construct

A procession of termites in Malaysia carries mud back to the nest for building.

The elaborate architecture of the interior of a termite nest.

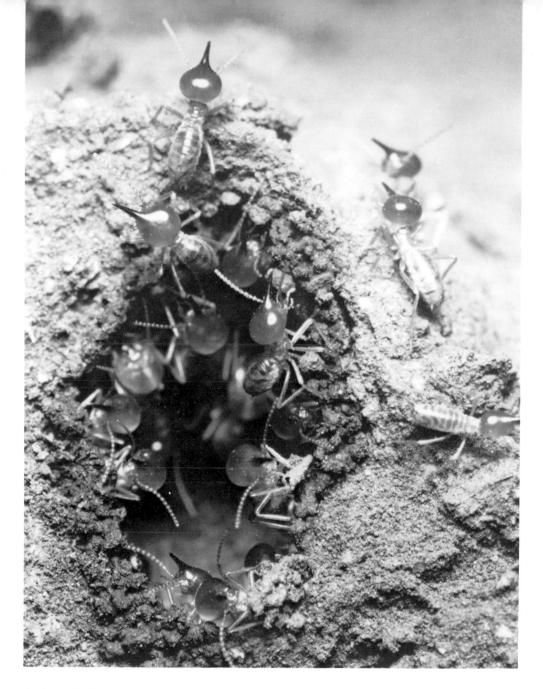

When the mound is damaged it must be repaired. These 'snout' termite workers make repairs while guards protect them.

their galleries, through which they move. They work always from the inside and the walls of the galleries need to be of no greater thickness than will shelter a termite – which means they can be paper thin. Thus they can hollow out a piece of wood until it consists of nothing more than its outer surfaces, and at this stage the slightest shock to the structure will cause it to collapse into a small pile of dust.

Termites were building their mounds, most probably just like the mounds they build today, long before our earliest primate ancestors walked the earth. No doubt they will still be building them long after our species has disappeared into palaeontological obscurity. When we read science fiction accounts of space colonies, or of cities in some remote future that are completely enclosed and isolated from the world outside, we might spare a thought for the termites, which have lived harmoniously in just this way for millions upon millions of years.

Mansions below Ground

NO one knows much about the origin of the rabbit. The British species is very similar in many ways to several of the North American cottontails, but the cottontails do not burrow. The British rabbit came originally from the Mediterranean region, perhaps from north-west Africa, for the Romans knew it but the Greeks did not. Probably it was brought to England in about the twelfth century either by the Normans or by returning crusaders, but it was not until the seventeenth and eighteenth centuries that it became fully established in the wild. Farmers were planting hedgerows at that time to enclose open land and the hedgerows provided rabbits with shelter, migration routes and, in the fields themselves, an inexhaustible larder. Today the rabbit is the most commonly seen of all British wild mammals. Before the first outbreak of myxomatosis in Britain in 1953, the rabbit population was estimated at between 60 and 100 million.

Apart from its habit of feeding upon crops grown for human use, the rabbit is best known as a mild-mannered burrower, and many of the legends and nursery tales associated with it concern its subterranean mode of life. The rabbit will make its tunnels in sandy, chalky or shale soils, away from coniferous forests but, because

opposite A rabbit at the mouth of a burrow that may lead into an extensive underground system of tunnels and chambers.

right Rabbits are born below ground, blind, naked and helpless. These are twelve days old.

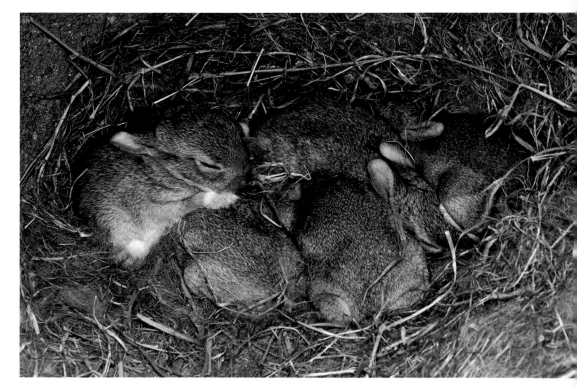

it has no special adaptation for burrowing, like the mole, where the ground is very wet or the soil lies thin above rock it is content to live above ground like its cousin the hare.

Despite their successful spread through countries to which they have been introduced, rabbits are not great travellers. They seldom move more than about 200 m (656 ft) from their burrows. Their population increases locally because the young simply add to the burrow system rather than leaving for an independent life elsewhere. New warrens are started by subordinate does, which make short, blind burrows some distance from the main part of the warren in which to bear their young. When seeking a suitable site, good cover seems the most important feature. They like hedgerows, especially those made from earth heaped around a stone wall core, like the hedges of Cornwall, or the complex, partly exposed root system of a large tree.

Warrens are not made according to any plan. A rabbit burrows where it will. If it meets a stone or other obstruction it may stop digging, leaving a dead-end tunnel, or it may make a diversion, so that its tunnel twists and winds. Otherwise it may continue digging until its tunnel encounters one made by another rabbit, and so the burrows become linked into a chaotic kind of network.

Within the tunnel there are chambers, which may be 60 cm (2 ft) across and 60 cm (2 ft) high, in which rabbits rest, and there are smaller blind tunnels containing nesting material in which the young are born. Rabbits make nests only for their young. The adults sleep on the bare earth. In older warrens, the tunnel system may be very extensive – although many of the older and more elaborate examples have been destroyed by ploughing in recent years – and while most of the burrows lie 60 to 90 cm (2 to 3 ft) below the ground surface, some tunnels have been found lying much deeper, as much as 2.74 m (9 ft) below ground level.

Animals which burrow will survive only if they are well aware of the risks of

The exterior of a rabbit warren (*above right*) on Skolkholm Island, Dyfed, Wales.

The camouflage around the entrance to the rabbit burrow has not been planned by the rabbits, but nevertheless it is effective. This rabbit (*above left*) lives on Farne Island, Northumberland.

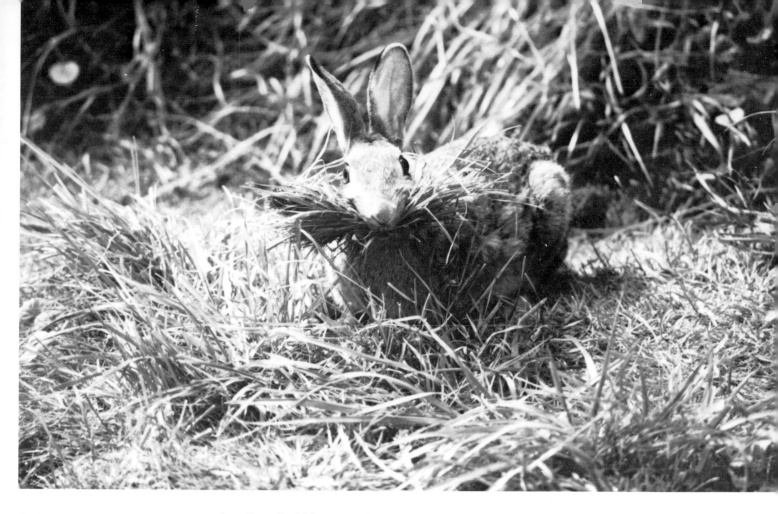

Rabbits use nesting material only for the birth and raising of their young. This doe has, or soon will have, young to tend.

flooding. Rabbits can swim well, and will do so if necessary when being chased, but they prefer to avoid it. Warrens are seldom made on level, low-lying ground, and on rising ground there will be enough burrow space at a high level to provide shelter should the lower levels flood.

In addition to the regular burrow system, there are many bolt holes. Unlike the hare, which evades capture by outrunning predators, the rabbit is capable of a good turn of speed – up to about 40 kph (25 mph) – but for only a very short distance. Its strategy is to remain at all times within reach of a hole down which it can vanish, like the White Rabbit, almost vertically. Unlike Alice, most predators are too large to follow it, and those that do are likely to find no trace of their quarry, which will disappear rapidly into the tunnel system, probably emerging above ground again some way from the point at which it entered. The warren, then, provides its occupants with security, but this is achieved without guile. Often the bolt holes are well hidden by vegetation, but this is quite fortuitous, and holes that are seldom used are likely to become overgrown.

The rabbits follow no architectural scheme, yet the warren develops in response to the social organization among the animals, for rabbits are highly social and the society is hierarchical, not to say dynastic. There are dominant bucks and does, and their offspring inherit the social status of the parents. The dominants occupy a communal territory and subordinates are not permitted to feed within it. In the warren the dominants occupy the best and most central places for sleeping and breeding. Junior individuals occupy outer regions of the warren, and feed in territories of their own from which others are not excluded, and the most inferior does of all are those whose young must be born in the short blind burrows some distance from the main warren, the burrows that may develop into new warrens. The hierarchy is most marked, and most strongly insisted upon, during the breeding season. The more senior the rabbit the longer its breeding season will be,

and the greater the number of young it will produce. Rabbits can be quite aggressive toward juniors that trespass. Generally the does are more likely to attack than the bucks, although a buck will attack a would-be rival that approaches its mate, and when an aggressive chase by a doe leads to capture, which happens sometimes, fur may fly.

Rabbits are able to breed at any time of the year, but the usual breeding season is from January to June. Since the introduction of myxomatosis, however, there is reason to suppose that the breeding season has been extended, probably as a response to reduced numbers.

If a society is to maintain its coherence, there must be a means of communication among members. They warn one another of impending danger either by thumping the ground, if there is time, or if not by displaying the white underside of their tails as they run. For many grazing animals, the sight of a patch of white moving rapidly is taken as a warning. Rabbits will also scream in terror, and make sounds to call their young back to the nest. Otherwise they communicate by scent-marking, using faeces, urine or the secretions of a scent gland beneath the chin.

Rabbits are preyed upon by all the mammalian carnivores, including feral cats, yet such cats have been found living inside warrens, their presence tolerated – although it is difficult to see what the rabbits could do to evict a cat even if they wished to do so. Other animals will share rabbit burrows, sometimes enlarging them to accommodate larger bodies. Badgers, which will eat young rabbits but probably not adults, sometimes live in warrens.

The European badger (*Meles meles*) is not closely related to the North American badger of the genus *Taxidea*, but both live in much the same way. They are highly social animals, no less so than the rabbit, and they dwell below ground, emerging at

Not all burrows lead somewhere. The most inferior does have their young in short blind burrows apart from the warren.

The entrance to a badger sett. Note the mound of earth removed during excavation.

Although well concealed, the entrance to a badger sett, often in woodland, is not difficult to identify.

dusk to feed. In winter they emerge less often from their setts, feed little and spend much of their time sleeping, but they do not hibernate.

A badger sett is rather similar to a rabbit warren, but it is more elaborate and often larger, in that it provides more space for each animal. Usually there are many entrances to a sett, and their burrows may penetrate a hillside horizontally to a depth of 20 to 100 m (66 to 328 ft) at several different levels. In a well established community there will be one main sett and several smaller outlying setts, and within an area the main setts will be some distance from one another, their location being determined by some system of spacing to which badgers respond.

Unlike rabbits, badgers line their sleeping chambers with bedding, as well as the chambers in which their young are born. This is made from bracken, grass, and other soft plant material, collected on dry nights – badgers do not like sleeping in damp beds – and up to thirty bundles of bedding may be collected and taken to the sett in one night. On bright winter mornings, badgers sometimes drag their bedding to the entrances of their setts and spread it out to air.

If a rabbit warren may be likened to an underground town, occupied by members of a huge and vastly extended family, then a badger sett is more like a series of underground apartment blocks, whose occupants may or may not be closely related. Some zoologists refer to the group of badgers as a 'clan', and in some ways they do behave clannishly, even to the point of possessing a chieftain, but the relationships within the clan are subtle. Probably each family group has its own 'apartment', which may consist of a complete sett or may be part of a shared one. The chieftain appears to exercise no overt authority over members of his clan, but should a strange badger venture too close he is likely to attack it savagely, leaving the intruder seriously wounded. During the day, these nocturnal animals spend much of their time sleeping, large adult boars often in the main sett, with the females and younger males in outlying setts.

In terms of protocol, the general rule in badger society is that adults take precedence over cubs, and among the adults the order of seniority runs from dominant, sexually active males, to females, to 'bachelor' males.

Badgers are clean animals and below ground they have side chambers that are used for defecation. Like many animals, they use their urine and faeces to scent-mark boundaries, but even then they defecate in latrine pits, dug for the purpose at selected sites around the range boundary.

Like other members of the weasel and stoat family (Mustelidae) the badger has a scent gland beneath the base of the tail which secretes a yellow, oily liquid with a distinctive smell, and an anal gland secreting a musk which is activated when the animal is frightened or otherwise disturbed emotionally. The scent gland is used a great deal. It marks out the range of each individual within the clan, it marks the routes the individual follows, in strange country it is used to help the animal find its way back to the sett, and the badgers within a particular clan use it to scent-mark one another. They do this frequently, so that by mixing the scents they acquire from one another, in time all members of the clan possess a clan smell as well as a personal smell. They also communicate vocally, with a variety of purrs, barks, growls and screams.

Their social hierarchy becomes important when they are feeding. Except when a sow is accompanied by cubs, badgers feed alone, and at some times of the year, especially in autumn, they may be away foraging for up to ten hours at a stretch. They are animals of very regular habits. A badger will patrol its range, almost always using the same paths, according to its own routine, so that all feeding areas are visited from time to time.

The clan as a whole may have a range of up to 80 ha (192 acres) or more. Within this, the females may each have an individual range, which only males may enter. The males have larger ranges, superimposed on the female pattern and

From time to time badgers air or change their bedding, bringing it to the surface.

Badgers leave the sett to feed alone, except when a female has cubs she cannot leave unattended.

Badgers are very playful, especially when they are young, but seldom leave the sett until they are about a year old.

opposite Badgers mark out their ranges with scents. They also scent-mark one another so that members of the same community may easily recognize one another.

overlapping female ranges. The 'bachelors' have the smallest ranges of all, as befits their lowly status.

As new cubs are born, old individuals die, and young males leave the home range in pursuit of females. The population at a particular sett may reach a peak during the summer of as many as fifteen animals, roughly half of them male and half female. The clan will consist of adult males, adult females one or two of which may have young, females born in the previous year and by this time possibly mated, and perhaps a few males born the previous year which have not yet departed. The pattern is complicated by the fact that after a female has been fertilized there is a delay of from three to nine months before the blastocyst (fertilized ovum) is implanted and pregnancy begins.

The cubs are born below ground, usually in early spring, and they remain there

until they are about eight weeks old. Their mother begins to wean them at about three months, by feeding them food she regurgitates, but they may still be suckling at four months. For some time after that the cubs remain close to their mothers and those which are to depart seldom do so until their first winter has ended and they are about a year old. No one knows just how long badgers live in the wild, but it is probably at least fifteen years.

The mole can expect to live for no more than about three years, but this is an average which includes the premature deaths of many young individuals. A successful mole which lives to maturity may be four or five when it dies, starvation being the most probable cause of death. It is not the food supply which fails the mole, but the mole which fails the food supply, because its teeth wear out so that it can no longer feed.

Moles are quite unlike either rabbits or badgers in two important respects. They live in solitude – the one thing a mole hates above all else is another mole – and they have not had to adapt bodies meant mainly for life above ground to a subterranean existence: they are built expressly for digging. Rabbits dig using their front legs, like dogs, and eject the loose earth with kicks from the powerful hind legs. They are very good at it and can dig rapidly provided the ground is not too hard.

All moles have an extraordinary sensory apparatus on their snouts, but it is extravagantly developed in the star-nosed mole.

The mole surfaces quite often, usually at night. Note the forepaws, turned sideways and modified to form shovels.

The badger, too, digs efficiently like a dog. The tiny mole, however, can outdig either of them. It is a true digging machine, and can manoeuvre its legs in ways that few other animals, including rabbits and badgers, can.

For most of the time, a mole holds its hind legs in the way other small mammals hold them, in a kind of 'knees bend' position. When it wishes to dig, however, they swivel out sideways so they appear to be mounted on the body at the midline and at right-angles to the spine. In this position the mole can brace itself against the sides of its tunnel while it works away with its forelimbs. It can rotate these as well, so that without the least discomfort it stretches them in front of itself with the 'palms' of its forepaws facing outward. The forepaws themselves can bend and stretch and the digits can be spread apart, so that each paw is like a small shovel. Thus armed and braced, the sturdy mole sets to, using first one paw and then the other, throwing earth to the rear. From time to time the loose earth is removed up a sloping gallery to the surface, where it forms a molehill. If the earth is soft, the mole may use both forepaws together and 'swim' through the ground in its own version of breaststroke.

As it moves backwards and forwards through the tunnel, which may be too narrow for the animal to turn around, the mole is not impeded by its own fur as a

rabbit or badger might be. The presence of badgers is often revealed by strands of their long, coarse hair that have caught on brambles or briars as they made their way along their well trodden paths. No mole would betray its presence in this way, for its fur is short and grows vertically from its skin, so that it lies equally well forward or backward.

Despite their reputation and their extreme physical adaptation for living in tunnels, moles spend a good deal of their time above ground. They will surface when the ground becomes very hard, during droughts, and it is believed that they surface quite regularly at night and feed on whatever morsels they find. If you should encounter one, handle it with care. Moles can and do bite.

A mole is at some disadvantage above ground. It can walk, but not well, and only the sides of its forepaws touch the ground. Its eyesight is extremely poor, even worse than that of a badger, but it is not blind. Poor eyesight is typical of many nocturnal animals. The rabbit, in contrast, has 360 degree all-round vision when it is alert, and holds its head erect. The mole's eyes have no bony sockets, are very small, and probably their owner cannot detect anything which moves as fast as a walking animal, just as we cannot see a bullet in flight (although some snakes may). It can hear low-frequency sounds, and since the mole itself is a somewhat vocal animal, its hearing may have quite a large range. It makes a twittering sound, but quietly as though to itself, when it is excited – usually because it has found some especially appetizing food – and a raucous squeal when it is frightened or angry. The thing most likely to enrage it is the presence of another mole.

The mole may appear rather senseless – its vision is poor, it can hear moderately well, its sense of smell is no better than average, and it may or may not have a sense of taste. This could not be further from the truth, however, because it possesses a sensory apparatus different from, and more advanced than, anything in the rest of the animal kingdom. All moles have it, but it is displayed most extravagantly by the North American star-nosed mole (*Condylura cristata*), whose splendid snout wiggles soft and pink, surrounded by twenty-two radiating appendages, like a star. The common European mole (*Talpa europaea*) boasts no such extravagance, but its more modest snout is hardly less sophisticated.

In the first place, the muzzle is surrounded by vibrissae – whiskers – which are also found in the tail (always held erect in healthy moles) and near the forepaws. These are acutely sensitive to touch, each whisker having its own nerve-ending to transmit the impressions it receives, and the information they obtain is reinforced by plates on the skin, especially on the abdomen, which are also sensitive to touch.

The fleshy appendages of the star-nosed mole are known technically as 'Eimer's organs', and in the common mole there are thousands of these tiny bumps each served by many nerves. No one really understands how the Eimer's organs work, or just what it is they do. Presumably they are sensitive to touch, but in an animal endowed so richly with touch sensors such elaborate apparatus would seem superfluous. They may respond to chemical stimuli, producing a sensation somewhere between those of smell and taste. They may be sensitive to air pressure, or to changes in temperature, which would be very useful to an animal which spends most of its life in darkness. They might enable the mole to identify the direction in which air moves through its tunnels, and also the source of that air – even though inside the tunnel the air must be almost still. At all events, the mole thrives in its underground labyrinth, and although it damages the roots of some plants its tunnels also aerate the soil, and it is far less serious a pest than many gardeners imagine.

Molehills tend to reappear year after year in the same places, and are the result of maintaining an existing tunnel system. Where new tunnels are excavated, in the

At the centre of the nest of a mole is the 'fortress' (*above*) to which the mole retreats to sleep and where young are born.

Inside the 'fortress' (*right*) the mole builds a proper nest, to which all the main tunnels lead. Note the water level in this marshy ground: from time to time the mole must swim to survive.

The mole's favourite food is earthworms, which it may store, having immobilized them by biting off the final segments.

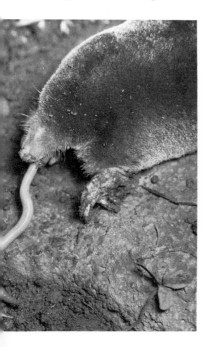

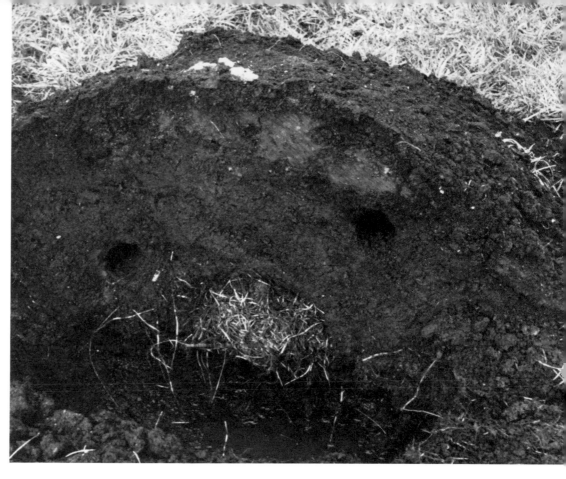

great majority of cases they do no more than extend the system. Moles will make an entirely new system only when the old one has been demolished, usually by the ploughing or digging of the soil. In undisturbed ground a young mole may inherit a tunnel system in which it will spend the remainder of its life without ever digging at all, despite its prodigious tunnelling abilities, and even those which do dig spend only a small part of their time in this activity. In general, young moles tunnel just below the surface, older moles tunnel at a lower level, and in frosty weather tunnels are made below the frozen soil.

Despite being solitary, except during the short breeding season in spring, moles have been found together, with more than one individual occupying the same section of tunnel. Some people believe that several moles living in the same area may share a communal tunnel leading to water. Others believe the mole may scent-mark its tunnel to deter rivals, but with a scent that fades quickly, so that tunnels are frequently invaded in error. It is also possible that moles have a social structure after all, and that subordinate individuals move about the tunnels when the dominant mole rests. What is known is that moles swim well. Their tunnels are more likely to be flooded than the burrows of either rabbits or badgers, because moles have no special preference for high ground, and when water floods in the moles swim out, returning, still swimming if necessary, as the waters recede.

It may be some feature of the soil itself which persuades a mole to tunnel in one place rather than another. There is one account of a mole which lived below a tennis court, its tunnels following the lines of the court which were marked out in lime, some of which may have reduced the acidity of the soil immediately below.

The tunnels supply the mole with all that it needs. Within them it is safe from predators, it can rest, its young can be born and raised safely, but the tunnels are more than this. They are also traps that supply their occupant with food. Earthworms are the favourite food for moles. They are highly nutritious and easily digested. A fresh earthworm is about eighty-five per cent water, but of its dry weight three-quarters is protein and there is very little fat.

If a mole has eaten its fill of earthworms but finds more, it may take them to a store. It bites off the final three to five segments of each worm, which does not kill it, but for some unknown reason it does prevent it from burrowing. The worms remain, alive, wholesome, but immobile, until the mole returns for his dinner.

Despite their fondness for worms, moles will eat a range of other foods: wireworms, beetles, leatherjackets and cutworms, which are ground-dwelling caterpillars, and all insect larvae. Insects provide a drier food than earthworms, but they also contain much more fat, while the chitinous exoskeleton of adult insects is probably indigestible. When they surface at night, moles will capture any earthworms they can find, but given the opportunity they will also kill and eat small birds and mammals.

Moles have large appetites, like all small mammals. In an average day they will eat about 100 g (4 oz) of food in three main meals, although when times are hard they can survive on half that amount. This is not much less than the body weight of a full-grown mole (87 to 128 g/3 to 5 oz). A hundred grammes (4 oz) may sound little enough, but in a human it would be equivalent to eating about 50 kg (110 lb) of food a day – without gaining weight! Fortunately, a hectare (2⅖ acres) of undisturbed pasture or woodland may contain two or three tonnes of earthworms, and other invertebrates as well.

An adult male mole has a tunnel system that extends for about 40 m (130 ft) from end to end. Females have smaller systems. In spring, however, the males set off burrowing in search of females, which they find by the simple expedient of breaking into their tunnels, extending their own tunnels in straight lines for perhaps 100 m (328 ft) beyond their former limit toward those of their neighbours.

The worm store is usually located close to the central part of the system, which is a kind of fortress to which the mole can retreat, and in which it has its nest. This is used for sleep, but in addition it also takes short naps in its tunnel. Day and night are concepts of little interest to the mole, although it is unlikely to surface during the day. When it does so, it comes up snout first, and spends a minute of two with just the tip of its snout – the Eimer's organs – exposed, emerging completely only when it is safe to do so.

Its internal 'clock' gives the mole a day lasting eight hours. In other words, each twenty-four hour period is divided into three eight-hour periods. This short term rhythm is recognized by the regular repetition of patterns of behaviour in moles

Molehills are made most commonly by the clearing out of old tunnels that have suffered from collapse, but they also occur when a mole is making fresh tunnels.

As it surfaces, the mole scents the air to check that it is safe to emerge. If not, it will vanish very rapidly.

that have been studied, but the mole leads a much less stereotyped life than this suggests. These eight-hour 'shifts' are not spent in precisely the same way. Humans lead lives that are far more repetitious. Consider, for example, the amount of time spent sleeping. We may have different times for going to bed and for getting up in the morning, but most probably we spend on average the same number of hours in bed each night. One mole that was observed for some time spent more than four and a half hours asleep in its nest during one of its eight-hour periods, then during the following period it slept for just over two hours, and over the whole period of the study it slept for an average of three and a half hours in every eight, resting in its nest and also, for periods of up to twenty minutes at a time, in its tunnels. This is a wide variation, but it is not all. This particular animal did a great deal of tunnelling, probably because it was on farmland where soil invertebrates were in short supply. Of the four and a half hours of each 'shift' during which it was awake, between one and a half and three would be spent tunnelling. For the rest of the time it was patrolling its tunnels in search of food. In doing so it might travel a total distance of anything from 20 to more than 800 m (66 to 2,624 ft).

If a rabbit warren may be likened to a subterranean township, and badger setts to apartment blocks, the mole in its tunnels occupies a system of bunkers, a self-provisioning fortress. Rabbits and badgers must emerge from their underground homes to feed. The mole also surfaces, but it has no real need to do so except rarely when its tunnels flood with water. It is truly subterranean, adapted physically and behaviourally to life below ground in ways the other mammals are not. Yet for all of them the burrow, sett entrance or molehill by which we recognize their presence conceals a structure that is elaborate, extensive, and sustains a very highly organized society.

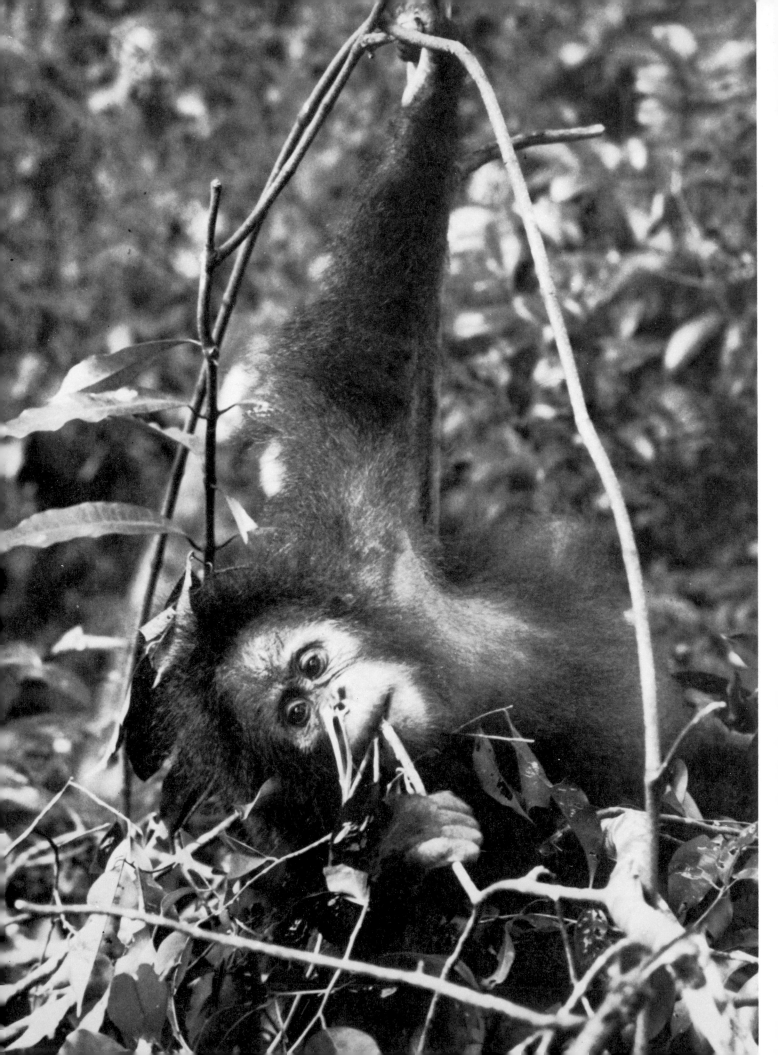

A Bed for the Night

THE great apes are of special interest since they are our closest living non-human relatives. While the differences between the orang utan, gorilla or chimpanzee and ourselves are profound, there are many similarities as well, and genetically the difference between one human being and another human being may be less than the difference between an average human being and an average chimpanzee. Indeed, the chimpanzee is related to humans so closely that some geneticists believe the two species should be placed within the same genus – Linnaeus himself named the chimpanzee *Homo troglodytes* – and an extremist might argue that they are no more than subspecies of the same species. There is little real risk of so radical a reclassification being made, but it does show that it is possible for large physical and behavioural differences to be associated with quite minor genetic differences.

Many scientists have tried to gain useful information about ourselves from studying the behaviour of apes. They are not attempting to relate humans with apes as they are today, but to see how far it may be possible to reconstruct the way in which our remote, pre-human ancestors might have behaved. Even so, the results are ambiguous.

The ingenuity, manipulative skill and willingness of the apes to experiment are

opposite An orang utan in its nest in Sumatra.

right As infants, baby chimpanzees sleep with their mothers, always on a platform she has built in a tree.

well known, and we have seen several examples of them in this book. How do they rate, then, in that most basic of animal activities, nest building? Humans carry this behaviour to extreme lengths. Our nests consist of buildings, often made from brick or stone we have quarried from the ground and processed, and we invest more in them as individuals than do most animals.

The apes invest very little. It takes an adult chimpanzee something like five minutes to construct a nest, and gorillas and orang utans devote no more effort to the task. Nests, it seems, are really not important. Perhaps we should ask why.

In general, a nest may provide security from predators while its owner sleeps, and protection from the weather. It may provide a secure shelter in which the young can be accommodated and tended until they are old enough to fend for themselves or to accompany their parents and keep up with them if the family is forced to make a rapid escape.

The apes live in the tropics. The climate is warm, only mildly seasonal, and the vegetation is plentiful. The orang utan and forest gorilla dwell in the forest itself and the chimpanzee lives at the forest edge. This limits the materials available to them to plants, perhaps with the addition of bones and stones lying on the surface, but in a tropical environment this allows wide scope. The same vegetation provides much of what they need without any modification. Should the weather not be to their liking they may find sunshine in forest clearings or on other open ground, shade beneath the trees, shelter from the rain beneath the large leaves of tropical plants. Should they feel cold at night they can – and all of them do – wrap themselves in leaves or grass. All three apes use 'blankets' when the need for them arises.

They have no really dangerous enemies. No doubt a chimpanzee would come off worse in combat with a large cat, or a pack of dogs, but groups of chimpanzees always have some members on guard, and predators can be outrun, outclimbed or, if they are alone, mobbed. An orang utan can move faster through the trees than a man can on the ground, and a gorilla has no enemies at all – other than disease, or such venomous animals as may be trodden on accidentally. In the depths of the forest there is no animal large enough to confront a gorilla, and should any potentially dangerous intruder approach a gorilla group too closely the threat display of a full-grown male is usually deterrent enough. In most cases the display is no more than that: once it is done the gorilla withdraws. It is only if his retreat is barred that he will fight, and his attack is most likely to begin with the hurling of

left The bed of a gorilla, made from bamboo.

opposite A baby orang utan, with a large leaf for protection against the weather.

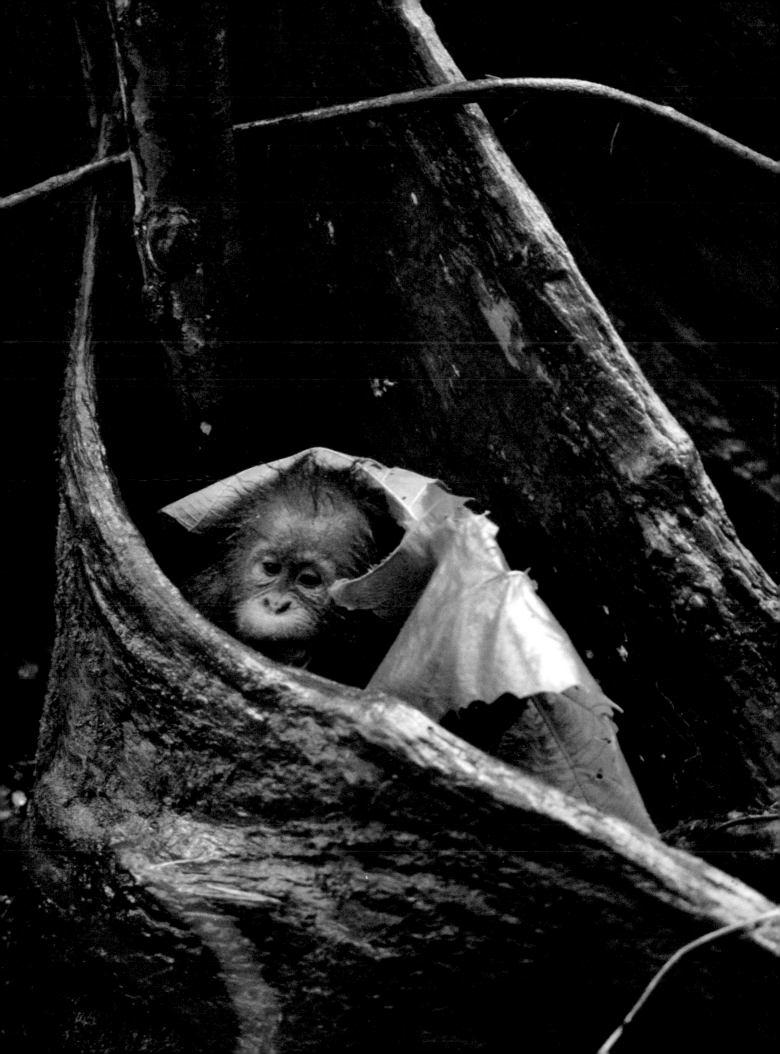

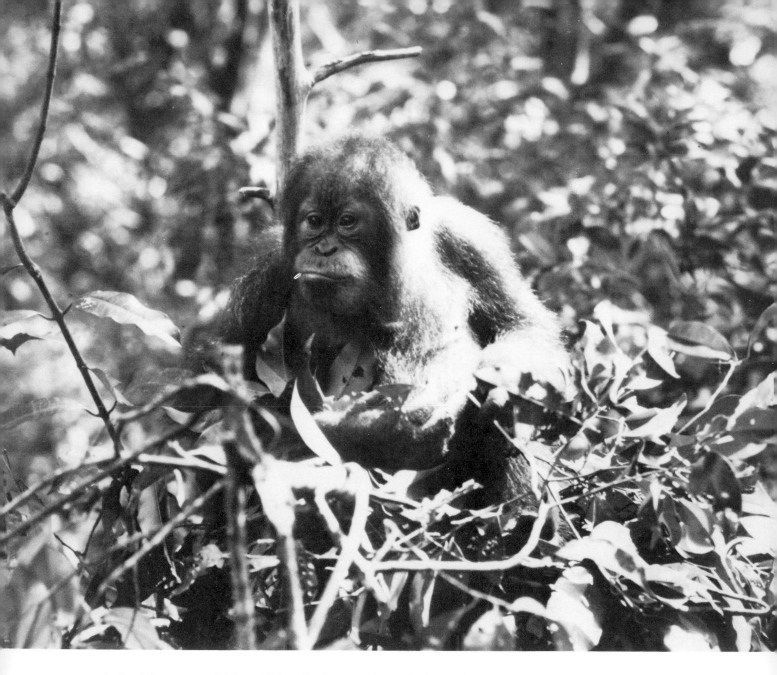

any missiles lying around him. All in all, the apes have little need to seek shelter from the weather, and even less need to find refuge from predators.

Their young live with them, and are carried by their mothers until they are old enough to walk. They remain near their mothers for four or five years, and the mother-offspring relationship remains close throughout life. Fathers are more remote figures and play no direct part in bringing up the young. Babies are never left unguarded; since they must be suckled at regular intervals it is much more convenient for the mother to be able to take her baby with her wherever she goes in search of food. The apes thus have no need for secure lodging for unprotected infants.

The apes do not need nests and so they do not make them. They do need a place to sleep, however, a bed for the night. Their beds are made quickly and with evident ease, but they are more elaborate than they seem.

Chimpanzees and orang utans sleep in trees. Gorillas, which can climb but seldom want to, usually sleep on the ground. Their method of making a bed for the night is much the same as that of their arboreal relatives.

The ape finds a suitable sleeping place, in a tree or on the ground. Obviously, it must be comfortable, and if it is in a tree it must be firm and capable of supporting

An orang utan on its sleeping platform, safe in a tree, in Sumatra.

the weight of its occupant. Branches are bent across to the main boughs or fork that forms the base, and are held in place with the feet while smaller twigs are woven into and around them, making a secure platform. The weaving may be elaborate, but it takes little time. The bed made, the ape lies down on it, pushing it flat and providing the final locking for the branches with its own weight. Minor adjustments are made, most commonly by plucking leaves from branches that are within reach and using these as a cushion for some part of the body, or as a pillow. If the night is likely to be cold, or if it is raining hard, the ape may make a blanket from leaves or from grass.

If the animals are moving, visiting new places each day, they will make a fresh bed each night, and gorillas almost always adopt this practice, even when they are not on the move, often choosing a different site each night. When they are living in one place for some time, however, chimpanzees and orang utans will often continue to sleep in the same tree night after night, and sometimes even in the same bed.

The nests are kept scrupulously clean, at least among healthy individuals, and should an ape need to urinate or defecate during the night it leans over the side of its bed to do so.

Apes sleep for rather longer, on average, than do humans. Chimpanzees, for example, sleep for ten hours during twenty-four, rather than the eight which is normal among humans.

Babies are not born in beds, which are used only for sleeping, but soon after a baby has been born its mother must make a bed large enough for the two of them, and what is more she must do so while holding her baby in one arm. Even so, the task takes only a few minutes.

Young apes begin to play as soon as they are physically capable of doing so, just as human infants do, and their games take many forms. When they are still very young they begin to play at 'bed-making'. They are very unskilled, their efforts are crude, and it may take an experienced student of their behaviour to recognize the activity for what it is, but their urge to make a bed for themselves is clearly innate. A 'toddler' will bend over a small branch and sit on it, then bend over other branches, or grass if, as is likely, it is sitting on the ground while it plays, and either covers parts of its body with them or try to tuck them into the branch.

When it is a little older it will make the bed up in a tree – even if the young animal is a gorilla, because young gorillas tend to climb much more than do the heavier, more cumbersome adults. The bed will not be used for sleeping, for 'toddlers' continue to sleep with their mothers. In most cases the bed-maker will proceed at once to demolish its bed by jumping up and down on it until it collapses. Later, though, it will lie down on the bed for a little while, in 'play sleep'. By the time it must leave its mother, when it is four or five years old and goes off to join the group of its peers, the young ape will have mastered the knack of making a bed. It will not have been taught to do so in any formal sense, but it will have watched its mother and mimicked her, it will have watched other adult members of the group, and it will have experimented and played until the beds it made were adequate.

An adult orang utan, held captive in a German zoo and provided with no material with which to make a bed, was once observed to mime the actions involved in bed-making. This may have been a melancholy rehearsal to comfort an individual whose memories of a former life spent swinging through and sleeping in the trees of its native forest were too painful. Alternatively, perhaps it was a mere mindless repetition of an innate behavioural pattern.

The imitative bed-making games of small children parallel those of infant apes, and it is probable that our own remote ancestors may have made beds for themselves as the apes do.

Landscape Architects

ALL living organisms must modify their immediate surroundings in order to live. Humans are in no way different from other animals in this respect. Nevertheless, it is supposed that the scale on which humans alter the face of the earth is unprecedented, unique, and sets us apart from all other forms of life. Although such a view may flatter our vanity, fortunately or unfortunately it is quite untrue. Certain animals especially have created landscapes on a scale that exceeds our puny endeavours, and there are other animals which would do so were their numbers to increase.

The scale on which animals may change landscapes can be staggering. In Britain, the rabbit and sheep have preserved the unique plant communities of the open Downs. At one time the Downs were wooded, although probably less densely so than most parts of the country. Early human settlers cleared the trees and the landscape underwent a series of changes, but in modern times the grazing

opposite By their grazing sheep maintain the type of landscape which suits them.

right The rabbits living on this hillside on Ramsay Island, Wales, ensure that the grass remains short and scrub cannot invade.

combination of sheep and rabbits has prevented shrubs and trees from becoming established and has ensured that the grass is kept short at all times. This has permitted plants to flourish that, strictly speaking, are woodland opportunists, occupying clearings made when old trees fall and sunlight penetrates to ground level, or confining their reproductive cycles to the spring – the brief period during which the ground is warm enough for seeds to germinate, but not shaded by the complete forest canopy. At the same time, the fact that even the grass is kept short throughout the year benefits low-growing herbs that cannot tolerate shade.

The relationships among the rabbits, the sheep and the plants of the Downs was known well enough, but it was taken for granted until history provided us with a convincing demonstration of it. In the 1950s and '60s, agricultural development in Britain concentrated heavily on the production of arable crops and on cattle, especially dairy cattle, as well as pigs and poultry. Enterprises based on these became profitable. The sheep declined, refusing steadfastly to tolerate indoor, intensive systems of husbandry, their litters stubbornly consisting of one, two, or very occasionally three lambs, but never the ten or twelve offspring typical of pigs. They became unprofitable, and little by little the national flock grew smaller, with fewer sheep on the Downs.

When myxomatosis arrived, within a single year it killed some ninety-eight per cent of all the rabbits in the country. Although rabbits recovered slowly, there was a time during which both sheep and rabbits disappeared from the Downs. At once the floristic pattern began to alter. Shrubs appeared; bramble, gorse and hazel started to colonize the region and it was clear that unless steps were taken to prevent it, the Downs would be blanketed by dense, impenetrable scrub. In time this would be succeeded by open woodland, the type of vegetation it supported before the arrival of humans. Volunteers helped to preserve the Downs by chopping back the undergrowth, and the rabbits began to return.

Many scientists suspect that the grasslands of the world may be artefacts manufactured by men and beasts working together to their mutual benefit. We met the process briefly in 'Pastoralists and Farmers', and can now consider it in more detail, beginning with the grazing animals themselves, the cattle, antelopes, deer and horses. Deer are forest animals that browse, but they can and do adapt well to life on open grassland. Antelopes prefer open country to grassland, as do horses. Cattle will live in either, but it is on grassland that they flourish. In the forest, cattle will feed on leaves during the summer, conserving such grass as there is for the winter, when leaves are scarce.

Despite its idyllic image, the sylvan life is far from easy. A mature forest is a dark place. The canopy shades the floor and prevents small herbs from growing except here and there. The leaves which comprise the canopy tend to grow high above the ground, and well out of the reach of animals which cannot climb in search of them.

Occasionally, however, a dead tree will fall, bringing other trees down with it, and so making an opening in the canopy. Eventually new trees will grow to fill the gap, but this takes time, and opportunists are waiting. Sunlight reaches the floor and grasses and herbs begin to grow, and it is here that the grazers can find food. As the new trees begin to assert themselves the canopy will close again, the grasses and herbs will disappear, and the grazers will have to find other clearings. In a large forest there are always natural clearings and so the forest can support a modest number of grazers.

If they are sufficiently numerous, the grazers may convert a temporary clearing to a permanent one. They must continue to graze, which will encourage the grasses to grow more sturdily, they must browse all young tree seedlings so severely as to kill them, and they must trample to destruction other small woody plants that may

The chital deer (*Axis axis*) graze the forest clearings of India and Sri Lanka.

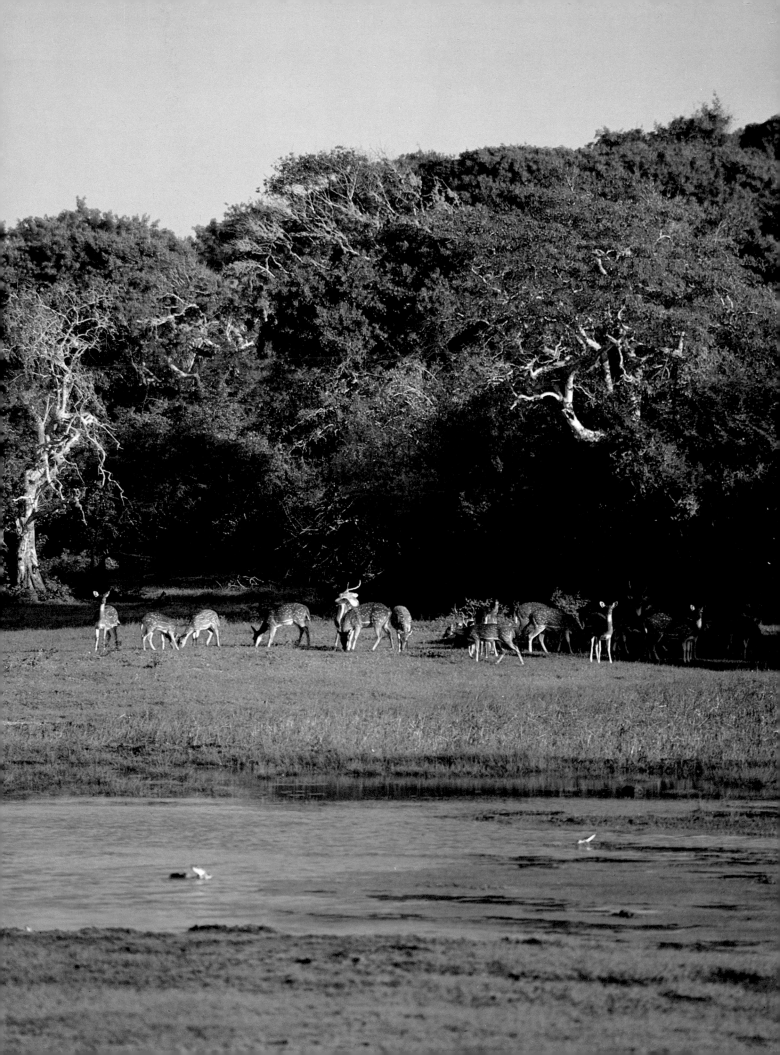

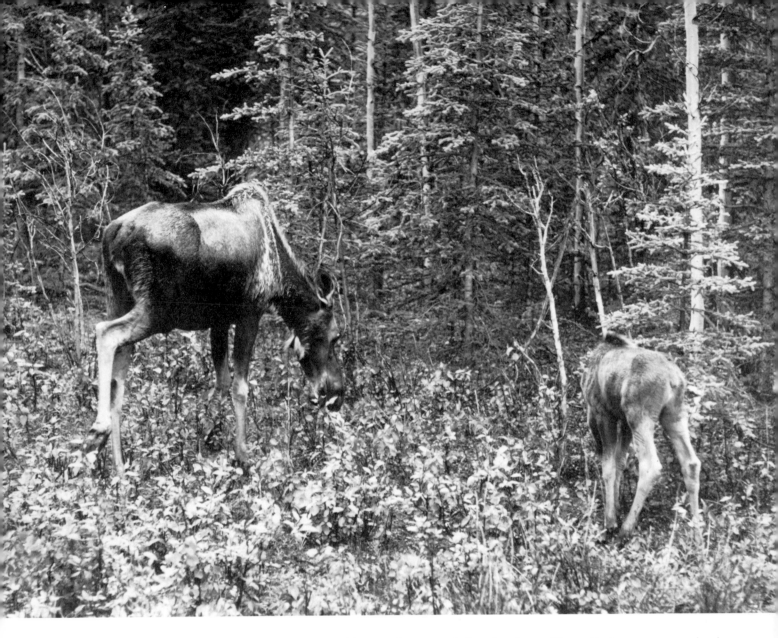

appear. If they do this the forest will be unable to reform, and the clearing will remain for as long as the animals sustain their efforts.

Primeval North America, Africa, China, and possibly central Asia were probably forested. Early men arrived, and lived by hunting, using fire to drive game. This is an activity more ancient than we may suppose, and there is evidence to suggest that *Homo erectus*, the ancestor of modern man, engaged in it. These people did not need to make fire. Fires occur naturally and it is necessary only to use them intelligently. After the forest has burned and game has been caught in the ambushes laid for it, grasses appear, just as they do in temporary clearings, and as grasses thrive so do the surviving large herbivores. If the forest is burned repeatedly and at fairly frequent intervals, those trees which grow more slowly will fail to establish themselves. The area will be dominated more and more by fast-growing, generally smaller species, whose leaves are within the reach of animals that will browse as readily as they will graze. The scrub that replaces the forest will tend to fail and the herbivores to become more numerous until a point is reached when they take full control of the habitat, permitting only grasses to grow.

As we saw earlier, this alters the climate. The soil is less sheltered from the wind once the forest is gone, and in continental climates this tends to increase aridity. Isolated trees do not tolerate the wind well, and so the more open such a landscape becomes the more difficult it is for trees to grow. In a dense forest

Alaskan moose grazing in a forest clearing. In time young trees will establish themselves, and the clearing will disappear. Were the moose to persist, however, the temporary clearing could be converted into permanent pasture.

competition is mainly for light, so the advantage lies with the tallest plants. In fact the great majority of trees grow to the same height. Those that project above the canopy will receive more light, but will also be exposed to the wind which will chill and dry the leaf buds.

Once the process is established it perpetuates itself, because the more open landscape favours grasses, which favour grazing animals, which encourage the further growth of grasses, while grasses and animals together suppress woody plants. The human hunters also become more prosperous. Everyone wins, except the trees themselves. There is an old saying that the prairies made North America, and the bison made the prairies. In fact the bison had help from the pronghorn, an animal rather like an antelope but the only living member of its family, the Antilocapridae.

Despite its very large scale, this is inadvertent landscape modification. The animals involved, other than the humans, did not set out deliberately to change their habitat. Other animals do, and the first of these to be considered is a rodent that has benefited greatly from the modifications brought about by grazers.

Prairie dogs are typical of North America. At least, that is the conventional view. They are ground squirrels which happen to live underground in large colonies. But there is a Soviet ground squirrel to match them, the bobak marmot (*Marmota bobak*), which lives on the steppes, and western Europe has the alpine marmot (*Marmota marmota*). The European and Russian species measure about 55 cm (22 in) from their noses to the roots of their tails, and their tails add a further 13 to 15 cm (5 to 6 in). They weigh up to 8 kg (18 lb), so they are rather large animals more like the American woodchuck, a marmot that spends more than half the year in hibernation. The most common of the North American species, the black-tailed prairie dog (*Cynomys ludovicianus*), is smaller, growing to about 30 cm (1 ft) with a 10 cm (4 in) tail. Sadly, all these animals are much rarer than they were. As landscape architects they have been unable to compete against the ploughs, with which modern humans achieve landscape changes that are minor in so far as cereal grasses take over from other grasses, but that are devastating to burrowers like the ground squirrel.

These social animals live in 'towns', formed from extensive labyrinths of tunnels and chambers and their society is based on family groups, each of which occupies its own region. Encounters between unrelated neighbours inevitably are common and so conflict must be avoided. This is achieved by gestures of appeasement and much mutual grooming which aids relaxation. In part this will serve to mark all the inhabitants of any particular area of the 'town' with a common scent, recognized by all and always kept fresh, and the appeasement gestures placate animals that otherwise might be aggressive.

They feed by day, and play a great deal, taking little notice of their surroundings. They can afford to relax, because at all times the marmots and prairie dogs have sentinels posted to watch for humans and, more dangerous still, for birds of prey, such ground predators as dogs or cats, and for snakes. When danger threatens, the sentinels sound the alarm, a whistling or barking cry, and it is heeded instantly.

The plants of the grasslands grow tall, and even when they stand upright on their haunches, prairie dogs and marmots are rather short. They overcome this handicap by building mounds from excavated earth at the entrances to their tunnels, and the sentinels stand on the mounds and so have a clear view, like tank commanders. The mounds serve a dual purpose by raising the tunnel entrances well clear of ground level, so that the occasional torrential rains cannot flood the tunnel system.

left A black-tailed prairie dog female with her offspring. It is important that the young learn the social behaviour of the community early.

Even so, shrubs which might grow around the mounds would provide concealment for predators, allowing them to move close enough to the colony to block the retreat of at least some prairie dogs. To prevent this, all such cover is removed. Within a wide area around the mounds the prairie dogs bite through and deliberately destroy any young plant that might grow too tall or too bushy for their liking. Thus the colony has its entrances in an open area, providing no cover for predators, and it is an open area of their own making. They modify their environment in the interests of security.

This has a second consequence. The removal of the large, woody plants favours the growth of the smaller herbs and grasses, and it is on these that the prairie dogs and marmots prefer to feed. Thus the 'citizens' of a prairie dog or marmot 'town' have ample room in which to meet and to play in safety, and their preferred food is available for them on their own doorsteps. This amounts to landscape modification of a high order. Its effect is rather similar to that achieved by the large grazing animals, but it is much more purposeful, and we should not underestimate its scale, for where these animals thrive they do so in large numbers and with a high population density, so that the territory of one colony lies very close to that of its neighbours and together the colonies may manage a substantial area of land.

In winter prairie dogs and marmots hibernate. 15°C (59°F) is the temperature below which many rodents begin to prepare for the winter and at around 8° or 9°C (46° to 48°F) they will sleep, allowing their body temperature to fall. Among colonial animals, whose sentinels must hibernate just like all the others, steps must be taken to ensure the security of the 'town'. Vegetation is dragged into the burrows

opposite above On their mounds, covering every direction, the black-tailed prairie dog 'sentries' are ready to give warning the moment they see danger.

opposite below Mounds made by black-tailed prairie dogs in South Dakota; each mound surrounds a tunnel entrance.

Within the prairie dog community, conflict is kept to a minimum by means of frequent greeting, in which individuals recognize non-aggressive neighbours.

A prairie dog 'town' in the Theodore Roosevelt National Park, North Dakota.

to make bedding, and then the entrances are blocked firmly with earth and stones.

Other squirrels modify their environment, but quite accidentally. Their habit of collecting acorns and nuts and storing them for the winter is legendary. It is also extremely inefficient, because most of the squirrels forget where they stored them. The effect, however, is to distribute seeds – for acorns and nuts are seeds – over a wide area, often some distance from the parent trees. There the seeds germinate and so the woodland spreads. While the ground squirrels seek the perpetuation of their grassland, therefore, the absent-minded arboreal squirrels help perpetuate and extend their woodland.

The supreme landscape – or more correctly waterscape – architect is the beaver. It is an animal that has been persecuted cruelly over the centuries. Because of its aquatic habits and its flat, rather scaly-looking tail, in the Middle Ages it was classed as a fish, and so could be eaten on fast days. Its flesh is said to be excellent and its fur has been prized highly throughout history. It is protected now and its numbers are increasing. In Europe, where it came very close to extinction, it is being introduced to regions once inhabited by its forebears. The European and American beavers are very similar, but constitute two species, *Castor fiber* and *Castor canadensis* respectively.

Essentially, the beaver is a large rodent which lives beside water in a burrow and feeds on leaves, bark and twigs from young trees. The burrow may be made in the bank of a river or lake, with the entrance below the surface of the water. The burrow rises upward from the entrance to a chamber about 1 m (3 ft) across and

A well established beaver lodge in Teton National Park, Wyoming, clearly showing the entrances.

half as high as it is wide. Each chamber will have several entrances, but all of them will be below water. At the top is a ventilation shaft to the surface.

Should the water level rise, the chamber will be flooded. When this happens the occupants pile sticks and twigs above the chamber, extend the ventilation shaft, caulk what is now known technically as a 'lodge' with earth, extend the burrow upward and make a new, higher chamber. In time the animals may be living in a lodge that is high above the ordinary water level.

Where they can, beavers prefer to be surrounded by water, and so they must build from the bottom. They use sodden wood that will not float, piling it on the bottom until they have made an artificial island. When the island extends above the water they continue to build, now using earth and mud to bind the wood from which it is primarily made. The lodge always contains a single chamber in which the beavers live, and a ventilation shaft from which steam can be seen rising on cold days.

If they have built in a fast-flowing river, there is a danger that the lodge will be swept away. Beavers must have still or slow-moving water, but this they can arrange. They dam the flow to make a pool, usually about 1 m (3 ft) deep. The dam is built from timber. Sticks are driven into the bed to hold the wall, heavier timber is used to weight smaller wood, and twigs to seal the cracks. Sometimes cross-members are used to add strength. The dam is weighted with stones and is secured

The dam (*above*) guarantees the depth of water the beavers require. Well built and sometimes large, it is a complex feat of hydro-engineering.

Two beavers (*opposite*) entering the chamber of their lodge. Beavers mate for life.

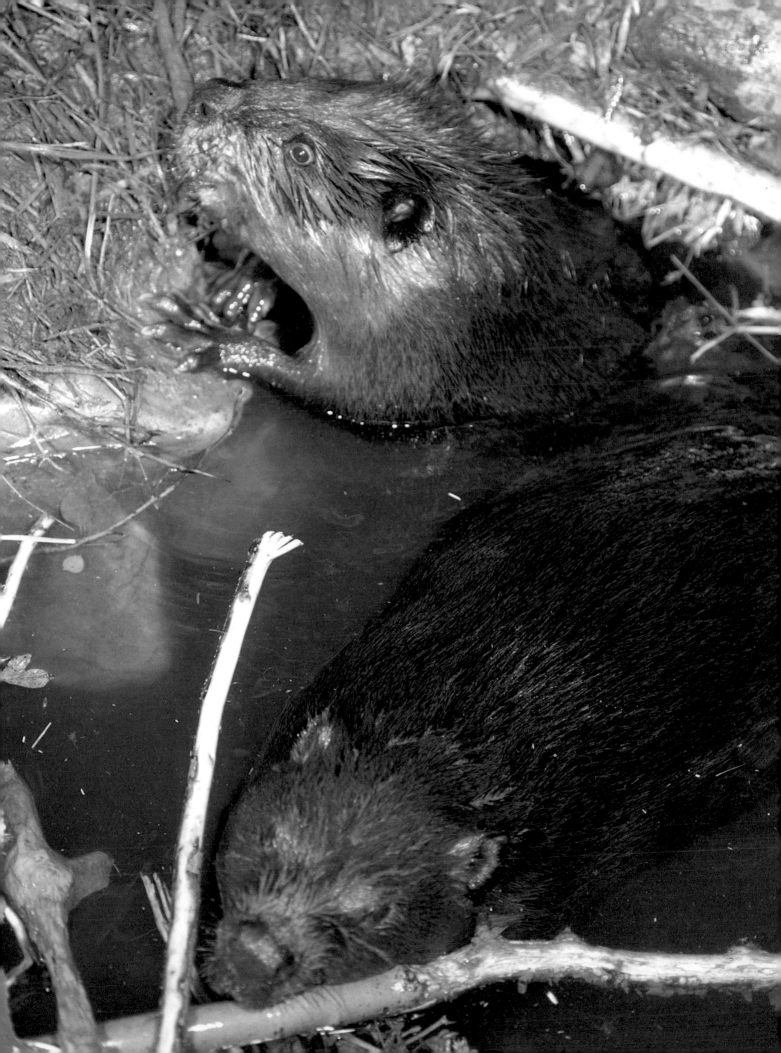

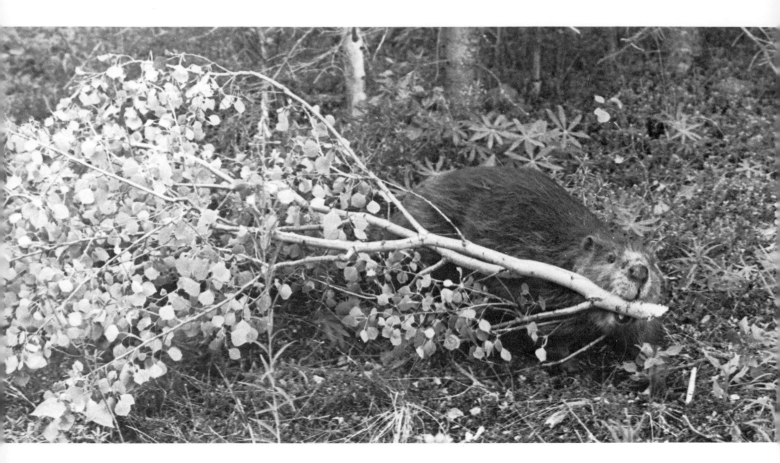

at either bank against growing trees or large boulders. Finally, the part of the dam that is above water level is caulked with mud. The part below the surface traps silt and so it, too, becomes quite watertight.

Beaver dams can be large. There are records of dams more than 100 m (328 ft) long. They are also strong: one American beaver dam was said to support the weight of a man on horseback.

Beavers mate for life, and the lodge is inhabited principally by the adult male and female. With them they have their young from two annual litters, so there may be up to twelve animals living in a lodge at one time. The young are born in the spring, so at that time the remaining young are one and two years old. The female has the lodge to herself while she gives birth and until the kittens are weaned, and it is during this phase that the older offspring leave the family to build their own lodges elsewhere, while their father lives on shore until it is time for him to return.

Their knowledge of building and water management is innate. Captive beavers which have had no opportunity to learn the techniques can build lodges and dams. Nevertheless, like most complex behaviour it can be improved with practice, and during their first two years the young beavers are given ample opportunity.

They build with wood, a material they do not find lying on the ground but which must be obtained, and that means the beavers must fell trees. Their skill at felling is associated only partly with building. They feed on leaves and the young parts of trees, preferring willow, aspen and other waterside species, and in the majority of cases the most delectable food is high above ground and well out of their reach. They must fell in order to feed, but they do not restrict themselves to food plants or to trees whose wood is soft. Beavers will fell oak.

They use as tools their long, chisel-like, sharp incisor teeth, which grow throughout their lives, gnawing around the stem of the selected tree in a circle until

Like all rodents, beavers have incisor teeth that grow continually and wear to provide chisel-like, very sharp edges. There are few trees beavers cannot fell.

Moving felled timber to the water presents few problems, and beavers will often collaborate in the task.

they hear the tell-tale cracking which warns them that the tree is about to fall; then they run clear. Legend has it that beavers can fell trees in such a way as to make them fall in a particular direction. This is untrue, unhappily for the beavers, for a significant cause of death among them is injury sustained by falling trees which hit them because they have run the wrong way. However, very often their trees do fall predictably. This is because waterside trees tend to be anchored less securely on the side closest to the water, and they tend to grow out over the water where there is more sunlight. When they are felled, therefore, almost invariably they will fall into the water.

The beavers then trim the side branches and twigs from the main stem, cut all the wood into pieces of a convenient size, and swim with them to the place where they are to be used. Moving timber through water is very easy for an animal which swims expertly.

Not all their timber can be obtained from the side of the water, however, and often they must move some distance inland. Here they face greater difficulty. Their trees may fall in any direction and once felled they must be transported to the water over land. If the ground is level and the felling site not too far from the edge of the water, the beavers will dig a canal, manoeuvre their timber into it, and float it to their lake, swimming alongside to push and guide it. If the site is more distant, or if the ground rises away from the water, this is impracticable, and the beavers clear a path from the felling site to the water and keep it smooth. All projecting twigs are removed from the timber that is to be transported, and then the load is pushed and dragged, while the smaller pieces are carried. Beavers have the manipulative forepaws of all rodents, with a digit that is used in the way we use our opposable thumbs, allowing them to grip objects firmly and with some precision.

Beavers do indeed 'work like beavers'. For once the popular estimation of them is correct, although even they do not work all the time. Once the lodge and dam are built, subsequent work upon them amounts to no more than maintenance. Nevertheless, the initial construction involves a great deal of work, and much collaboration. Although each lodge houses only a single family, a lake may contain several lodges, and the building and maintenance of the dam is undertaken by all

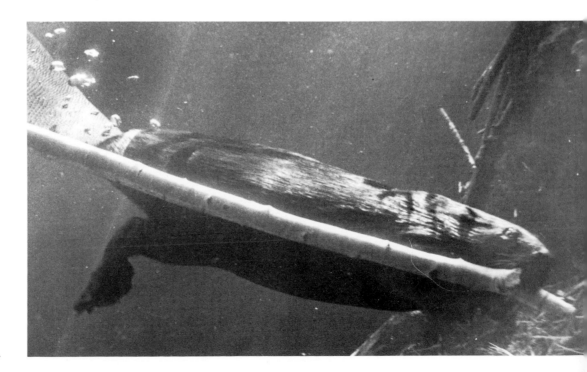

Once in the water, the beaver guides the timber with its body.

the beavers, though working as individuals rather than as a team. They scent-mark the dam and lodges, so that all members of a colony can identify one another.

They do not hibernate, so beavers must lay in a store of food for the winter. The food consists of small branches and twigs, and it is stored at the bottom of the lake, weighted to keep it in place. Each lodge has its own store.

Many beavers plaster the outside of the lodge with wet mud early in winter. The mud freezes hard and so the walls of the lodge are made very strong, and quite sturdy enough to keep out predators. It is necessary to take special steps against predators, of course, because the cold that freezes the mud walls also freezes the surface of the lake so carnivorous animals can walk over it.

The ice does not inconvenience the beavers. They are snug inside the lodge, and the entrances that they use when taking food from their stores are below the ice. Often they will make a temporary opening in a dam after the ice has formed, so that some water drains from the lake to leave an air space below the ice. This enables them to move through the water and to breathe at the surface, without breaking the ice.

A beaver lake may inundate several hectares of land and it is a clear and deliberate modification of the landscape. While beavers will enlarge their lodges as necessary, and the young will build new lodges, the lake cannot be extended so easily and when it becomes too small for the number of beavers inhabiting it, some will leave and build a new dam and new lodges elsewhere. The landscape modification can multiply, therefore, until quite large areas are affected.

The modification is not permanent, at least not in the form in which it was made. In time the beaver lake fills with silt, and ingenious though they are, beavers cannot remove soft mud. As the lake becomes more shallow, in time the beavers will have no choice but to move to a completely new site and to start work all over again. It is not a frequent occurrence. Indeed, it is one most beavers may never face at all, because although some individuals may have to move elsewhere when the lake becomes too crowded, a dam-lake-lodge complex will serve many beaver generations.

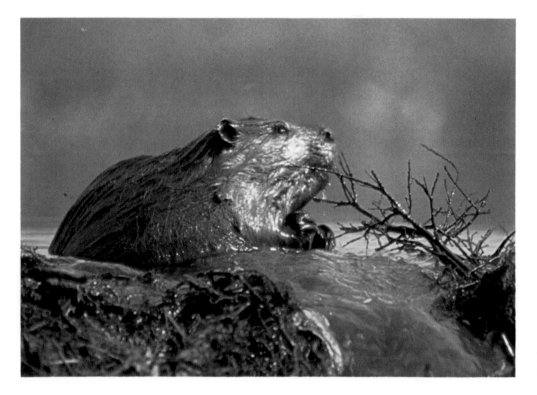

Each stick is positioned carefully in the dam wall.

A beaver lodge and dam in Vermilion Lake, in the Rocky Mountains.

When the beavers depart the dam remains. In time it may collapse for want of maintenance, but long before that most of the lake will have filled with silt and grasses will have entered to colonize what soon turns into dry land. At this stage grazing animals or humans often appear, the one to graze the grass, the other to farm it. Beavers thus convert forest into farmland, and that is a further, if inadvertent modification of landscape. If no other animal wishes to use the new-made land no harm is done, for in the natural course of events trees will begin to grow among the grass, then they will dominate and shade out the grass, and so, finally, the forest will be restored. In the United States, where once beavers were considered the enemies of foresters, today they are parachuted into forests in containers from which they can easily escape once they are on the ground. Their dams help prevent soil erosion in upland areas, and the lakes and temporarily marshy areas they make provide a habitat for many semi-aquatic species.

Sea Transport

EVERY fish can swim, but it does not follow that on all occasions it will choose to do so. Fish swim in order to find food or mates or to avoid predation. These tasks take many fish on long migrations between feeding and spawning grounds, and between one feeding ground and another in the course of a year.

Swimming along migration routes is rather different from migrating over land, on foot or by flying. The medium itself moves, as does air, but unlike the air, the oceans are affected not by short-lived weather systems but by predictable currents and drifts, and by tides. Fish exploit this fact, so that their migrations are not a matter of swimming stoically from one point to another on the earth's surface, coping with the movements of the water as these are encountered. They are much more subtle than that.

Fish migrations were observed first by scientists at the Fisheries Laboratory, Lowestoft, Suffolk, equipped with a sonar device that produced a picture on a screen much like a television. The first subject of experiment was the plaice. Because of the shape of the plaice, and the behaviour it had been observed to exhibit many times, everyone assumed that it lived on the sea bottom, and that it migrated along it. The scientists caught a plaice, tagged it with a device that made it show up clearly on the screen, released it, and followed by ship. They

opposite A shoal of fish off the Great Barrier Reef. Shoals take advantage of the tides and offer protection from predation.

right Plaice rest until the turn of the tide, burying themselves in gravel, where they remain motionless and invisible.

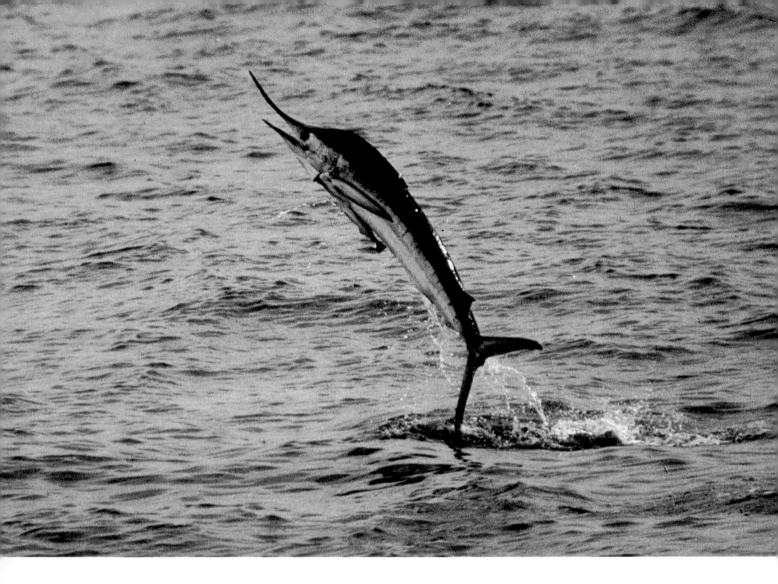

found that the plaice swam in midwater, far from the bottom, but that it did so for only part of the time. In fact it was riding the tidal flow. When the tide was flowing in the direction in which it wished to travel it rose into midwater and swam with the tide. When the tide began to turn, the plaice sank to the botton, lay on the sea bed, and rested. Later, cod were found to use their own version of the technique, and it seems probable that most, if not all, migrating fish use it to some extent.

This discovery demonstrates two things. The first is that the journeys of fish are purposeful and have definite destinations. The second is that the mode of travel is efficient and economical. Fish do not waste their time and energy swimming against the tide. Sailfish, of course, and some whales, swim at the surface and use the wind, extending a large fin or, in the case of the whales, their tail flukes, allowing themselves to be blown through the water.

Since sea travel is purposeful, we should not be too surprised to learn of fish that find it too much of an effort, but whose need for it is in no way diminished by their reluctance to work. The sea, then, has its hitch-hikers, and they are highly adapted for their way of life.

There is a whole family of them, called Echeneidae, whose common name is derived from the name of their most famous genus, *Remora*. There are about seven species of remoras and they live throughout the tropical and temperate seas.

Remoras possess a spiny dorsal fin, modified to form a sucker on the top of the head. The spines provide the structure for plates from which the disc is composed, and each plate can be raised independently to create a partial vacuum if the disc is pressed against an even surface. Thus the sucker is under the direct control of its

A striped marlin leaping from the water, with two remoras attached to its underside.

owner at all times. The remoras pick on a shark, whale, porpoise, turtle or other large animal that is travelling in what seems to be a promising direction, attach themselves to it firmly, and go along for the ride. If their transport starts to feed, its remora may join in, eating fragments that fall from the larger animal's mouth. If the transport is not feeding, the remora will detach itself when it reaches a locality in which food is likely to be found. It is not a parasite, merely a passenger, and it swims perfectly well when it is searching for food. Its grip is very tight, and to detach a remora it must be slid forward. Any attempt to pull it off merely attaches it more firmly.

Obviously, sea transport presents no difficulties for marine animals. It is their medium. For others, though, the ocean may form an obstacle that cannot be crossed. Yet some animals do cross it. Birds peculiar to one hemisphere sometimes are found in the other hemisphere, as vagrants. Clearly they have flown across the ocean by accident, carried on winds they were too weak to resist. Insects, too, may be carried long distances, and bats are dispersed by air on journeys that carry them over water.

There are other cases, however, which are not explained so easily. They arise from studies of the animal populations of oceanic islands, and from the composition of the fauna of Australia.

Australia, it is believed, separated from the ancient continent of Gondwanaland before the appearance of placental mammals, but after the marsupials had established themselves firmly. Parts of Gondwanaland came into contact with the northern continent of Laurasia (which became Eurasia and North America), where placental mammals appeared first, but Australia became isolated, and although well stocked with marsupials, it supported no placental mammals. In the rest of Gondwanaland (which became South America, Africa, Madagascar, Antarctica and India), placentals entered from Laurasia by land and the marsupials declined until they were all but extinct. The reasons for their extinction

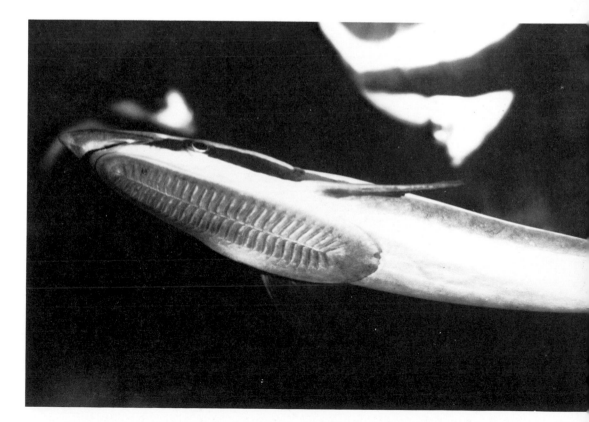

The sucker of a remora; once attached it is almost impossible to remove it.

are far from certain. Marsupials are highly efficient mammals, and while it seems clear that they could not compete against the placentals it is difficult to see why this should be so. Be that as it may, at one time the world consisted of fragments of the old Laurasia and Gondwanaland, which had joined, and Australia and Antarctica, which were isolated from them; the main continents were populated by placentals, while Australia continued to be populated by marsupials.

This seems clear enough, but unfortunately there are just a few exceptions. Australia possesses native placentals in the form of bats, which evidently flew to their new abode, and some rodents. They arrived not by swimming, for most rodents do not swim from choice, and in any case they could not possibly have swum the hundreds of kilometres which separate Australia from the nearest land.

The conclusion is that they 'hopped' from island to island, right across the Pacific, from Asia or from America. Their travels were not made deliberately, of course. A fierce storm might blow down trees or detach branches that would be swept into rivers. A small animal, finding itself thrown into the water in the turmoil, might climb on to floating vegetation to seek refuge, and would be carried out to sea. Most castaways would perish, starving before their raft became waterlogged and sank, or before it reached land. Just a few, however, might reach a shore on which they could settle and find food, and if enough survived, a new population might become established. The chance of this happening is extremely remote, but where time is measured in millions of years, there will be many occasions.

This method of dispersal is adequate for small animals, but most large animals could not use it. Once in the water it is almost impossible for a large, heavy animal, whose limbs extend vertically downward from its body, to climb on to a raft, although there are stories of tigers – which swim well and readily – climbing on to boats at sea. Claws can provide the grip necessary for an animal to drag itself from the water, perhaps, and the strong hands of a monkey or ape might serve, but

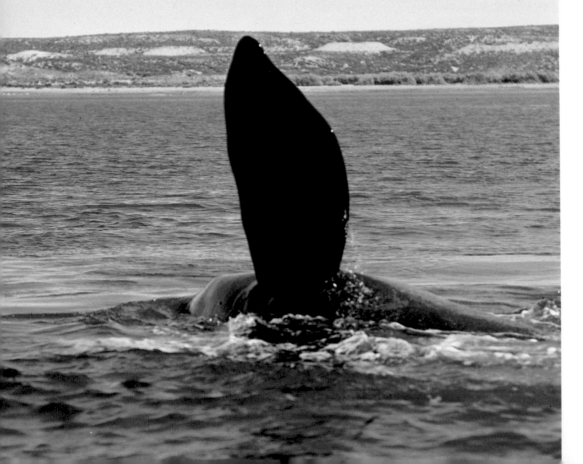

A southern right whale off the coast of South America, riding with one fin raised as a sail.

Velella, the by-the-wind-sailor, a Portuguese man o' war, its float extended to form a sail.

hooves almost certainly would not. So it is the small, agile animals that have colonized remote islands whereas by and large the grazing herbivores have not, unless the distance between islands is small enough for strong swimmers to cross. Most animals swim strongly if they must.

There is at least one example of deliberate boating by a non-human. Orang utans have been observed to make and use rafts and boats, and in some cases to propel them.

The animals concerned were being rehabilitated to the wild in the Tanjung Puting Reserve in Central Indonesian Borneo. The zoologist B. Galdikas watched individuals use rafts made from any nearby article that would float and support their weight, including rafts made by humans and boats, in order to cross rivers. Some orang utans discovered they could direct and accelerate their vessels by pulling at water weeds, and others learned to paddle their boats. One enterprising ape was seen pulling repeatedly on the starter cord of an outboard motor – happily without succeeding in unleashing a force it might have failed to control. No knot was too complex for them to unfasten, and so no mooring could be considered secure. The orang utans based their behaviour on their observations of the humans, but their ability to learn from examples set by another species detracts in no way from the skill and initiative they displayed.

Water, especially large bodies of water, presents a formidable obstacle to the spread of animals which can neither fly nor swim, but it is not necessarily an insuperable obstacle. Animals have crossed water in the past, and do so still, and not all the swimmers choose to waste time and energy swimming when larger, more powerful animals can be made to carry passengers.

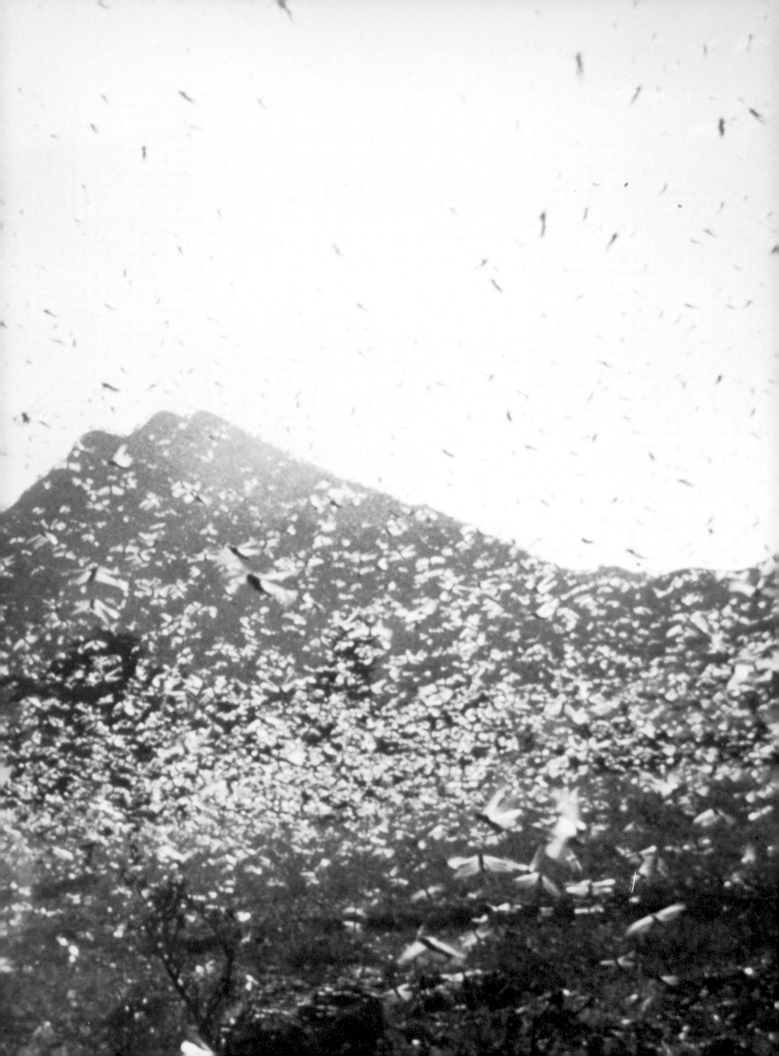

Air Transport

EVERYONE must have seen ants flying. There is a particular day in the year when all the ants from all the nests in the neighbourhood take to the air at the same time. The phenomenon does not last for more than a few hours, but while it lasts the world seems filled with ants.

Appearances are deceptive, for it is not all the ants that fly, only the sexually mature males and females. The great majority of ants, like all hymenopterans, are sterile female workers. The flight is nuptial, and the fact that many colonies fly together ensures much cross-fertilization, which is genetically advantageous, as males seek out females. After the flight the males die and the impregnated females,

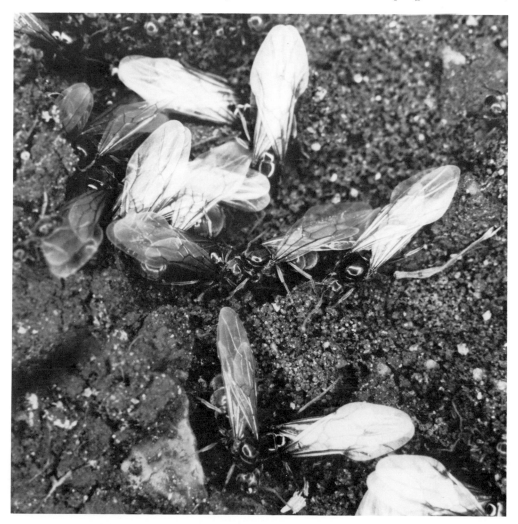

opposite Desert locusts swarming in Ethiopia. Individuals fly in every direction, but the swarm as a whole moves with the wind.

right Common garden black ants preparing for the nuptial flight. Each colony produces winged forms which fly together, mate, and disperse. The ants will fly as soon as weather conditions are favourable.

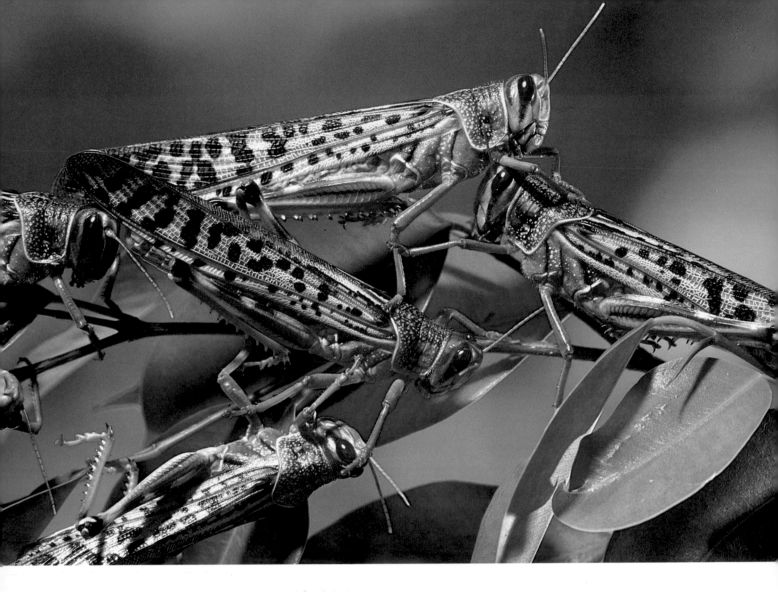

which will spend the rest of their lives laying eggs, shed their wings. Among ants, flight is used only to allow for the dispersal of colonies and the subsequent founding of new colonies, and mating forms an essential part of this process.

The termites use flight in a rather similar way, sexually mature males and females developing wings only for the purpose of the dispersal flight, then losing them. There is a difference between the flight of the termites and that of the ants, in that the termite flight is not nuptial. Individuals do not mate in flight or immediately upon alighting, but merely use their wings to disperse to new areas. When they land and their wings are shed, males seek females with which to mate. The flight is more of a 'courtship' flight. There is a further difference. Among the more primitive termites the males survive after mating and make a positive contribution to the community, whereas male ants die.

Aphids also grow wings for dispersal and mating, although their strategy is different yet again, and asexual winged forms may be produced at any time during the season.

Dispersal is not always entirely voluntary among insects. They are small animals, and although they may fly strongly they remain always at the mercy of the medium through which they travel. Thermal currents and winds may carry them high and far, and while a long journey may suit their purpose, in some cases it is injurious and purely accidental. The May or June beetles – the name is different according to the month in which they are most commonly seen in a particular locality, but the insect is the same – embark on nuptial flights early in summer. Those that live in forests may be caught in rising thermal currents, then

Adult, sexually mature desert locusts.

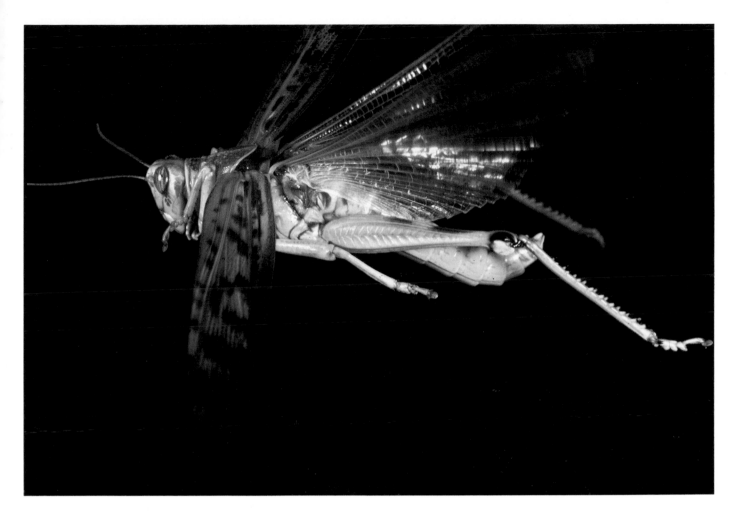

A male desert locust in flight. The immature 'hopper', which does not join swarms, is coloured indeterminately, often resembling its background. The sexually mature, swarming adult is yellowish and spotted. This locust is changing from one state to the other.

transported many miles before the cooling air drops them helpless and exhausted, sometimes over cities.

The mechanism is arbitrary, but that is not to say that insects are unable to take advantage of it. When solitary locusts find their food supply dwindling, their behaviour and appearance change so dramatically that throughout history until the 1920s the migratory locust was believed to be a distinct species which appeared only during infestation by swarms and which vanished completely afterwards. The solitary locusts, which are distributed widely in the more arid parts of the world and are very common, become more aggressive, their colour changes, and singly or in great swarms they take to the air. As they fly, slow motion film of a moving swarm has shown that individuals are flying in all directions. The swarm as a whole moves, but its members may be flying in the same direction or in any other direction, including the opposite direction. Probably they will turn back toward the centre of the swarm when they reach the edge and the insects around them become fewer, but they are not migrating as birds migrate, each individual flying quite deliberately from one place to another. The swarm is moving with the wind.

How, then, can such drifting benefit the locusts? The answer is subtle. The swarm climbs until it finds itself in a strong wind, the stronger the better, but almost always a wind whose speed exceeds the flying speed of a locust. Strong winds flow around air pressure systems and gradually fill areas of low atmospheric pressure. Thus an insect which rides the wind eventually will be carried into a cyclonic region and then to its centre, if only it can remain airborne for long enough. At the centre of a low-pressure area there is likely to be rain, and where there is rain, plants

are likely to be growing, that is, food. The locusts did not work this out for themselves. They merely fly. The weather does the rest, but it enables the locusts to thrive.

Many flying insects, perhaps most of them, migrate. Dragonflies have been known to do so, and in great numbers, and even ladybirds have been found hibernating or aestivating high in mountains 150 km (93 miles) or more from the places where they feed and breed.

For a small animal, wings are not absolutely necessary for flight, and for long-distance flight often they serve only to keep their owner airborne. Even spiders can and do fly, both as juveniles and, if they are small, as adults.

All spiders produce silk continually, and while they are moving about away from their traps they lay drag lines, secured at intervals, so that they may escape from any danger they meet by dropping vertically to safety. They reproduce by laying eggs, and a female spider may lay up to 3,000 eggs in a single laying session. She wraps the eggs in one or more cocoons made from her own silk, and then, depending on the species, she may place the cocoons on her web or in her lair, or she may attach them to her own spinnerets and drag them behind her until they hatch.

The eggs hatch to produce spiderlings, minute replicas of the adults. Before very long, the spiderlings face a serious problem of overcrowding. If there may be up to

A locust swarm settling for the night.

Spiderlings, crowded on a web from which they must 'balloon' to find food and avoid predators.

3,000 of them from a single female, and if there are many females in the area, the spiders must experience either a huge population explosion or the death of some 2,998 out of each 3,000 infants – from predation, since they present a large source of food to others, or from starvation, if the predators do not arrive quickly enough. This is hardly efficient.

After a few days, therefore, each spiderling climbs to the topmost point of the highest plant it can find. Usually this will be a tall blade of grass or a shrub. It clings tightly to the plant, paying out a line of its own silk, which billows in the wind. As soon as the spiderling – or it might be a small adult spider – feels itself being tugged strongly by the silk line, it releases its hold on the plant and is carried into the air, through which it travels until its line tangles on a solid object and it is brought back to the surface, swinging on what has now become a drag line.

The technique is known as 'ballooning', and while its practitioners are utterly at the mercy of the wind, in fact they are no more so than are most migrating insects or, for that matter, than human balloonists. The possession or non-possession of wings can be misleading.

Most spiderlings travel no more than a few hundred metres, or perhaps a few kilometres, but there are exceptions. Spiderlings have landed on ships at sea and hundreds of kilometres from the nearest land, and they have been found at altitudes up to 3,000 m ($5\frac{1}{2}$ miles).

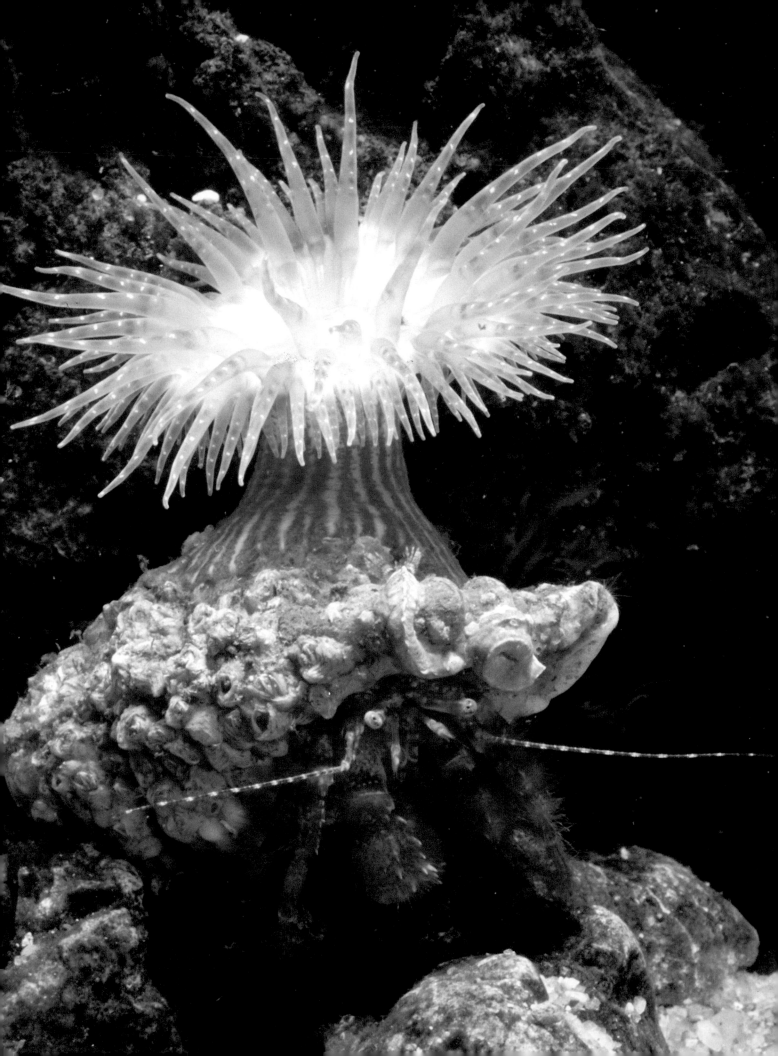

Teamsters

THE great majority of crabs possess a strong exoskeleton, which provides more or less adequate protection against the many animals that feed on them. The hermit crabs, however, lack shells of their own, and far from this being a serious disadvantage, they have compensated so successfully that for millions of years they have thrived in seas all over the world. A few of them even venture on to land. They have freed themselves from the need to invest food and energy in the production of their own shells, and from the hazardous business of moulting. All animals with exoskeletons can grow only by discarding one skeleton and growing rapidly in the short interval before a new skeleton hardens. During this time they are highly vulnerable to predators, and the task of extracting limbs from a tightly fitting casing results in many injuries and frequent deaths.

The hermit crabs use the discarded shells of other animals, usually gastropods such as limpets or whelks. Their own bodies have evolved a shape that suits such occupancy, and a hook by which they can attach themselves securely to the shell of their choice. Once inside their shells they can and do move freely, and when a crab outgrows its shell it seeks a larger one to replace it.

Hermit crabs are among the more intelligent of invertebrate animals. They choose their shells with great care and discrimination and some of them are able to communicate with others of their own kind, conveying a surprisingly large amount of information. Some, most notably those of the genus *Pagurus*, have a social hierarchy that determines which crab gets the best shell.

These crabs have been seen to assemble in the vicinity of a shell that is about to be vacated, an event they are able to predict very easily if the present occupant is being eaten by a predator. While they are waiting for the accommodation to become available they make threatening gestures at one another until a dominant crab is identified, and chosen to receive the new shell. As soon as the predator drops it the crab begins to examine the shell and, if it is suitable, will climb into it. This can take several minutes, but the remaining crabs do not merely stand and watch. They all change shells among themselves, quickly scrambling out of shells and into them as though their lives depended on it, in a ritual whose purpose is utterly obscure.

The most dangerous enemy of the hermit crab is the octopus; once ensconced in a shell large enough to allow it to retreat completely the crab is fairly safe, but there are hermit crabs which demand still greater protection. Those of the genus *Dardanus* carry sea anemones on their backs. There are other, more conventional crabs whose shells are camouflaged with bits of broken shell or sponge, and anemones, which sometimes attach themselves to crabs. *Dardanus* crabs actually choose anemones, place them on their backs, and then carry them wherever they go, and it seems they prefer those of the genus *Calliactis* as passengers. They are

A hermit crab carrying a sea anemone on its shell for protection.

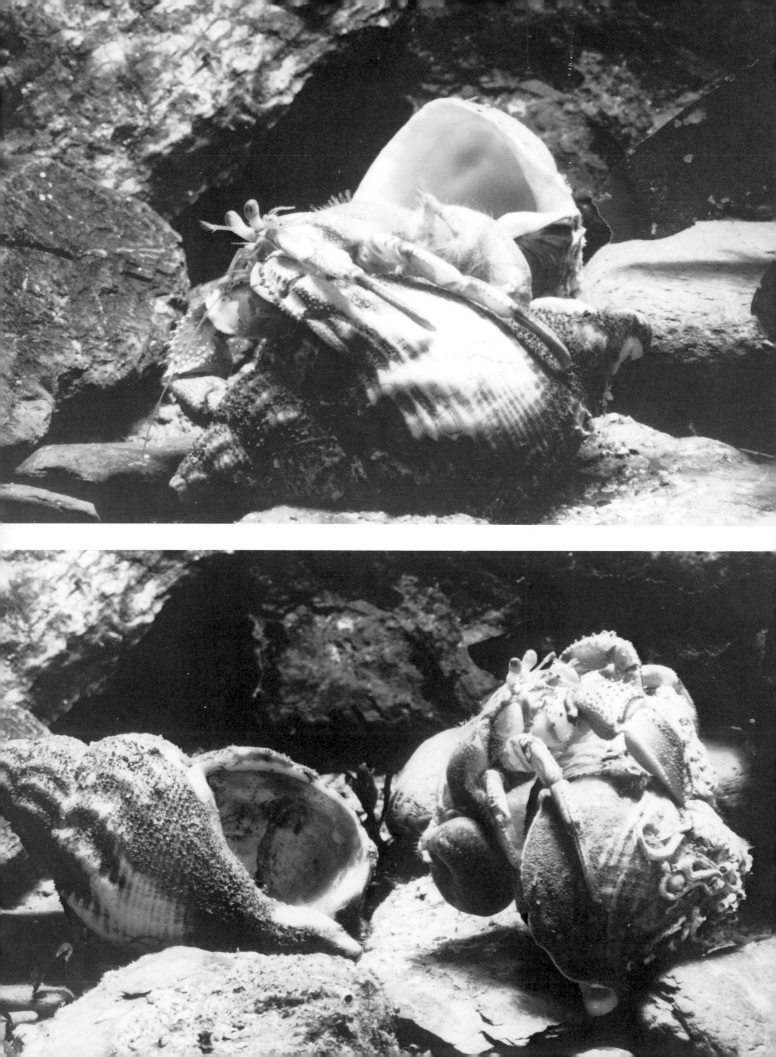

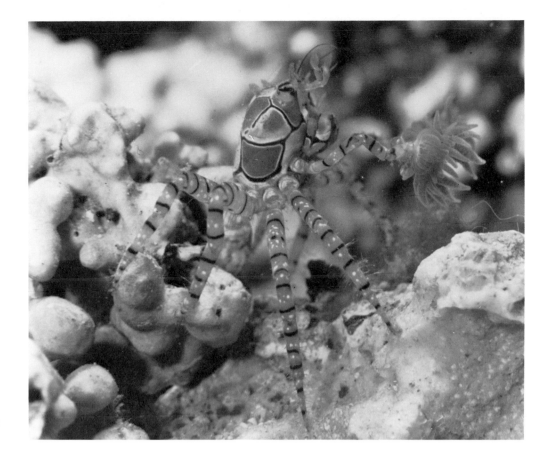

A grenadier crab, brandishing a stinging sea anemone in each claw.

mutually beneficent partners, or 'commensals', for the stinging tentacles of the anemone are potent enough to discourage the unwelcome attentions of octopuses, and the anemone is carried to areas in which food is likely to be abundant.

Obviously, when the hermit crab moves to a new shell, the anemone must move with it. Although the simplest way to effect the transfer would be for the crab to move and then to pick off its anemone and place it on to the new shell, observers have claimed that this is not what happens. By some intricate means of communication, the anemone is informed that the crab intends to change shells. The crab detaches itself from the old shell, and so does the anemone. Then both partners move independently to the new shell.

Eupagurus prideauxi is a small hermit crab with a unique solution to this problem, and one well known to students of invertebrate zoology. Its anemone (*Adamsia palliata*) dissolves the mollusc shell and takes its place.

The grenadier crab (*Melia tessellata*) is even more dependent on anemone weaponry than the *Dardanus* hermits. The grenadier has small, weak claws, and uses its walking legs to seize food and carry it to its mouth. Those same legs are used to capture anemones, detaching them from the rocks on which they live and passing them to its claws. The claws are used only for carrying anemones, which are held firmly but without being injured, one in each claw. Grenadier crabs are found in seas throughout the world, and it is rare to see one without a pair of anemones. Laboratory grenadiers have been deprived of their anemones to see what they would do, and in particular to see whether they would revert to more usual crab behaviour and use their claws for feeding. They did not, but continued to collect food with their walking legs, which were seen to be modified for grasping.

The species of anemone that is preferred varies among grenadiers from one part of the ocean to another, but the crabs are selective and a grenadier holding a

The hermit crab chooses its shell with care. This crab (*opposite above*) is inspecting a vacated whelk shell. The new shell is satisfactory (*opposite below*), and the hermit crab moves from one shell to the other.

opposite The Portuguese man o' war, *Physalia*, consists of a gas-filled float and sail, and tentacles. The organism is not one animal, but a colony of animals living and working in harmony.

left A coral feeding. The individual polyps can clearly be seen projecting from their tubes. This is *Dendronephithya*, a soft coral, leathery or fleshy in texture rather than calcareous.

below Sea pens live on a soft sea bed. They consist of a large primary polyp, with a stem-like base by which it is anchored to the bottom, and a fleshy body containing calcareous spicules. The body gives rise to secondary polyps of different types.

damaged anemone will discard it if it finds a whole one of the preferred type. It uses the anemones as weapons. Threaten a grenadier crab and it will turn toward you and wave its anemones in your direction. If you come close enough, the anemones will sting you. The weapons are very effective.

What benefit the anemone derives from all this is uncertain, because the crab also steals food from its companion. It will 'groom' its anemones, with its walking-feeding legs, removing small particles that cling to their surfaces and eating any that are edible, but it will also try to take food in the vicinity of the anemone and even to remove food from the tentacles after the anemone has caught it.

Team work of the highest order, however, is found further down the evolutionary scale among animals much simpler, or apparently so, than the crabs.

Sponges are animals, the simplest of all multicelled animals. As adults they are incapable of movement, but grow 'branches', and for this reason they were thought to be plants until closer observation of them in the eighteenth century revealed characteristics that are clearly animal, but different from the characteristics of any other group of animals. Sponges have existed for more than a billion years, but no other animals have evolved from them and they have no close relatives. They have no internal organs: no mouth, no gut, no nervous system, but are organized around a system of canals through which water passes, food particles being filtered from it and waste products added.

The origin of sponges is obscure, but one theory holds that they are derived from colonies of single-celled protozoa. The cells of which a sponge is composed perform specialist tasks, but they remain relatively independent and most of them are able to live alone. This gives the sponges remarkable regenerative powers, which can be demonstrated by passing one through a silk screen. The screen breaks the animal into minute fragments. If conditions are suitable, these fragments will recombine to form several new sponges, each individual cell moving to the position relative to the others which it occupied in the original sponge. Sponges are cultured by cutting a living sponge to pieces, attaching the pieces to blocks of concrete, and placing them in the sea to regenerate.

It seems likely, then, that a sponge is not so much an animal as a colony of single-celled, amoeba-like individuals that work together, each individual specializing for a role in the community. Some of these cells, known as 'archeocytes', are able to form other types of cells as these are needed.

There is no doubt whatever that the siphanophorans consist of such colonies. The best-known member of the order Siphanophora is *Physalia*, the Portuguese man o' war, whose tentacles may extend for several metres below the surface on which the colony floats, and can deliver a painful, even dangerous, sting.

The colony consists of hydras, animals that may exist as medusae, as polyps, or as both, at different stages in their life cycles. The medusa is a free-swimming animal shaped like an umbrella. Its mouth is situated at the centre of the concave underside and tentacles hang from the rim of the umbrella. We recognize the semi-transparent, soft-bodied medusae as jellyfish. The polyp consists of a tube, anchored by its base to a solid surface and with a mouth, surrounded by about five tentacles, at the outer end. The surface layers of both types of hydra, and especially the tentacles, contain cnidocytes, cells unique to the phylum *Cnidaria*, to which all these animals belong. The cnidocytes carry the stinging apparatus, in the form of nematocysts; there are several types of these, but they consist essentially of a thread-like tube, often barbed, that in some species contains a poison. The nematocyst is discharged explosively upon receipt of an appropriate stimulus, either completely or with one end still attached to the hydra, and its purpose is to capture food. All hydra are carnivores, and their nematocysts either entangle the

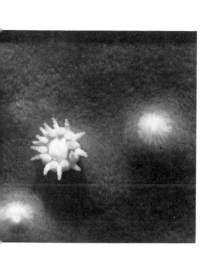

above A single polyp of a hard coral, surrounded by polyps about to emerge to feed.

above right Coral polyps feeding by night, each fanning the water from the mouth of its tube. This is a member of the family Poritidae, which lays down a thick, heavy, calcareous skeleton.

prey or puncture it and deliver a paralysing poison. Humans are not susceptible to all hydrazoan poisons, but there are some that have been known to kill. The hydra as a group are most remarkable for the fact that they have achieved immortality as individuals. It is not easy to kill one, and they never die from old age. New cells are produced at the base and old ones shed at the end, so that cells migrate constantly along the length of the animal, no part of which is more than three weeks old. If a hydra is cut into pieces it simply grows such replacement parts as it needs.

The siphanophorans are colonies of modified medusae and polyps. A medusa filled with gas forms the float. In a Portuguese man o' war this individual may be 30 cm (1 ft) long and has a structure on its upper side which functions as a sail. Some siphanophorans can control the amount of gas – which is mainly carbon monoxide – and so move vertically in the water. Others have 'swimming bells', medusae modified to pulsate and so propel the colony, below the float.

In the Portuguese man o' war there are modified polyps below the float. They act like the keel of a ship, so that the colony does not drift with the wind, but at an angle of about 45 degrees to it. Those which live in the northern hemisphere tack to the right of the wind, and those in the southern hemisphere to the left, because of the positioning of these polyps.

That is only a small part of their job, however. The polyps are formed from two main types of 'zooid' – 'dactylozooids' and 'gastrozooids'. The gastrozooids form clusters, have no tentacles, and are concerned with feeding and digestion. The dactylozooids, which vary in size, bear the tentacles by which prey is caught, and then carried to the gastrozooids. If the item is small, a polyp just swallows it. If it is large, several polyps attack it together, sometimes covering it completely, and each swallows a portion. In addition to these polyps there are also reproductive polyps, containing male and female gonophores. These produce eggs, which are released and then develop into polyps. Each new polyp becomes a medusa, which forms part of the float for a new colony, and produces budding zones from which the other members of the colony arise. Although the members of the colony are distinct individuals, they are attached to one another and all are descended from a parent, who is their float.

The corals are close relatives of the sea anemones, and rather more distant

relatives of the siphanophorans. Both the sea anemones and the corals belong to the class Anthozoa, in which the medusa stage has disappeared entirely. The animals live only as polyps and they reproduce by budding. Sea anemones are usually solitary, and so are some corals, including the curious *Umbellula*, which has been photographed standing upright, about 1 m (3 ft) tall, and quite alone on the bed of the Atlantic at a depth of more than 5,000 m (3 miles). Most corals are colonial, however, and the structures they build, which in some species form reefs, support a vast diversity of life on which the coral polyps themselves depend.

There are many species of coral, but they fall into three main groups; the stony corals which build reefs, the soft corals and the gorgonian corals. In addition to these there are the sea pens, sea pansies, sea feathers and similar delicate forms, all of which live in colonies.

It is easy to be deceived by the corals, for those we see used for decoration are dead. They are pretty and they are genuine, but they are abandoned and look quite unlike living corals.

In most species, the individual polyps are very small, few being more than 3 mm ($\frac{1}{8}$ in) in diameter. They secrete calcium carbonate from the lower part of their sides and from their bases, so forming tubes into which they can retreat almost totally when threatened. It is very difficult for a predator to extract a coral polyp from its

A gorgonian coral, part of the Great Barrier Reef. The living polyps are very small animals which secrete the calcium carbonate from which their 'fans' are made. They live inside the protective covering and are connected to one another where their 'skeletons' touch.

Although the tubes are so long, each polyp is small and lives only at the top of the tube, constantly secreting new skeletal material and so raising the floor beneath itself. These are in the Red Sea, and they are feeding.

The branches of the coral contain innumerable polyps, all in contact with one another at their bases, and each with its own aperture through which it extends itself to feed. When disturbed, the polyps retreat instantly. The polyps on the left of the picture are feeding, but those on the right have withdrawn into their tubes.

fortress. The polyps are all connected to one another at their bases in the case of the reef-building corals, and by their upper parts in the case of those which produce flower-like and fan-like structures. The shape of the coral varies from species to species according to the way the polyps arrange themselves in the colony and the way the colony grows, but in a living reef, where the skeleton is produced at the base of the colony, all the polyps live above the skeleton and cover it completely. They reproduce by budding, the site of the bud varying from one species to another, but as it develops, so the bud is surrounded by calcium carbonate. This substance is being deposited all the time, and once in a while polyps of many species will lift themselves up a little and secrete a new floor to their tubes, so enclosing a small empty chamber beneath themselves.

How do new colonies arise? A colony grows by budding, but the polyps are also capable of sexual reproduction, which leads to entirely new polyps. These settle in a favourable spot and give rise to another colony.

Reefs are able to grow only in shallow water, where light can penetrate, and in water that contains few planktonic organisms. In fact, coral reefs thrive in marine deserts. Despite this, they themselves are so productive, and form the basis of such large and diverse communities of living things, that within their deserts they are oases, worlds quite of their own.

The collaboration by which the polyps live together, connected to one another, and sharing a common defence strategy, is only a small part of the total collaboration that is involved. Some sixty species of corals, including virtually all the reef-building types, contain within their cells zooxanthellae, microscopic organisms that give many corals a brown or yellow colour, but which also contribute a large amount of the food required by the polyps. In addition, most corals have algae growing on their surface. These simple photosynthesizing plants use sunlight, water and carbon dioxide to manufacture sugars. The reef also supports many organisms that bore into it. This may cause part of a reef to collapse, especially when it is being attacked from below, but it also exposes more surfaces that become encrusted with algae and other simple organisms that deposit more calcium carbonate and so strengthen it, and the destruction of coral is often halted when it reaches a stage in which the borers are buried in the debris they have excavated.

Reefs may be very large indeed, extending for many kilometres horizontally and for anything up to 1,000 m (3,280 ft) vertically. Since reefs can grow only in water of a particular depth, the existence of such deep reefs provides evidence for changing sea levels and a time when the corals grew in seas much shallower than they are today – during the ice ages.

Apart from their dependence on algae and zooxanthellae, the coral polyps feed like their cousins the sea anemones. They are carnivores and use their tentacles to catch small animals that swim within their range. The animals themselves are feeding upon the algae, on the minute organisms associated with the algae, and on one another. Many small fish are found beside coral reefs as they are able to escape pursuit by seeking refuge in small crevices. Everything depends on everything else, but the entire community exists only because of the colonial habit of the polyps. It is their team work that supports their world.

Even so, elsewhere in the animal kingdom we find examples of even closer collaboration, so close in fact than an entire colony, consisting of thousands of individuals, can behave almost as one being. Certain insects have mastered this close communal living, namely the termites and the hymenopterans – the bees, wasps and ants.

Insects are much more complex animals than hydra, and within their colonies

right There is no sense in which the queen bee, at the centre of the picture, can be said to rule the hive. She lays eggs, which are tended by the workers until they hatch, and are then fed for the five days or so they spend as larvae. Finally the workers cap the cells and leave the young to change into adult bees.

above The bee brood at various stages of development, with its worker attendants. The capped cells contain young which are metamorphosing, soon to emerge as new workers.

above right All the workers in a bee hive are sisters, but related more closely than human sisters.

each individual remains an individual, in that it moves freely and is not attached physically to its fellows. What makes the insect colony so remarkable, is that its very existence depends on the fact that the great majority of its members have relinquished the right to reproduce. Since the drive to transmit genes to a new generation is so fundamental to all living things, its abandonment puzzled scientists for many years. Charles Darwin recognized the difficulty. In *The Origin of Species* (chapter 7, called 'Instinct') he wrote: '. . . with the working ant we have an insect differing greatly from its parents, yet absolutely sterile; so that it could never have transmitted successively acquired modifications of structure or instinct to its progeny. It may well be asked how it is possible to reconcile this case with the theory of natural selection?' It was more than a century ago that Darwin attempted to solve the riddle. Today we know the answer.

An insect colony consists of a single fertile female, the queen, various types of sterile females, which are workers and, in some species, soldiers, and finally of sexually complete males. All these individuals go through the same stages of development, from egg to larva to pupa to adult, but the caste differences begin with the eggs.

During her nuptial flight, the queen mates with a male and stores his sperm in her body. Since only the queen is fertile, she alone can lay fertilized eggs, and all of them develop into females. These females do not develop to a point at which they are capable of mating. Exceptionally they may lay unfertilized eggs, but for the most part they are completely sterile.

The queen, too, is capable of laying unfertilized eggs, and these develop into males, which are sexually active.

The control over the development of the female workers is based on chemical substances in the food given to the larvae.

During the nuptial flight the queen receives sufficient sperm to last her a long time, and ant queens have been known to lay an egg every ten minutes or so for six years. The eggs and larvae are tended by the workers, and in many species the workers must also tend the queen, who is incapable of looking after herself. They are rewarded for tending the larvae in many species by an anal secretion produced by the larvae which the workers eat.

The question is why a caste of sterile females should evolve, and why they should devote themselves to the offspring of others, rather than their own.

The answer lies in the genetic relationships within the colony, which are rather different from genetic relationships among humans. In sexual reproduction, the offspring receives half its genes from one parent and half from the other, so that the relationship between parent and offspring is $\frac{1}{2}$. Because each parent contributes only half of his or her genes to each offspring, relationships between brothers and sisters are very variable, but on average they too are, and statistically must be, $\frac{1}{2}$. If the purpose of reproduction is the transmission of the genes carried by each individual, then the degree of relationship within a family and the amount of effort expended in the care of the young can be measured as the fraction of the parental genes carried by each offspring and the fraction of their own genes carried by brothers and sisters. In humans, the relationship between parents and children and brothers and sisters is $\frac{1}{2}$.

Worker ants are all daughters of the same parents, so they are full sisters. If they were human, their relationship to one another would be $\frac{1}{2}$, but their father developed from an unfertilized egg and so received only half a complement of genes. All his sperm must be identical and so all of them contain his full gene

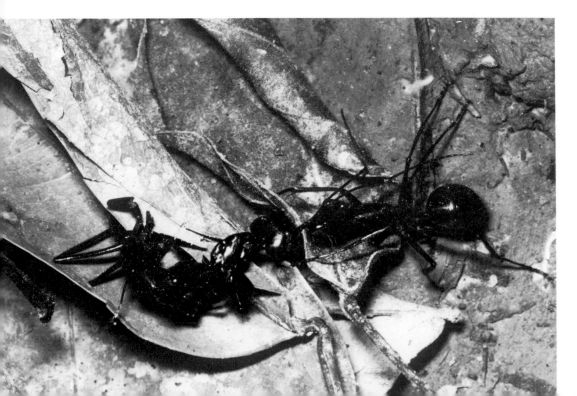

No community the size of a hymenopteran colony could exist unless members were able to communicate with one another. As these ants face one another and make complex movements with their antennae, information passes between them.

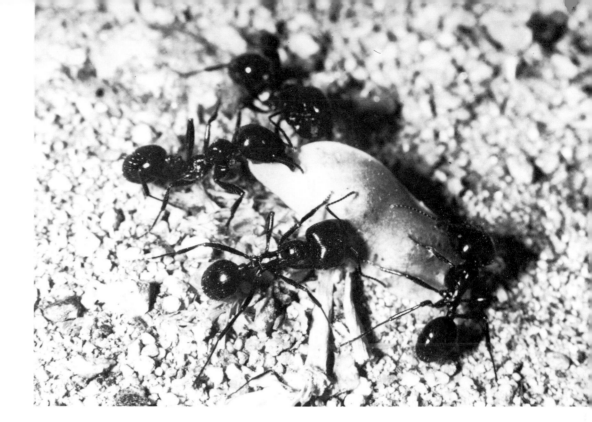

Cooperation among ants is a familiar sight. These ants are moving to the nest a piece of plant material that is too cumbersome to be carried by an individual.

endowment and all of his genes are transmitted to all of his daughters, so the sisters possess all their father's genes and half their mother's, and this means the relationship between sister and sister is $\frac{3}{4}$ of her own genes. Were she to mate and lay fertilized eggs, the offspring for which she cared would carry only $\frac{1}{2}$ of her genes. Genetically, therefore, she is better off caring for her sisters. She must also devote some attention to her mother, to whom her relationship is $\frac{1}{2}$. Her brothers are less important. They carry only the maternal genes and only half of those. On average their relationship with their sisters will be only $\frac{1}{4}$. We should expect, therefore, that the workers would devote twice as much attention to the queen as they devote to their brothers, and three times more attention to their sisters than they devote to their brothers. This has been measured, and found to be what actually happens.

The implications do not stop there, for far from being a dictatorship in which behaviour is controlled by the queen, the ant colony in fact is a sorority run by the workers. The queen, after all, is related just as closely to the males, which develop from unfertilized eggs and so receive all their genes from her, as she is to the females. In both cases the relationship is $\frac{1}{2}$, and so far as the queen is concerned the workers might as well tend her sons as her daughters. There are ants among which this happens, but they enslave ants of other species. When the eggs and larvae are tended by slave workers, which are not related to them at all, there is no differentiation and all the young receive equal attention. Again, it is not the slavemaster queens that direct operations, merely the workers which have no preference. Curiously enough, workers of the slave species do exhibit the usual female preference when they are in their own colonies and raising young to which they are related.

Relationships among ants and among the social bees and wasps have been studied intensively, and far from proving a difficulty in Darwin's theory of natural selection, today they supply a great deal of hard evidence to support it.

From time to time people have made comparisons between the societies of insects and those of humans, usually of humans whose social systems are unpopular. Such comparisons are superficial and do not help us to understand the insects or ourselves. The insects are modified physically to equip them for the roles they will fill in life. We have met the 'soldiers', armed with large and powerful mandibles,

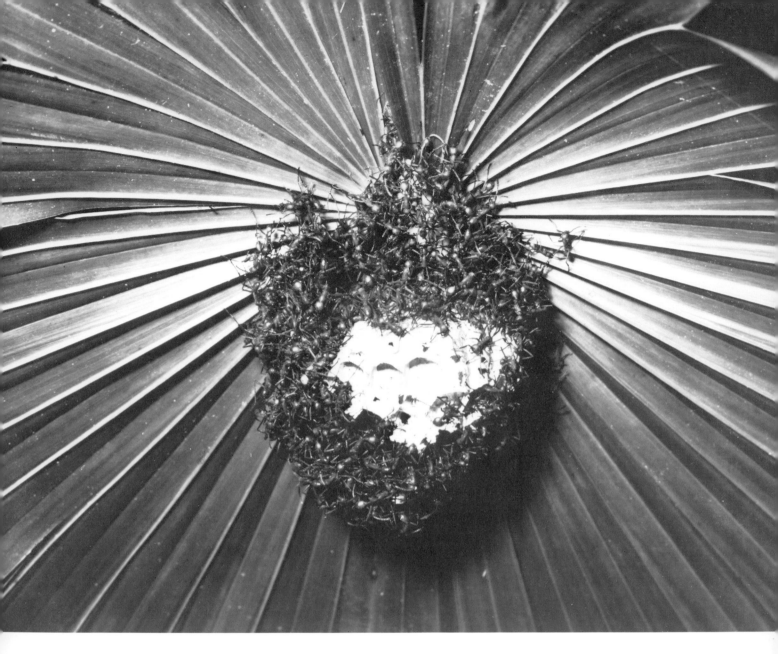

that crack open hard foods and defend the colony against invaders, the 'repletes' whose 'honey stomachs' swell to the size of garden peas, converting their owners into living food stores, and the 'gatekeepers' whose large heads have turned into doors. Human societies are not based on such structural modification. Nor are relationships among humans determined by the kind of genetic distribution that occurs when some members of the community are produced sexually and some asexually.

However, there is much more to the internal organization of an ant or bee colony than reproduction and the raising of the young. The colony itself must be housed and the housing maintained, and among honeybees the workers must perform several different tasks. As each worker grows older so her role in the hive changes. The bees are highly versatile. When young, the workers are engaged in constructing combs, cleaning cells, storing food and caring for the larvae. For these tasks they secrete substances from various glands, but by the time they are about three weeks old such glandular activity ceases and they give up nursing and commence foraging. The honeybees you see visiting flowers are middle-aged workers. Some of them will be scouting – searching for sources of food and returning to inform the rest of the hive. When they are too old to forage, the workers spend much of their time resting, occasionally inspecting the hive and its

The driver, or army, ants are hunters. In this case their prey is a solitary wasp, whose nest is being attacked.

surroundings and directing younger workers to important tasks.

No animal colony can survive without some effective means of communication among members, and ants and social bees have such means. Again, despite superficial similarities which appear once we allow for the fact that the communication is not vocal, the transmission of information among these insects does not amount to the use of language in any sense that allows it to be compared with human language. Nevertheless, it serves its purpose well.

The message the social insects need to pass to one another relates to sources of food. There are some ants which forage alone for small items which they carry back with them to the nest. Most of the time, each food item can be carried by the ant which finds it and there is no need for others to be summoned. Occasionally, though, such an ant will come across something too large for it to handle alone. Its most usual strategy then is to swallow a small portion of the food as a sample, return to the nest, regurgitate the food in front of another ant, then to turn around, raise its abdomen and extend its stinger, which releases a chemical stimulus. The second ant then approaches the first and touches it with its antennae. After that, both ants set off one behind the other, still touching, to retrieve the food. When more than one helper is needed, the ant that finds the food may perform a 'waggle dance', rather like the waggle dance of the honeybees, but in this case it does no more than set other ants foraging for food that smells like the specimen regurgitated before them. Sometimes the ant that finds the food may lay a scent trail from the food back to the nest, and this guides the foraging party. Many ants lay scent trails that last for only a few minutes in order to guide other members of their colony to food. That is how army ants are able to descend suddenly in force on a victim located by one of their scouts. Ants of more regular habits sometimes make pathways, along which foragers travel, seeking food to either side.

The most sophisticated communication of all has developed among the honeybees, whose scouts cannot clear trails or lay scent, or even lead their fellows, for as flying insects they must move from their base to food and back without touching the ground. The honeybees dance.

There are two types of dance, a round dance which is used to inform the hive of the existence of food nearby and which merely sends the bees out foraging, and the

The wasp nest has been broken open and the larva removed. Far too large for a single ant, it is carried off by many ants joining forces.

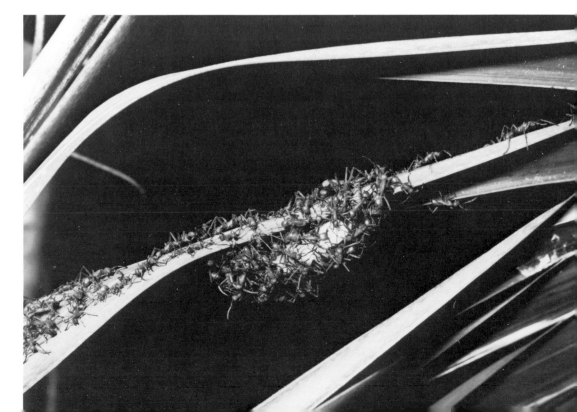

waggle dance. This is far more advanced, because it informs the bees of the kind of food available, its direction, and its distance from the hive. The type of food is indicated by the nectar and pollen carried to the hive by the scout, but the rest of the information is conveyed by means of a ritualized set of movements.

The scout bee performs a figure-of-eight run on a vertical surface, the clues being supplied by the straight run between the two halves of the figure. This run is made at an angle to the vertical. This is the angle to the sun at which the bees must fly. If the run is made upward they must fly towards the sun, if downward they must fly away from the sun. This tells them the direction in which to travel. As it makes its straight run, the dancing bee waggles its abdomen and emits sounds. This tells the bees the distance they must travel. The greater the frequency of the waggles, the closer is the food source. It seems likely that the sounds made by the bee also concern the distance from the hive, and they may be important, because it is fairly dark inside a beehive and no one knows just how well the audience is able to see the dancing scout.

We cannot make direct comparisons between human societies and colonies of non-humans, but one thing is certain. Complex, stable, peaceful and large communities are by no means an exclusively human invention. They have developed in many places at many times, and among some invertebrates they have been even more successful than they have been among ourselves.

A worker honeybee performing the round dance to inform her sisters that food is available nearby. When she has finished her audience will go foraging.

Bibliography

Alcock, John, *Animal Behaviour, an Evolutionary Approach*, second edition (Sinauer Associates, Inc., Sunderland, Mass., 1979)

Allaby, Michael and Crawford, Peter, *The Curious Cat* (Michael Joseph, London, 1982)

Beck, Benjamin B., *Animal Tool Behavior* (Garland STPM Press, New York, 1980)

von Frisch, Karl, *Animal Architecture* (Harcourt Brace Jovanovich, New York, 1974)

Goodfellow, Peter, *Birds as Builders* (David and Charles, Newton Abbot, 1977)

Lorenz, Konrad, *On Aggression* (Methuen, London, 1966)

McFarland, David (ed.), *The Oxford Companion to Animal Behaviour* (Oxford University Press, 1981)

Manning, Aubrey, *An Introduction to Animal Behaviour*, second edition (Edward Arnold, London, 1972)

Acknowledgments

The author and publisher would like to thank the following photographers, institutions and agencies by whose kind permission the illustrations are reproduced:

Ardea Photographics: 103, 104, 142, 152; I. R. Beames 117, 183; I. & L. Beames 133 *top right and left*; Tony Beamish 93 *bottom left*; Hans & Judy Beste 82, 83; Jean-Paul Ferrero 8, 119 *top*, 127 *top*; Ken W. Fink 37; Bob Gibbons 23 *top*; François Gohier 16 *centre*, 17 *left*, 148, 149 *top*; D. W. Greenslade 169; Don Hadden 100; Eric Lindgren 105; John Mason 57 *right*, 68, 116 *left*, 120 *below*, 135, 181, *top and left*; J. L. Mason 115 *left*, 182; E. McNamara 102 *top right*; Pat Morris 87 *below*, 119 *below left*, 120 *above*; R. F. Porter 91 *below*; Ron & Valerie Taylor 177 *left*; Valerie Taylor 158

Biophotos: Heather Angel 22, 44, 51 *top*, 74 *left*, 77 *left*, 124 *right*, 127 *below*, 131; S. Summerhays 174 *below*, 178

Centre for Overseas Pest Research: Gianni Tovoli 164; John Manuel 168

Bruce Coleman Ltd: 101, 156; Helmut Albrecht 137; Jen & Des Bartlett, 153, 162; J. Boswall 67 *left*; Jane Burton 48, 54 *below*, 75, 94, 122, 165, 166, 173; Bob Campbell 6; Stephen Dalton 166; Adrian Davies 45, 113 *top*; M. P. L. Fogden 92, 184, 185; Jeff Foott 10, 11 *right*, 36, 151; C. B. Frith 101; Masao Kowai 39; J. Mackinnon 32; Owen Newman 33; J. Pearson 29; Mike Price 30 *below*, 136, 139, 140; H. Rivarola 28; Alan Root 31; W. E. Ruth 146; Dr Frieder Sauer 49, 72, 73, 89; George B. Schaller 138; Eugen Schumacher 96; John Shaw 149 *below*; Kim Taylor 14, 21, 143; Norman Tomalin 102 *top left*; Fritz Vollmar 145; Peter Ward 16 *top*, 59 *bottom left*, 118, 119 *bottom right*; Gunter Ziesler 67 *right*, 91 *top*

Eric Hosking: 95 *top*, 128 *above*; D. P. Wilson/Eric & David Hosking 159

Institute of Geological Sciences: 46, 47

Frank Lane: 71 *left*, 99, 116, 154 *below*; Lynwood Chace 130; Arthur Christiansen 26, 150 *top*; Roger Collorick 129 *below*; Treat Davidson 110; Tom & Pam Gardner 102 *below*; H. Hoflinger 35; Frank W. Lane 161; Wilfrid L. Miller 150 *below*; R. van Nostrand 160; Walker van Riper 15 *below*; A. J. Roberts 51 *below*; Leonard Lee Rue III 154 *above*, 155; A. Faulkner Taylor 133 *below*; Dr T. S. V. de Zylva 69

Natural History Photographic Agency: 77 *right*, 157; Anthony Bannister 12, 19, 57 *left*, 58, 59 *right*, 70, 71 *top*, 121; Stephen Dalton 27, 76, 106, 109, 111, 114 *above*, 115

right; J. B. Free 108; J. Good 124 *left*; Brian Hawkes 30 *top*; Peter Johnson 93 *top left and right*; Dr Ivan Polunin 86, 87 *top*; Mandal Ranjit 90; E. Hanumantha Rao 84; Roy Shaw 50 *left*; M. W. F. Tweedie 74 *right*; Bill Wood 177 *right*, 179 *below*

Nature Photographers: Hugo van Lawick 40, 41

Natural Science Photos: P. J. K. Burton 95 *below*, J. A. Grant 112; Dave Hill 174 *top*, 179 *top*; Gil Montalverne 170; Nat Fain 175; R. C. Revels 134; W. R. Tarboton 80; P. H. Ward 55; Curtis Williams 113 *below*; D. Yendall 114 *below*

Oxford Scientific Films: G. I. Bernard frontispiece 123, 125, 126, 172; Dr J. A. L. Cooke 16 *below*, 17 *right*, 53, 56, 60, 64; Stephen Dalton 54 *top*; M. P. L. Fogden 18; Laurence Gould 25; Z. Leszczynski 62; Mantis Wildlife Films 50 *right*; Peter Parks 20, 23 *below*, 163; D. M. Shale 107; David Thompson 13, 15 *top*, 78, 79, 167, 181 *below right*, 186

Seaphot: Kenneth Lucas 63

Zoological Society of London: Michael Lyster 38

Index

Page numbers in italics refer to illustrations